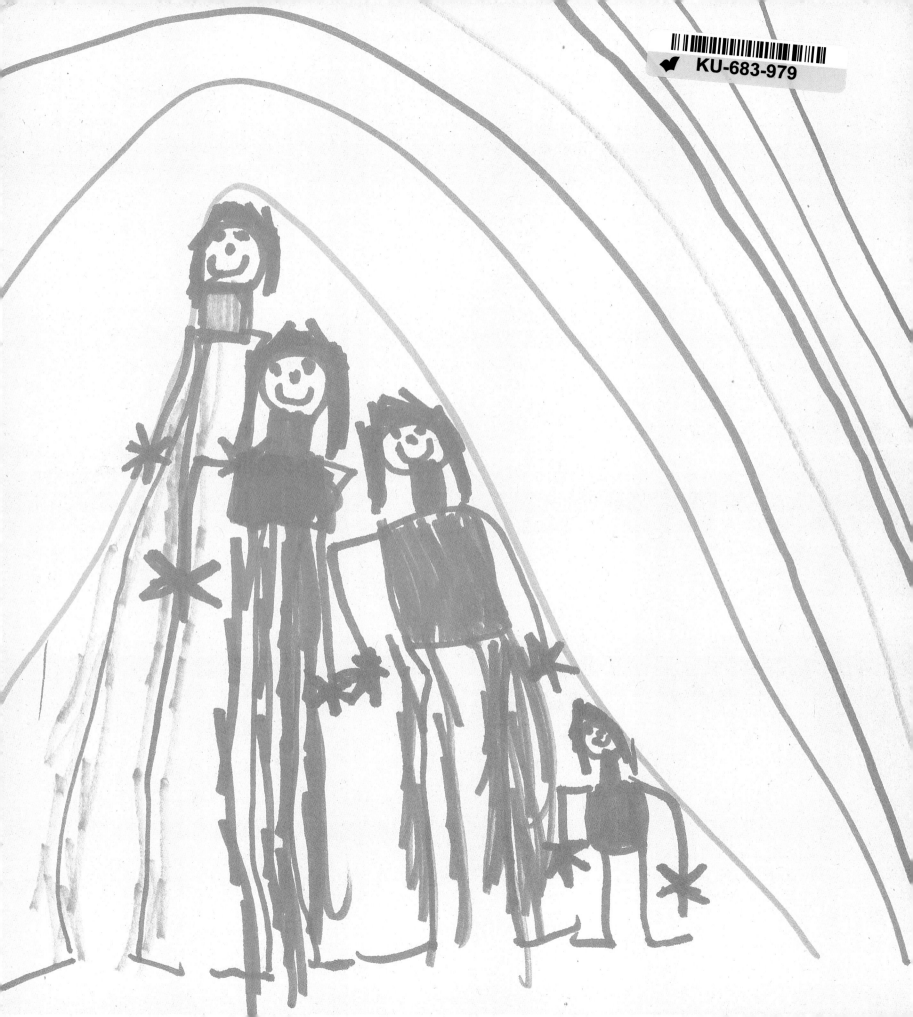

family ties
a contemporary perspective

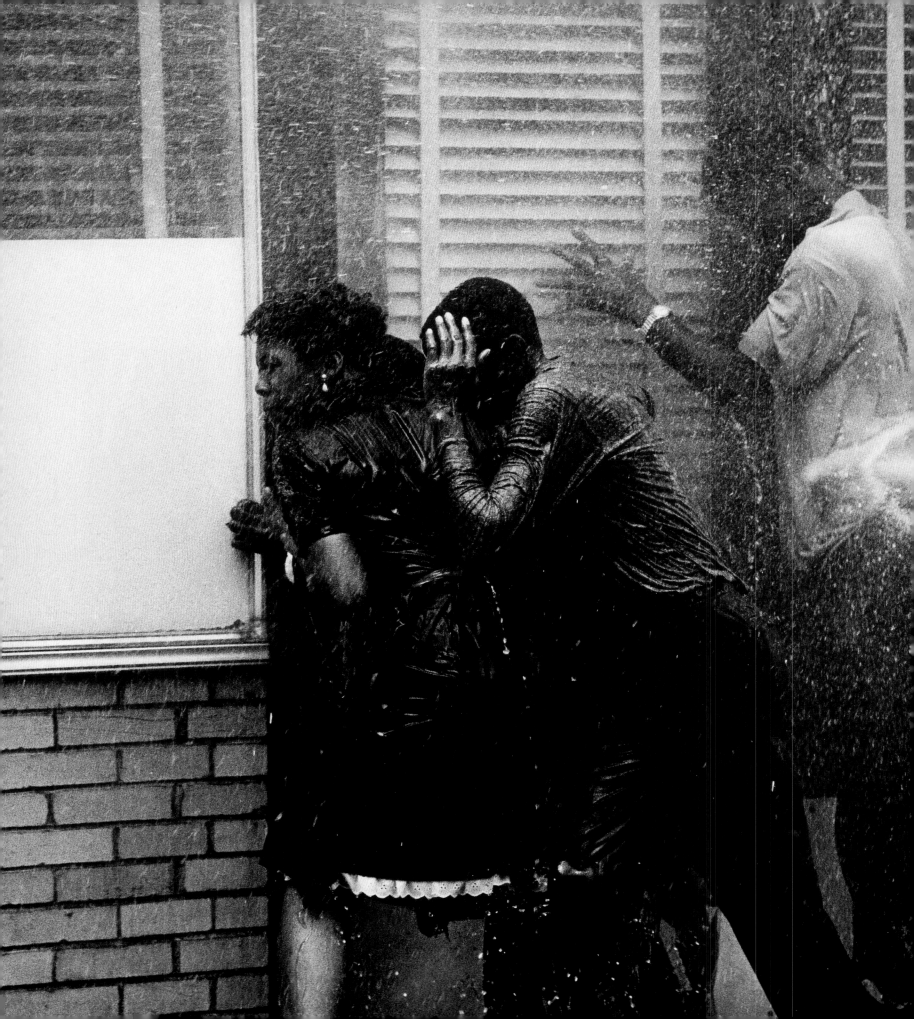

family ties
a contemporary perspective

Trevor Fairbrother

with an introduction by
John R. Grimes

and a contribution by
Sarah Vowell

PEABODY ESSEX MUSEUM
Salem, Massachusetts

in association with
MARQUAND BOOKS

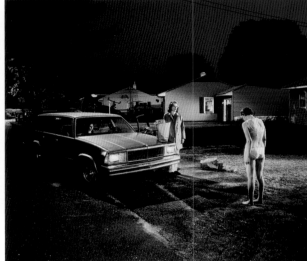

This book has been published in conjunction with the exhibition *Family Ties: A Contemporary Perspective*, organized by the Peabody Essex Museum, Salem, Massachusetts, June 21–September 21, 2003.

Library of Congress Cataloging-in-Publication Data
Fairbrother, Trevor J.
 Family ties: a contemporary perspective / Trevor Fairbrother ; with
an introduction by John R. Grimes and a contribution by Sarah Vowell.
 p. cm.
 Catalog of an exhibition at Peabody Essex Museum held in summer
2003.
 ISBN 0-9706394-7-3 (softcover : alk. paper)
 1. Family in art—Exhibitions. 2. Art, Modern—20th century—
Exhibitions. I. Vowell, Sarah, 1969– II. Peabody Essex Museum. III. Title.
N8217.F27 F35 2003
704.9'4930685'0747445—dc21 2003004878

Available through D.A.P./Distributed Art Publishers
155 Sixth Avenue, 2nd Floor, New York, NY 10013
Tel: (212) 627-1999 Fax: (212) 627-9484

Printed and bound by CS Graphics Pte., Ltd., Singapore

Front cover: Janine Antoni, *Momme*, 1995 (detail of Plate 45)
Back cover: Romare Bearden, *Family*, 1967–68 (detail of Plate 3)
Endsheets: Sarah Wincapaw, age 5, *Rainbow Family*
Frontispiece: Shellburne Thurber, *Edinburg, Indiana: My Mother's Portrait*,
1976 (detail of Plate 41)
Pages 2–3: Charles Moore, *Birmingham*, 1963 (detail of Plate 6)
Pages 4–5 (left to right): Shellburne Thurber, *Edinburg, Indiana: My
Grandfather's Study*, 1976 (detail of Plate 43); Gregory Crewdson, *Untitled
(penitent girl)*, 2002 (detail of Plate 70); Seydou Keita, *Untitled*, 1945–51
(printed 1996) (detail of Plate 16)
Page 7: Jim Goldberg, *We haven't done anything to promote it, but she
seems to think that she is Shirley Temple. She is so sophisticated. I wonder
what she may become*, 1982 (see Plate 53)
Page 8: Nicholas Nixon, *The Brown Sisters*, 1975–99 (detail of Plate 35)
Page 10: Alice Neel, *Linda Nochlin and Daisy*, 1973 (detail of Plate 17)
Page 134: Edward Koren, *Mailboxes*, 1992 (see Plate 50)

"What I See When I Look at the Face on the $20 Bill," from **TAKE
THE CANNOLI** by Sarah Vowell. Copyright © 2000 by Sarah Vowell.
Reprinted by permission of Simon & Schuster, Inc., New York

Edited by Michelle Piranio
Proofread by Jennifer Sugden and Carrie Wicks
Designed by Jeff Wincapaw
Typeset by Marie Weiler
Color separations by iocolor, Seattle
Produced by Marquand Books, Inc., Seattle
 www.marquand.com

contents

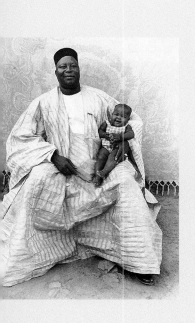

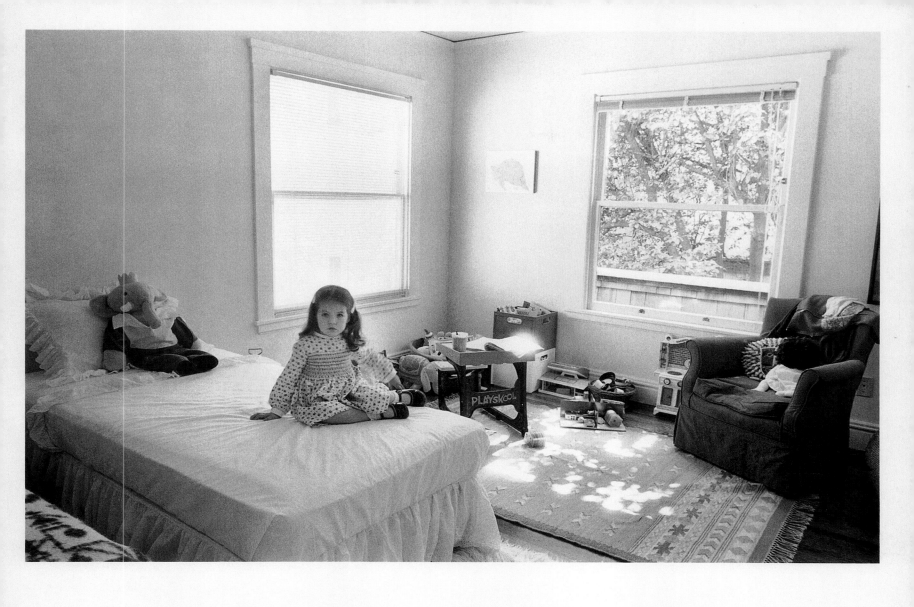

We haven't done anything to promote it, but she seems
to think that she is Shirley Temple.
She is so sophisticated.
I wonder what she may become.

Jeffry Thomas

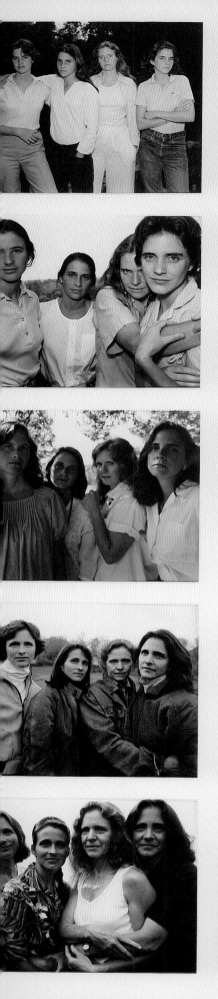
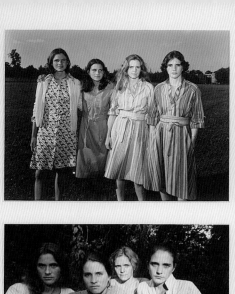
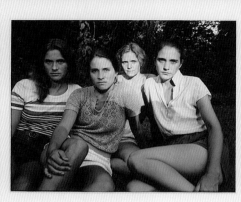
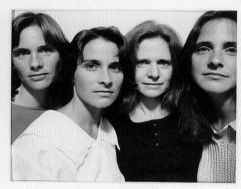
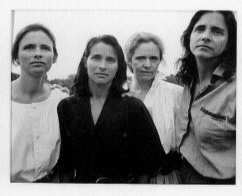
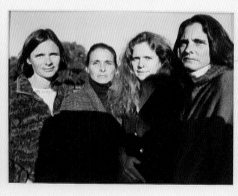
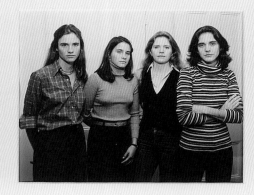
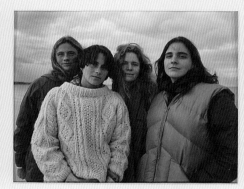
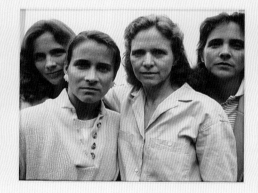

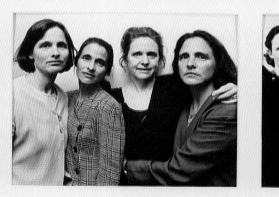

foreword

Art has an inherent direction. Artists have no choice but to speak from the moment and the location they occupy as they express emotions and ideas about inner and outer worlds. The work they create cannot influence the past, but only the present and the future.

The experience of art is also directional. It provides a gateway to new knowledge and perspectives. Through art, in all its many forms, we can refocus or alter our view of the world, making new pathways visible. Art has the ability to change people's lives as they later unfold.

Likewise, the compass needle of museums, of all kinds, points from the present to the future. This orientation is not maintained merely by placing an object or an artwork on a pedestal and affixing nearby a miniature list of facts and figures. It is not accomplished by relegating the viewer to memorization, or veneration, of the institutional voice, of curatorial knowledge and "taste." Nor is it advanced by creating theme park–like exhibitions, where objects simply illustrate or titillate and success is measured solely in numbers and revenue. Instead, it is the responsibility of museums, and of their curators and educators, to engage individuals, through objects and artworks, with other vistas and paths, to help them discover other positive life journeys, and then to assist them on their way. This is as true when displaying objects and artworks of other times and places as when presenting those more familiar to us.

It is easy to examine the past and come away from it with information, feelings of nostalgia, or even disdain. It is much more difficult to seek in it insights that are relevant to the present and the future. And the hardest task of all might be to look to our own time for meanings that inform how we choose to live our lives. In *Family Ties,* Trevor Fairbrother has taken on such a challenge, looking at a selection of contemporary artworks relating to family, in its broadest sense, and from that encounter helping us to expand our vision.

Family Ties plays an extremely important and fitting role in the reopening of the Peabody Essex Museum, which has been reborn this year through new galleries, new exhibitions, and a new interpretive philosophy. Now, more than at any time in its history, the museum has dedicated itself to engaging with the present, while maintaining an abiding interest in the past. It is dedicated to enriching people's lives, and making a positive difference in their future. It is dedicated to a wider sharing of its global collections of art and culture, and to stimulating respectful inquiry and dialogue among diverse communities. This exhibition and catalogue, which bring together a moving group of artworks assembled around a widely relevant theme, have helped to nobly inaugurate each of these new initiatives.

On behalf of the Board of the Peabody Essex Museum, I would like to extend our deepest gratitude to Trevor Fairbrother for sharing his vision, and all of his hard work, which have made this exhibition a reality. In addition, I would like to thank all those staff members who assisted in the many facets of this effort. I am particularly grateful to John Grimes, Fred Johnson, and Vas Prabhu, who collaborated closely with Trevor on concept, design, and interpretation; and William Phippen, Claudine Scoville, Naomi Chapman, and Carolle Morini, who coordinated the complicated matters of logistics, loans, transport, photography, and permissions. Finally, I'd like to thank Ed Marquand, Jennifer Sugden, Marta Vinnedge, Marie Weiler, and Jeff Wincapaw of Marquand Books and editor Michelle Piranio for working so hard to produce this beautiful catalogue.

Dan L. Monroe
EXECUTIVE DIRECTOR, PEABODY ESSEX MUSEUM

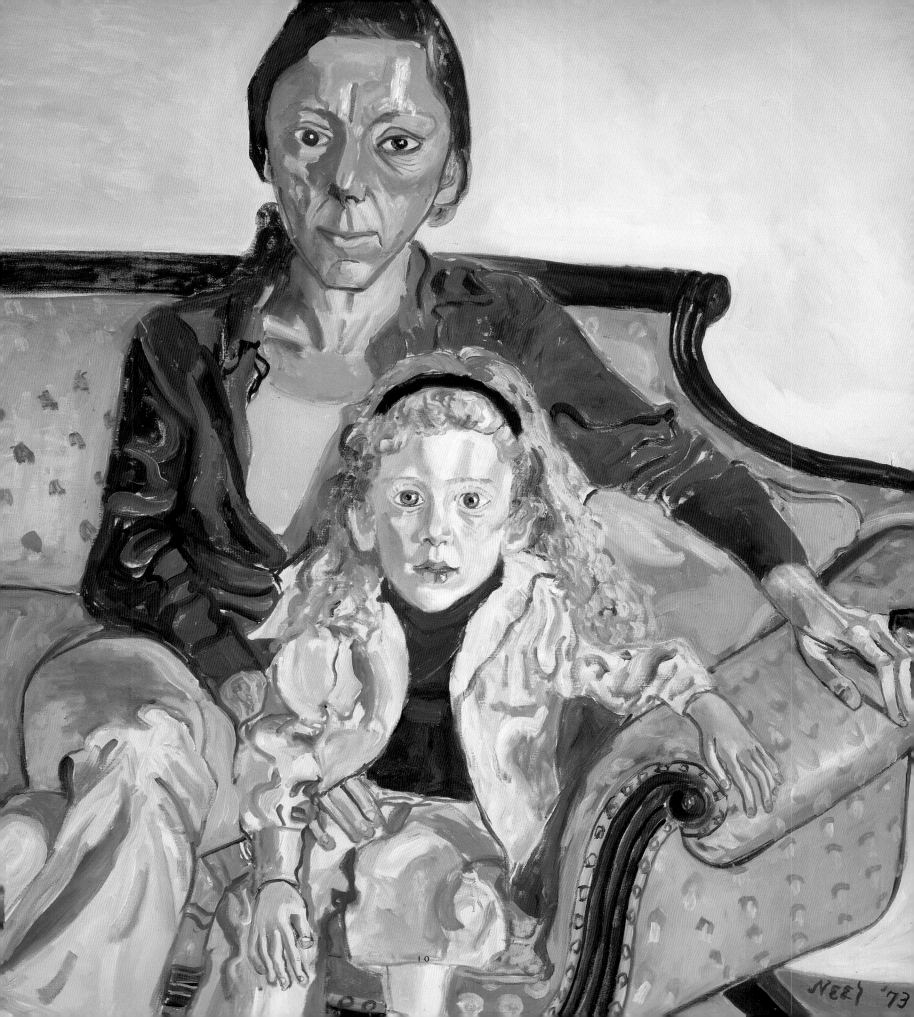

being in a circle of family

John R. Grimes

With *Family Ties,* Trevor Fairbrother has brought together a poignant group of artworks selected for their relationship, direct and indirect, to the concept of family. In doing so, he takes on a task reminiscent of that of the curator in Nick Bantock's novel *The Museum at Purgatory,* who is confronted by an odd and bewildering assortment of highly personal heirlooms, displayed in winding galleries:

> And so I became Curator. . . . One of my chief responsibilities was to give ear to the stories told by the contributors, and assist them in understanding the relationship between their collections and their past lives. . . . The connection, as I learned by degrees . . . was inexorable.[1]

That the works of art included in *Family Ties* are inexorably linked to the lives of the families they represent is readily discernible, but the qualities of these ties elude crisp definition. Beyond the difficulties involved in defining the nature of "art," it is, as Fairbrother alludes, simply facile to assume that there are universal experiences of family on which to draw. Around the world, and within cultures, families vary widely in their attributes and qualities, internal dynamics, personal and cultural associations, and rules of inclusiveness—the distinctions and implications of inside-ness and outside-ness. Even the apparent constancy of the procreative family, father-mother-child, is a cultural convention in only certain parts of the world. In others, father(s)-mother-child or mother-child, among others, is considered an equally valid possibility. And as humankind stands on the threshold of artificial cloning, we can only imagine how the definition of "nuclear" family will take on profoundly new meanings.

Some of the strongest familial associations arise from the process of birthing and rearing children, and the varying strategies for coping with the exigencies of child care result in a range of family structures. Infants require a tremendous investment to feed, nurture, and instruct. While these responsibilities place considerable demands on parents (however defined), especially the mother, the welfare and education of children necessitates an extended cooperative network. An illustration of this can be found in author Donald Rubinstein's portrayal of family life in the outer islands of Yap, Micronesia, where he lived during a portion of the 1970s. There, a variety of neighbors and relatives, including siblings, provided daily child care, with older children minding their younger brothers and sisters, who, in turn, take care of still younger children. The system placed parents

> at the top of the chain of command . . . [with] collective child-rearing authority . . . distributed among relatives and non-relatives who may provide temporary foster care. . . . This collective sharing of childcare responsibilities gives children a sense that kinship support is inexhaustible, and it gives parents a wide network of support and assistance . . . families were part of ever widening circles of social relations.[2]

Kerry James Marshall, *Souvenir II*, from *Mementos*, 1997 (detail of Plate 74)

In their interplay with the surrounding society, families take on greater complexity. In Yap and elsewhere, family and community are mutually dependent. Even in impoverished circumstances, families extend their roots widely in society, seeking the support and cultural enrichment of other families and social structures. Communities depend, in turn, on the cohesive ties within and among families. Additionally, families are the seedbeds in which individuals are acculturated and from which they mature to become functional participants in society. The importance of this function is evidenced in the dogma of almost every religion, ideology, and culture, which carefully defines family structures and individual roles. As the "family values" debates of our own time attest, social and political divisiveness can arise when differing views seem to impinge on one another.

Setting polemics aside, one could argue that the essential requirements of a healthy family are few: it should provide a safe and nurturing environment for individual growth; it should foster in each family member the capacity to give and receive caring support and affection; and it should equip each family member to assume, at the proper time, a constructive role in the larger human community. Within this domain, families are simply self-organizing associations, circles of interdependence and commitment, whose province far exceeds that of child-rearing. The circles of family can form around almost any permutation of gender, age, ethnicity, and intellectual, emotional, or sexual orientation. In the forest of human communities, families are groves. Where there is nourishment, the roots of individual trees flourish and grow; where there is none, they atrophy and die. Where nutrients are rich, roots of several trees may become so intertwined as to seem to merge into a single body. Thus, the propagation of groves, and families, is not simply the consequence of closely scattered seed, but the outgrowth of common nourishment, intimacy, and time.

Through births and deaths, and other comings and goings, every family evolves over time. But families also change according to the changing needs and capacities of their members, each of whom is involved in a lifelong process of self-realization. Each personal milestone is a rebirth that challenges the family envelope. To cohere over time, a family must re-form itself around these changes, and thus each rebirth gives birth to a new family as well. Some personal milestones are largely private matters, leaving individuals and families to find their own manner of accommodation. Other milestones accord with cultural norms, and are managed by rites of passage that codify new individual roles. Yet other changes are accommodated by giving individuals leave to join other families, in marriage and otherwise. Typically, and ideally, individuals belong to many families during the course of their lives,

managing multiple memberships through careful social coordination, usually cognizant that some families are exclusive of, and sometimes antagonistic toward, others.

As families change, so does the world in which they exist. The external currents of nature and nations challenge and restructure families no less than internal forces. Indeed, families are often situated in the vanguard of change, the interface between individuals and the world at large. Economic cycles, cultural trends, shifting boundaries, wars, and changing environments—each inevitably translates into specific repercussions in the everyday lives of families, altering identities and bending roles and relationships among their individual members.

In the end, with all its dynamic qualities, "family" is far more a verb than a noun, a group of actions rather than an object. It follows, then, that it is in the *being* of family that we find the most meaningful commonalities. This distinction does not relieve us of any overall burden of potential complexity, but it does tell us that the truest inquiry into the nature of family is an existential meditation, not a taxonomic study.

"The premise to be puzzled is indeed the premise of all creation,"[3] and the contemplation of family provides a rich ground for artists. Each of the works in *Family Ties* represents an artist's response to the germs of puzzlement planted when stepping back from his or herself, as he or she exists *in* and *out* of family, to gain a broader view of personal identity, context, and connection to others. In doing so, prior truths have been momentarily displaced, and previous perspectives shifted, sometimes to the point of vertigo; familiar moments have assumed sudden and unexpected new meanings.

New viewpoints must be resolved in the mind, or result in persistent dissociation. Each of the works in *Family Ties* is the artist's confessional mirror, a place for self-revealing and for seeking inner resolution. In this, the art assumes a therapeutic role. The insights of these artists include many of the categorical complexities of family-ness: the myriad circumstances that bring families together; the changing identities and roles of their members; their responses to community pressures; and impacts of larger trends.

The artists included in *Family Ties* have lived amidst the major social, ideological, and technological currents that followed World War II. Some were born early enough to witness the lingering apogee of modernism; others only in time to stand in the pyrotechnic rain of postmodernity—deconstructivism,

left to right: William Klein, *Holy Family on Wheels,* 1956 (detail of Plate 10); Romare Bearden, *Family,* 1967–68 (detail of Plate 3); Tracey Moffatt, *Useless, 1974,* 1994 (detail of Plate 60)

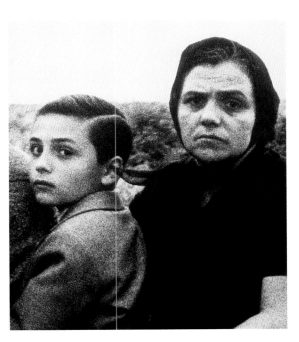 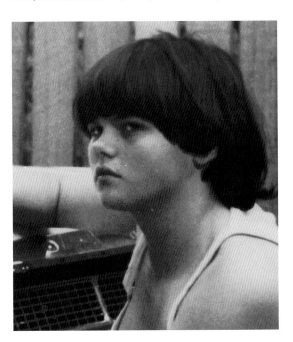

postcolonialism, globalization. These postwar decades have comprised an era of increasing

> freedom of personal choice and its concomitants—the breakdown of universal norms and absolute values, and the expansion of autonomy, individualism, pluralism, and permissiveness. The social control of life in community has gradually disappeared, and privatism has become dominant.[4]

It is a world where, one by one, many of the seemingly solid landmarks of family and society have dematerialized, revealing a hall of mirrors where little seems fixed—perhaps least of all the certainty of one's own reflection, and that of family and others near to us. All of the *Family Ties* artists have worked in this uncertain and changing milieu, grappling with the personal, familial, and social implications of each new view and reflection. Behind each artist, as behind all the artists of our age, looms the troubling possibility that the final legacy of postmodernity will be the leached and shallow soil of nihilism. This is a specter of barrenness, and of universal diaspora, where every individual is continuously displaced from the familiar by overwhelming forces of change. In bearing on this and other issues, the implications of these works go far beyond the lives of the individual artists and their families.

Family is not a thing or a place, nor is it utopian. Rather, as families exist in their being and doing, they suffer all the possible flaws of human intent and action. They can be infected with abusiveness and selfishness, and can mutate into circles of exclusion and hatred. But families cease, in fact, to be families when they no longer nurture, give mutual support and affection, and prepare members for constructive roles in society.

Humankind is a mosaic of families, each flawed and unique, and yet interdependent on all; it is not, and cannot be, the singular "family of man" of the modernist vision. If the possibility for unity exists in the postmodern era, it lies not in the *thing* of family, but in the total of every *being* and *doing* of family.

Art is an infinite arrow, pointing in two directions. In one direction, it points to a moment in the inner world of the artist, and in the other, to a moment in the inner world of the viewer. When we look only to the artist, art becomes entertainment, and its viewing becomes voyeurism. When, however, we allow it to compel our gaze back to ourselves, art has the capacity to connect ideas, illuminate new perspectives, evoke dialogue, and create opportunities for true human communion.

"All real living is meeting,"[5] and no meeting is without family.

> No one goes anywhere alone . . . not even those who arrive physically alone, unaccompanied by family, spouse, children, parents, or siblings. No one leaves his or her world without having been transfixed by its roots, or with a vacuum for a soul. We carry with us the memory of many fabrics, a self soaked in our history . . . our culture; a memory, sometimes scattered, sometimes sharp and clear, of the streets of our childhood, of our adolescence.[6]

In the meeting of individuals, families are also embraced; they are connected to others and, outward and outward, to the whole of humankind. Through the artworks in *Family Ties,* Trevor Fairbrother has not only given us the potential to meet each artist, but has also tendered a greater and more compassionate possibility: that in the mirrored halls of these meetings, as our dialogues unfold, we might see the fleeting reflections, and hear the whispering voices, of our own families, and of every family in time.

Notes

1. Nick Bantock, *The Museum at Purgatory* (New York: Harper Collins, 1999), pp. 106–107.

2. Donald H. Rubinstein, "Changes in the Micronesian Family Structure Leading to Alcoholism, Suicide, and Child Abuse and Neglect," in *Micronesian Counselor* (Pohnpei), no. 15 (June 1994).

3. Erich Fromm, "The Creative Attitude," in H. H. Andersen, ed., *Creativity and Its Cultivation* (New York: Harper & Row, 1959), p. 48.

4. Judith Stacey, review of *The Postmodern Family,* by Richard Quebedeaux (New York: Basic Books, 1990), in *The World and I Online,* vol. 5 (December 1990), p. 401.

5. Martin Buber, *I and Thou* (New York: Scribner, 2000), p. 26.

6. Paolo Freire, *The Pedagogy of Hope* (New York: Continuum, 1994), p. 31.

family ties
Trevor Fairbrother

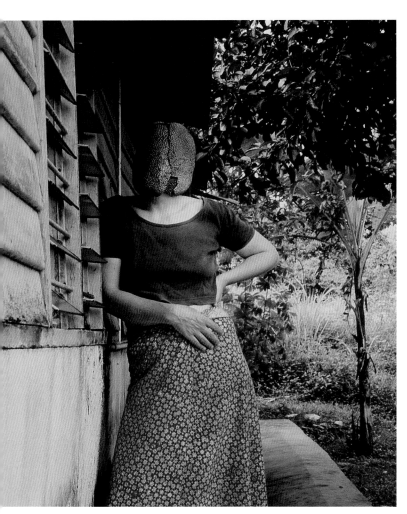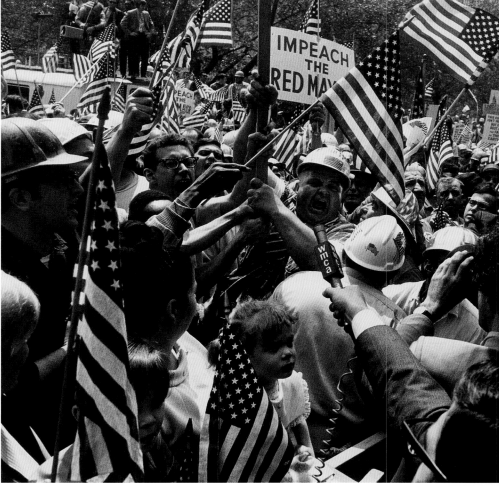

details of Plates 79 and 7

the meanings of "family"

Ruminating on the notion of family can feel like confronting an overstuffed cupboard. It opens up a mental place where we have carefully preserved, hurriedly tucked away, or buried a mess of issues: facts about our biological origins and social background; good and bad memories of childhood and educational upbringing; and awareness of any legal statutes and religious decrees that shape our familial experiences. These personal associations have usually been colored and shaped by diverse cultural forces. For example, most of the world's religious traditions give vital roles to emblematic families, including the Egyptian deities Isis, Osiris, and Horus and the Christian holy family of Mary, Joseph, and Jesus. And for centuries all branches of the creative arts have embraced family sagas, which give life to issues of identity, personal accomplishment, and the passage of time. From children's stories to opera, the subject is usually there in some guise.

The word family entered the English language in the late fourteenth century, coming from the Latin words for household (*familia*) and servant (*famulus*). Since then it has connoted different things to different groups, and it will continue to be a concept that inspires new thinking and revision. Family often signals a small kinship group united by blood relationships, but it may refer to a diverse assembly that functions within a single household. It also encompasses such broad concepts as lineage, tribe, cult, and ancestor veneration. For example, the United Kingdom of Great Britain is the euphemistic name for a political entity in which a sovereign clan presides over its family of English, Irish, Scottish, and Welsh peoples. In the early 1980s, when Tim Heald examined social networking in the United Kingdom, he observed: "In Britain we retain a strong sense of family. . . . We are helped in this by the fact that our keynote institution, the monarchy, is the most effective and powerful network in the world. . . . [Underpinning the monarchy] is a hereditary peerage, a network of often interconnected families who still share, by right, in the parliamentary process—and get paid for doing so."[1] This study also included a telling comment made publicly by the Prince of Wales, in which he envisioned the monarchy as a kind of business: "A family firm—I think that probably puts it right. I suppose, in the sense that we're all doing the same job, it is a coordinating influence. I like to think of us more as a family than a firm. It's a great help to have a lot of people all doing the same thing because you can go and talk to them about it, and you can learn a lot from each other."[2]

Scientists once conceived of two basic forms of social organization: the nuclear family, consisting of a married couple living with their unmarried children, and the extended family, which includes all offspring, people who have married into the family, and other living relatives. Anthropologists, however, have now documented so much variability in the nuclear family that it can no longer be considered a basic form. The current definition in the *Encyclopaedia Britannica* states: "It is safer to assume that what is universal is a nuclear family 'complex' in which the roles of husband, wife, father, son, daughter,

brother, and sister are embodied by people whose biological relationships do not necessarily conform to the Western definitions of these terms. In matrilineal societies, for example, a child may not be the responsibility of his biological genitor at all but of his mother's brother, whom he calls father."[3]

The development of capitalism in the early nineteenth century depended on a labor force composed of large reserves of basic family units: each "man of the house" earned wages to support "his" family. Manufacturers, politicians, and religious officials have long used newspapers, radio, and television to target such families in their homes. The practice of capitalism and democracy since the 1950s has also fostered the evolution of a liberal social climate; notions about what constitutes an effective family unit are now more inclusive than ever. The forces of change include: a greater equality between women and men; two-career households; a high incidence of births outside of marriage; increases in adoption, divorce, remarriage, joint custody, and single parenthood; growth in domestic partnerships; new forms of contraception and vigorous debates about abortion; and more respect for interracial and interfaith relationships and for different sexual orientations. Introducing this ongoing process of redefining and recalibrating the family, a recent academic textbook—aptly titled *Families as Relationships*—noted: "Single parent families, childless couples, lesbian or gay male couples with or without children are all represented in the broad mix of relations we may usefully refer to as families."[4] Books with titles that signal transformation—for example, *Changing Family Values* and *Reinventing the Family*—flourished during the recent millennial transition.[5]

The family has become a topic that may seem clichéd one day and relevant the next. The television industry, which originated as a medium directed at families in their homes, has heightened this duality. Situation comedies about domestic life have always been prime-time staples on TV, and their fantasy families have adapted to reflect shifts in the prevailing social and moral climate of their time. Although the carefree and wholesome white, upper middle class dominated the airwaves in the beginning (*The Adventures of Ozzie and Harriet*, 1952–66), many subsequent products tapped into the diversity of the viewing public: for example, the blended family (white and upper middle class in *The Brady Bunch*, 1969–74); the blue-collar household (white and ethnically mixed in *All in the Family*, 1971–79, and black in *Good Times*, 1974–79); and the upper-middle-class black family (*The Cosby Show*, 1984–92). It is telling that television's longest running domestic comedy with the most clear-cut dedication to social commentary and artistic innovation is a cartoon—*The Simpsons*.

Debuting in 1989, *The Simpsons* gained a popularity that was deemed sufficiently rambunctious and subversive to draw the public censure of President George H.W. Bush. At the same moment, reality-based television programming emerged as a "hot" new commercial market. In 2002 *The Osbournes*, a much hyped reality show devoted to the brash and wacky family of an aging heavy-metal singer, was notorious enough to win approving nods from the *New York Times*: "Americans instantly saw themselves in the Osbournes—if only we'd had more colorful pasts or more colorful lives."[6] The lucrative on-camera posturing of the Osbourne clan has also inspired new interest in *An American Family*, the groundbreaking, unscripted documentary series first aired by the Public Broadcasting Service in 1973. This twelve-episode project followed the lives of the Loud family of Santa Barbara during a seven-month period, riveting an audience that had never before seen such a blunt televised presentation of infidelity, divorce, ill-behaved teenagers, and an obviously gay son.[7]

Television's ability to blur the line between "the news" and entertainment is stronger than ever. Given that news reporting is never impartial or free of packaging, it may be expected that some coverage of prominent real people, including heads of state, seems interchangeable with the fictional realm of sitcoms and the warped, bloated trueness of reality television. In this context, it should not be surprising that the production of family-related artworks has grown steadily since the 1960s, due in part to an increased awareness of the rich visual heritage surrounding notions of family, from the rarest and most elaborate historical portraits to countless homemade photo albums, movies, and videos. A more particular catalyst is the reassuring appeal of an ostensibly "safe" and universal topic during a period when unpredictable waves of social, economic, and technological change are creating widespread anxieties.

Family Ties looks at some of the ways in which artists have broached a fundamental yet loaded subject. The topic is vast; therefore the project does not presume to be definitive, and the selections ultimately reflect the subjectivity of the author/ curator. This publication and the exhibition it accompanies are organized around various thematic groupings: Entering a Family; Parents and Children; Artists' Families; The Force of Time; Words in Play; and Allegorical Expressions. This is not a work of social history, even though it takes an interest in the specific contexts in which artworks are produced and then interpreted. Ultimately, an artwork can never be completely reliable as a sociological document, for it is first and foremost an intuitive product shaped by the artist's unique personality.

SELL THE
HOUSE S
ELL THE C
AR SELL
THE KIDS

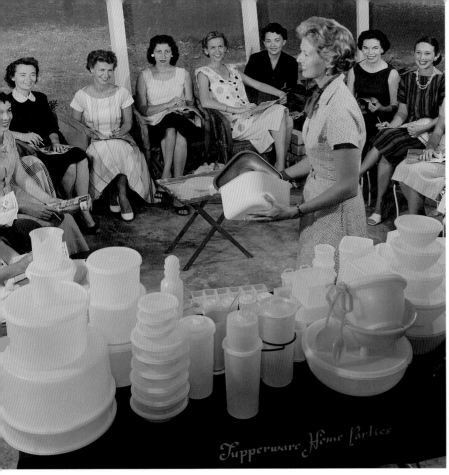

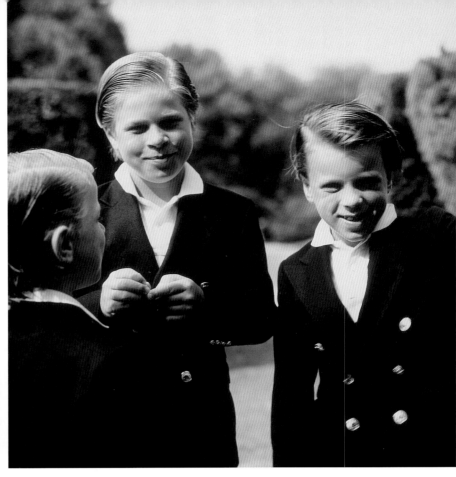

details of Plates 5 and 9

entering a family

In terms of universally shared experience, the most common means of entrance into a family is via the mother's womb. Ann Agee celebrates this occurrence in her recent work *The Birth of Emilio* (Plate 1). Her hand-painted porcelain statuettes build fondly on the Rococo style, but not its fanciful subject matter. It is surprising to encounter ceramic figurines honoring present-day individuals instead of quaint shepherdesses and scantily clad cherubs. *The Birth of Emilio* shows a kneeling midwife, focused intently on her work with an ecstatic couple. The lively arrangement of bodies, the vibrant colors and patterns of the clothes, and the compositional focus on the emerging infant constitute an exuberant homage to the birthing process. Agee did not make this work as a self-portrait, but she did name it after her son and thinks of the young onlooker in the red dress as her daughter Lucia. Even though the act of giving birth typically involves a bloody, visceral mess, it is, far more importantly, the greatest symbol of the power and mystery of the female body. Considering how rare this subject is in the history of art, Agee's shame-free and loving approach reflects new attitudes toward childbirth that are ultimately indebted to feminist-inspired reforms.

Janine Antoni's silver sculpture *Umbilical* (Plate 2) inspires the viewer to contemplate the links between a mother and her child, before and after birth. To produce this work, the artist made casts of three elements: the inside of her own mouth, the palm of her mother's hand, and a spoon bearing her family's monogram. When activated by Antoni's astute title, this curious trio of forms evokes the immaterial as well as the bodily ties between the two women. The work also reflects the artist's fascination with the Virgin Mary, the ultimate Catholic symbol of maternal nurturing. Antoni suggests with this sculpture that despite the separation and loss that birth inevitably entails for both parties, nurture can be an ongoing process. This object's haunting strangeness coaxes us to realize that the lifeline between womb and fetus and the sustenance delivered on the family silverware are both gifts of the mother. Indeed, all nourishment recalls our very beginnings.

The infant enters an immediate family circle after he or she is born. This usually involves the biological parents, but circumstances can dictate a host of other possible situations. What matters most is that there is at least one caring, nurturing adult to give food, shelter, and emotional support. Romare Bearden's *Family* (Plate 3) evokes in a semi-abstract, intriguingly generalized style a child's first familial experiences. The artist explained that the collages he began to make in the 1960s used black characters to address the universal theme of the human condition: "I did the new work out of a response and need to redefine the image of man in the terms of the Negro experience I know best."[8] Bearden also wanted his art to echo the solemn grandeur he admired in various artistic traditions, from ancient Egyptian sculpture to the revolutionary murals of the Mexican modernists. In addition, he chose subjects that were fundamentally in tune with the myths and the rituals of diverse cultures and epochs. Thus, while *Family* shows an

PLATE 1 Ann Agee

The Birth of Emilio
2001
Porcelain, china paint,
gold luster
8½ × 9 × 14½ inches
Courtesy of the artist
and PPOW Gallery,
New York

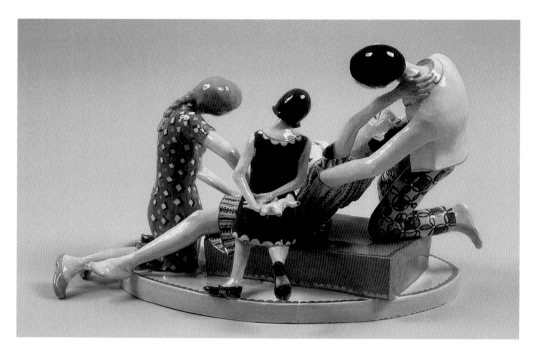

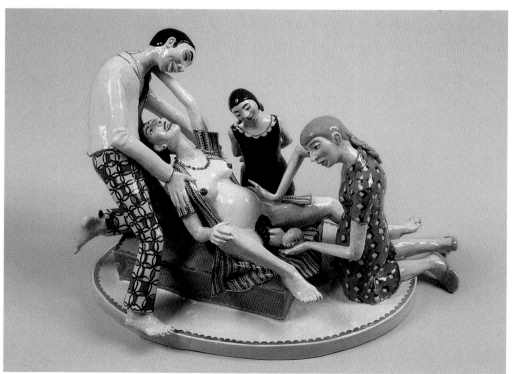

PLATE 2 Janine Antoni

Umbilical
2000
Sterling cast silver of
family silverware and
negative impressions
of the artist's mouth
and mother's hand
8 × 3 × 3 inches
Courtesy of the artist
and Luhring Augustine
Gallery, New York

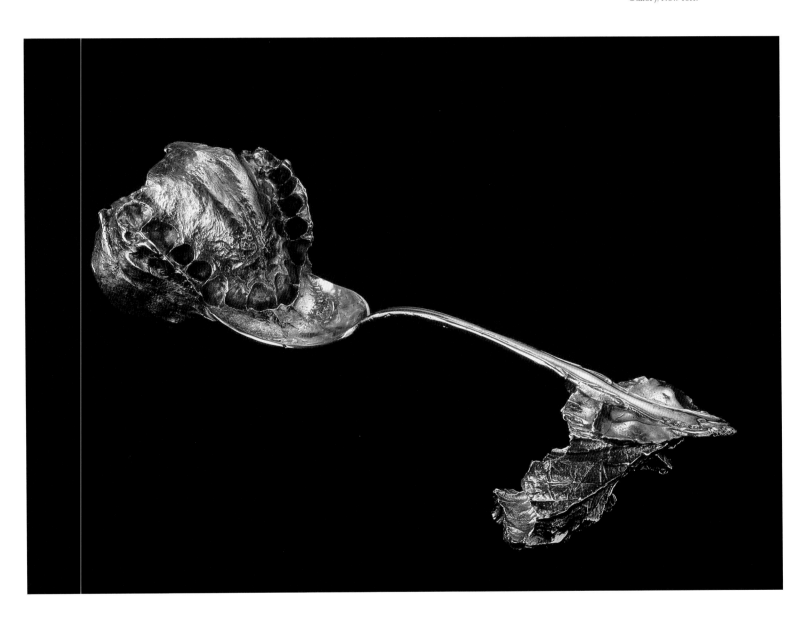

Romare Bearden

PLATE 3 *Family*
1967–68
Collage on canvas
56 × 44 inches
Museum of Fine Arts,
Boston, Abraham
Shuman Fund

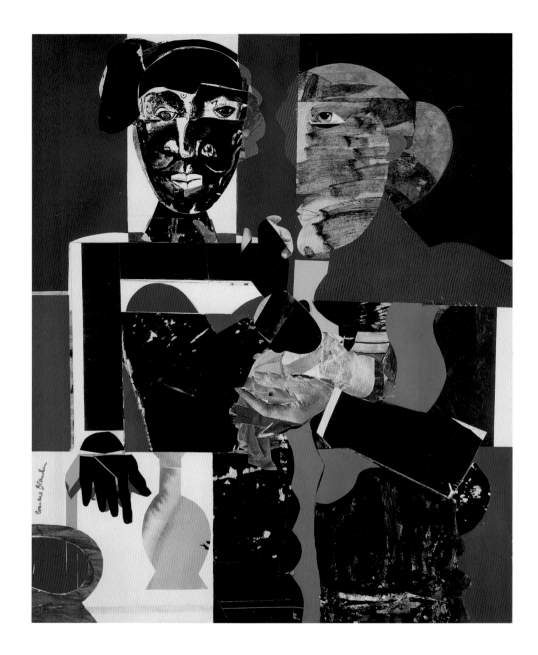

African American group, it alludes to a more universal need: the ceremonial welcoming of a new child into its family.

Influenced by Picasso's experiments with Cubist fragmentation, Bearden cut out and combined many types of paper— some with photographic images, others solidly colored—to create *Family*. He also painted and drew on certain areas to suggest texture and to enhance details. The picture shows two women standing beside a table bearing a tall green flask and a bowl of water. Bearden's blocky composition echoes the architecture of loving relationships: the arms give strong support, and the faces are thoughtful and sympathetic. The artist also

imbued the image with racial complexity. The skin tones, for example, include the blacks of black-and-white photographs and at least three different shades of solid brown. The hand that appears to bless the child combines solid brown paper and parts of a color photograph of a white-skinned hand. The woman at the right has a blue eye and wears a striking, seemingly masculine white cuff and black sleeve. She may be an older relative, a ministerial figure, or a ''conjure woman'' (a black American who has inherited African spiritual and divining powers).[9] Created when the campaign for black civil rights in the United States had entered a violent phase, Bearden's

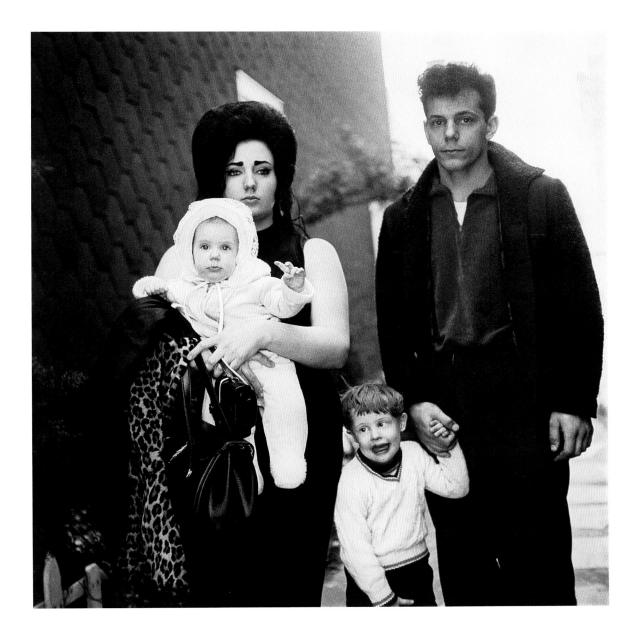

racially complex *Family* projects an ambiguous but winning message of hope, mystery, and familial dignity. Bearden indicated in 1964 that he chose the mediums of collage and assemblage with a metaphorical intent: "I have tried to look at anything in my encounters with the outside that might help translate the innerness of the Negro experience. . . . Assemblage forges a variety of contrary images into one unified expression."[10]

Diane Arbus's photograph of a young family (Plate 4) was created at roughly the same time as Bearden's collage. Both artists struggle to show how unity can prevail among disparate elements, though Arbus's pointing of a camera at real people

Diane Arbus

PLATE 4 *A young family in Brooklyn*
going for a Sunday outing.
Their baby is named
Dawn. Their son is
retarded.
1966
Gelatin silver print
14¹⁵/₁₆ × 14¹⁵/₁₆ inches
Courtesy of the Fogg
Art Museum, Harvard
University Art Museums,
National Endowment
for the Arts Grant

Joe Steinmetz

PLATE 5 *Untitled (Tupperware party,*
Sarasota, Florida)
1958
Gelatin silver print
9¾ × 12½ inches
Courtesy of the Fogg Art
Museum, Harvard University
Art Museums, on deposit
from the Carpenter Center
for the Visual Arts

on the street is a far cry from Bearden's imaginative studio exercise. Whereas Bearden slowly draws us into a collective humanistic spirit, Arbus seems to unleash a thunderclap that momentarily makes us voyeurs of this odd nuclear family unit. We register the uncanny stare of the baby girl, the mask of the showily dressed mother, the confusion of the mentally impaired boy, and the stoicism of the modest father; they project a collective sense of knowing that they are being scrutinized. When this photograph appeared in a British magazine in 1968, Arbus identified the parents as Richard and Marylin Dauria, a couple who had met at school and married when Marylin was sixteen. Arbus noted that they had a third child, and indicated that the husband was an Italian immigrant who worked as a garage mechanic. She continued: "Marylin, who is 23, says she is often told she looks like Elizabeth Taylor. She is not Irish but she told me she had dyed her hair black to make it look as if she is. Richard Jnr. [the boy] is mentally retarded, and the family is undeniably close in a painful, heartrending sort of way."[11]

Even though Arbus touches on some of the tensions that threaten this union, *A Young Family in Brooklyn* is an iconic family image. It reminds us that people enter numerous families in the course of their lives. The two parents have moved beyond their original families and started one of their own. And they have joined other kinship groups, for the couple clearly represents a class, a neighborhood, and a particular generation.

Arbus's eye for captivating characters and her identification with outsider types contribute to the viewer's conviction that these anonymous working-class subjects have exposed themselves. Like the woman in the photograph, Arbus was a wife with two young children of her own, but her social background was one of privilege. She denied that her photographs were cruel, saying that she always had the willing consent of her subjects. She spoke of her contribution to photography as "a sort of contemporary anthropology," but in the wake of her 1971 suicide, it has always been tempting to connect her bleaker views of humanity with her own personal hardships.[12]

It is not necessary to rear a child in order to develop a "family" of one's own. Families are born from the fellowships we find in religion, social class, professional occupation, nationality, and any number of culturally reinforced communities: a particular sport, a genre of music, a sexual engagement, or a collecting hobby. The last five works in this section are photographs that convey a strong sense of group identity that can happen outside of one's biological family. A picture of a Tupperware party taken by the prolific studio photographer Joe Steinmetz (Plate 5) provides an example with white, middle-class subjects. Here, fourteen smiling women have gathered in suburban Florida in 1958 to socialize and shop in domestic privacy. Regardless of the fact that Steinmetz's picture was intended to have a commercial or promotional use, it is a memorable visual record of people who are happily united by gender, race, class, and lifestyle. Steinmetz's artistry confidently trumpets the conviction that acquiring the latest set of Tupperware products will strengthen all these bonds.

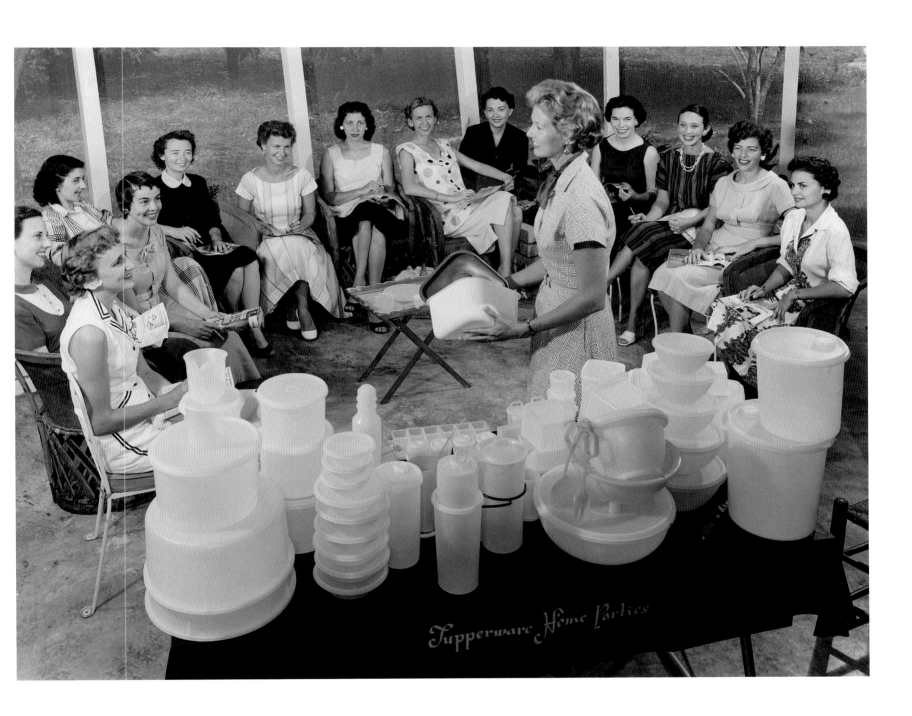

Tupperware Home Parties

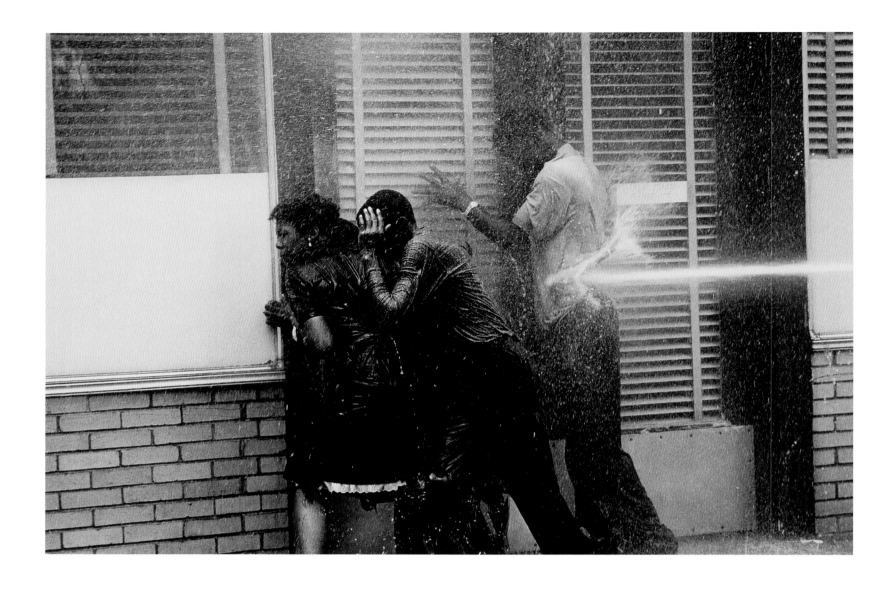

Charles Moore

PLATE 6 *Birmingham*
1963 (printed later)
Gelatin silver print
11 × 14 inches
Courtesy of Howard
Greenberg Gallery,
New York

Charles Moore was working on assignment for *Life* maga-
zine when he documented the Civil Rights protests in Alabama
in 1963 (Plate 6). Earlier that year, Martin Luther King Jr. had
launched a nonviolent campaign to end segregation in public
facilities. In this photograph of a related protest, the Birming-
ham police are responding with fire hoses that direct powerful
blasts of water onto the demonstrators; they also used vicious
dogs to intimidate the crowd. Moore's stark image of three
black protesters huddled together in the recess of a building
immediately symbolized this social crisis for the world at large.
The blast from the fire hose recalls the oppressiveness of
racism, and the statuelike immobility of the figures speaks of
their righteous cause.

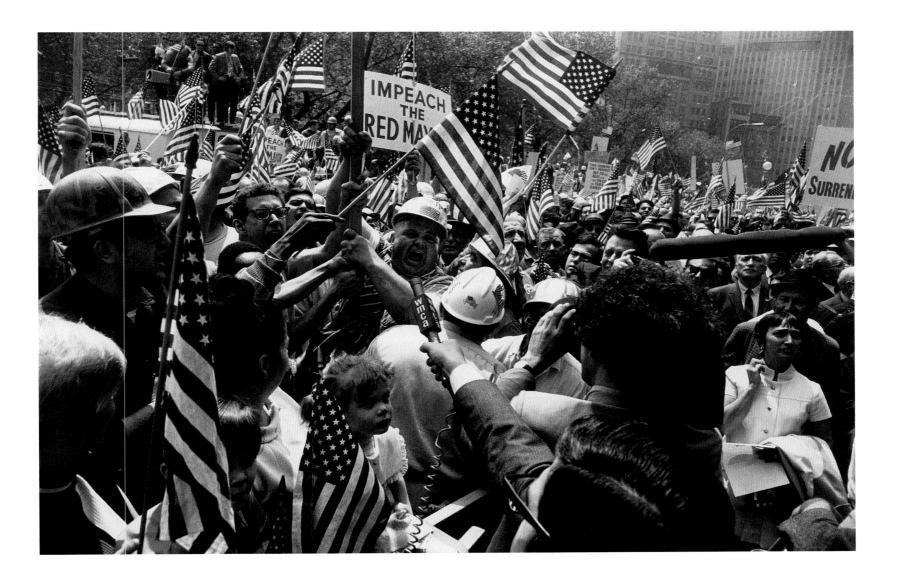

Garry Winogrand's *Hard Hat Rally* (Plate 7) evokes the mobbish solidarity that often propels fervent political protests. The protesters are wearing their hard hats in a show of occupational and class unity, and one of them bellows aggressively into a reporter's microphone. (Workers have traditionally thought of themselves as a brotherhood, and professional guilds, fraternal orders, and unions have all built on these ties.) The working-class protesters are waving American flags to taunt their perceived nemesis, Mayor John V. Lindsay of New York. Lindsay was an upper-crust, Ivy League liberal whose decision to oppose the Vietnam War allowed this angry faction of constituents to denounce him as a "Red." Thus, this picture demonstrates, among other things, the ways in which separate but

Garry Winogrand

PLATE 7 *Hard Hat Rally*
1969
Gelatin silver print
13½ × 19 inches
Hallmark Photographic
Collection, Hallmark
Cards, Inc., Kansas City,
Missouri

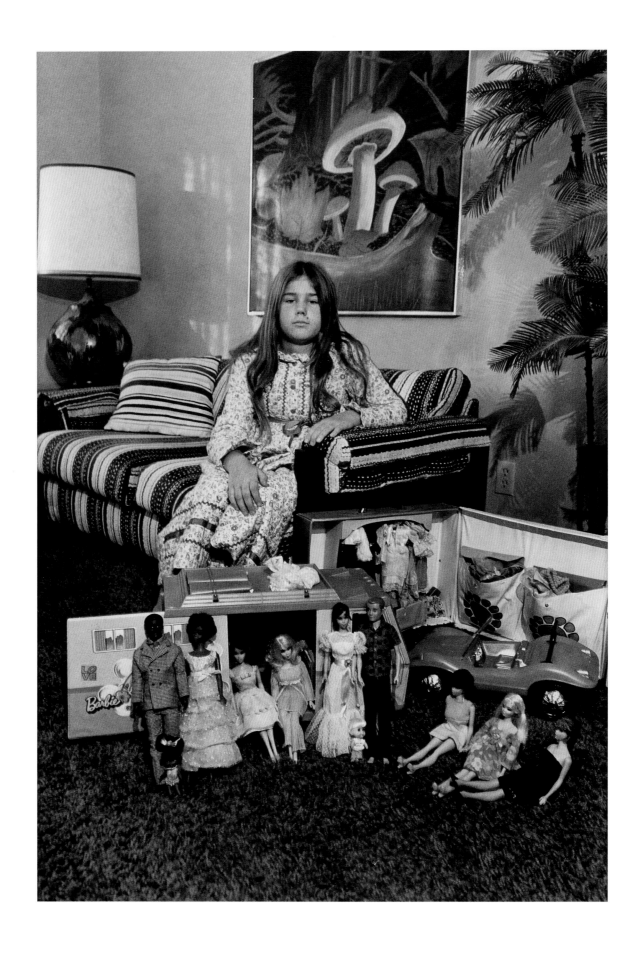

Bill Owens

mutually reinforcing notions of family—worker solidarity and patriotism—can be intertwined to intensify a political point.

Such ties, which result in a family-like sense of coherence, are the core of David Halberstam's recent book *Firehouse,* a documentary portrayal of members of Engine 40, Ladder 35, of the New York City Fire Department. Halberstam notes that many of those he interviewed became firefighters because they had seen their fathers and their uncles derive a sense of purpose and honor from the work. He observes that, "A firehouse, most firemen believe, is like a vast extended second family—rich, warm, joyous, and supportive, but on occasion quite edgy as well, with all the inevitable tensions brought on by so many forceful men living so closely together over so long a period of time. What gradually emerges is surprisingly nuanced: the cumulative human texture has slowly evolved over time and is often delicate. It is created out of hundreds of unseen, unknown, and often unidentified tiny adjustments that these strong, willful men make to accommodate one another, sometimes agreeably and sometimes grudgingly."[13]

Firefighter Terry Holden comments on the fact that life and work at the house have remained essentially the same since the 1960s, even though the country and the city have undergone drastic changes: "Part of it is that the talent pool is so similar—we come from the same places, the same kind of families, sometimes even the same parochial schools, and we have the same values. And we still have the same purpose, though we don't like to talk about it openly. But we like it when we get back to the firehouse after a fire and someone says you did a good job."[14]

Children, as well as adults, create and participate in their own kinship groups. A photograph from Bill Owens's *Suburbia* project (Plate 8) portrays a girl called Valerie with her multiracial fantasy community of Barbie and Ken dolls. She poses in the family living room, with the spiffy dolls and their accessories assembled before her on a shag rug. The caption that Owens provides as an accompaniment to the picture confirms that these dolls express the girl's wish for a world in which there is no "war, racial hate or misunderstanding." This photograph

Tina Barney

PLATE 9 *The Boys*
1990
Chromogenic color print
(Ektacolor)
48 × 60 inches
Museum of Fine Arts,
Boston, Contemporary
Curator's Fund, includ-
ing funds provided by
Barbara and Thomas Lee

was part of an independent documentary project and publica-
tion that Owens undertook while working as the staff photog-
rapher for the local newspaper of Livermore, California. Every
day his job took him to countless domestic and civic events and
celebrations that provided him with the contacts he needed to
make his visual study. In the introduction to *Suburbia* Owens
wrote: "This book is about my friends and the world I live in.
. . . [The subjects] have realized the American Dream. They
are proud to be homeowners and to have achieved material
success. . . . At first I suffered from culture shock. I wanted to
photograph everything, thousands of photographs. Then slowly
I began to put my thoughts and feelings together and to docu-
ment Americans in Suburbia. . . . The comments on each pho-
tograph are what the people feel about themselves."[15]

Tina Barney's grandly scaled, brightly colored picture *The
Boys* (Plate 9) shows three happy youngsters wearing match-
ing summer outfits. The double-breasted jackets, the cheery
body language of the subjects, and the formal garden setting
convey the impression that these are good-mannered "little
gentlemen." It is easy to see them as premonitions in minia-
ture of the privileged, blazer-clad adults they are destined to
become in a couple of decades. Beyond sharing the simple
gender ties suggested by Barney's title, these boys present
a cohesive visual unit. This picture is artistically successful
because of the deliberate ambiguity imposed on the subjects.
Should we draw more from the faces or the clothes? Is this a
friendly snapshot, a sociological exposé, or a seamless, seduc-
tive blend of both? Technically, it is far from being a snapshot
because Barney works with a large-format camera mounted
on a tripod and takes great pains to compose and light her
images.

These three boys are in fact brothers, the only children of
a couple who vacation near Barney's own summer residence
on the Rhode Island coast. The picture fits perfectly with the
photographer's artistic program in the late 1980s: she wanted
to take advantage of her own privileged social rank to make
a visual study of "a style of life that has quality."[16] The artist
recently noted that *The Boys* marked the emergence of "a new
generation—the yuppies."[17] She indicated that her subjects
were probably wearing Ralph Lauren blazers, whereas their
sociological predecessors, the preppies, donned seersucker
as a summer uniform. With hindsight, this photograph crystal-
lizes the particular materialism of that period. Economic pros-
perity in various parts of the world engendered an obsession
with the trappings of wealth, which in turn inspired such inter-
nationally popular TV shows as *Dynasty*.

No matter how one relates to the social milieu suggested
by *The Boys*, it is easy to read the image in terms of specific
kinships and particular lifestyles. A year before Barney made
this picture, Tobias Wolff had written a passage that resonates
with the photograph's objectifying trait. In *This Boy's Life* Wolff
described the ambivalence he felt when he—a blue-collar
rural kid—was admitted to a fancy prep school in the late
1950s. He instinctively knew that he was about to enter a
new kind of family. With the letter of acceptance he had also
received a copy of the school's alumni bulletin, whose words
and images conjured up the new social world for him: "The
students looked different from the boys I knew. It wasn't just a
difference of clothes and hair style. The difference was tribal—
bones, carriage, a signature set of expressions. I pondered
these pictures the way I pondered pictures of Laplanders and
Kurds in *National Geographic*. Some faces were closed to me.
I could not feel the boys behind them. In others I sensed a
generous, unguarded spirit. I studied each of them closely,
wondering who he was and whether he would become a
friend of mine."[18]

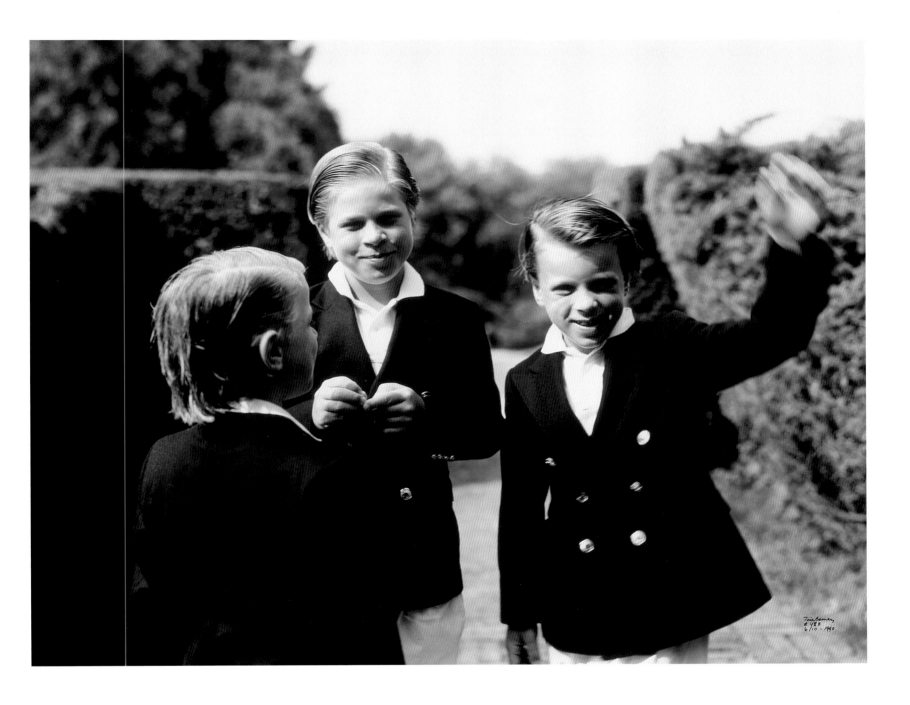

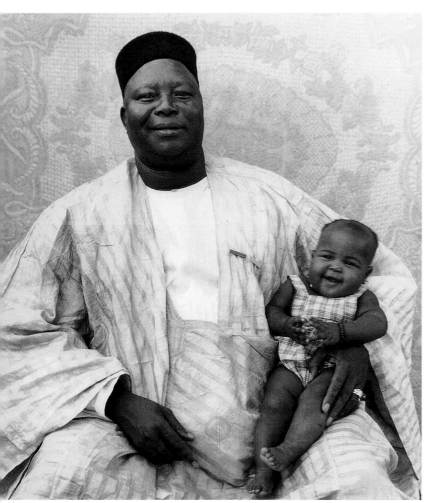
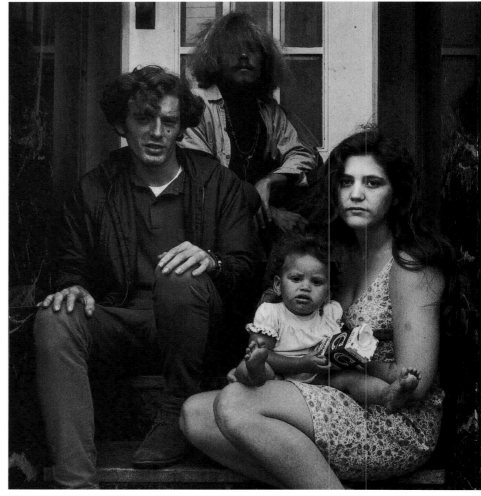

parents and children

Some idealists are drawn to the concept of a universal family unit and the notion that parenting is in some way eternal. From religious works to secular portraits, art has promoted the idea of universality for centuries. A few basic scenarios—in particular the family group and the mother and child—have accrued an iconic power that crosses time and language barriers with ease. The most familiar examples of this kind of imagery are probably children's drawings of stick-figure families.

William Klein's *Holy Family on Wheels* (Plate 10) confirms that the family unit is a powerful visual formula. Grainy and seemingly fleeting, the photograph could be an emblem of the unending parade of motorized families in today's industrialized world. Taken in 1956, it shows three modest Romans heading out for a Sunday outing in their best clothes: a father preoccupied by driving, an unsmiling mother clutching her handbag, and a wistful boy protectively sandwiched between them. Klein's droll title casts the group as an up-to-date, Mediterranean version of Mary, Joseph, and Jesus. But the photographer was more intrigued by the fact that affordable new two-wheelers were abetting social and moral change in Italy in the late 1950s. Once motorized, people engaged in leisure pursuits and amorous behavior in public could more readily avoid the watchful eye of the Catholic authorities, who forbade hotels to accept unmarried couples and ruled against kissing in public places. Klein published this family portrait as the main image in a sequence about Italians on wheels; in the accompanying text he quipped about the variety of styles that Italians perform when riding their motorbikes and Vespas: "The most prevalent is, evidently, Holy Family Style, where the Whole Holy Family is distributed between seat, back-seat, middle-seat, and handlebar. How long have they been there? Do they eat there? Entertain? Procreate? Anyhow, how comfortable Italians are in their skins, on this earth, and above all, on a Vespa."[19]

A recent work by Catherine Opie, titled *Catherine, Melanie & Sadie Rain, New York, New York* (Plate 11), continues a long-standing compositional tradition in which affectionate parents hover over their offspring.[20] This tender and beautifully lit photograph is part of Opie's *Domestic* series—works that portray various lesbian acquaintances across the United States in everyday situations in their homes. Although this grouping of New Yorkers echoes a traditional compositional formula, the interracial female partnership reflects contemporary attitudes of openness about different kinds of families. Opie says that she conceived the *Domestic* series in response to the widely discussed exhibition *Pleasures and Terrors of Domestic Comfort,* presented at the Museum of Modern Art, New York, in 1991. Frustrated by the project's overlooking of queer households, Opie felt the need to make a correction: "I wanted to complete the picture and to provide representations for ourselves and for future generations of gays and lesbians."[21]

Diane Arbus produced an unforgettable contribution to the visual archive of three-person family units with *This is Eddie Carmel, a Jewish giant* (Plate 12). Here, a sensitive eight-foot-tall son towers awkwardly over his parents; the mother appears

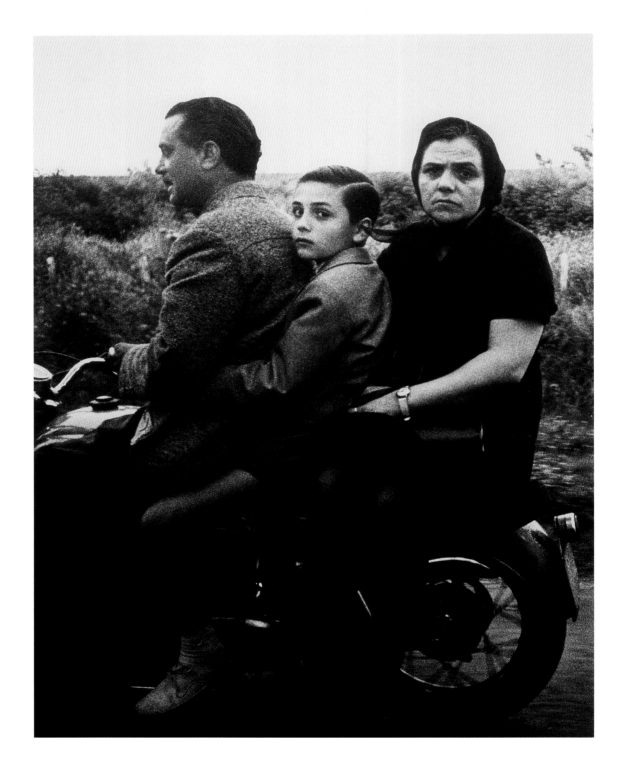

William Klein

PLATE 10 *Holy Family on Wheels*
1956 (printed later)
Gelatin silver print
19¹¹⁄₁₆ × 15¾ inches
Courtesy of Howard
Greenberg Gallery,
New York

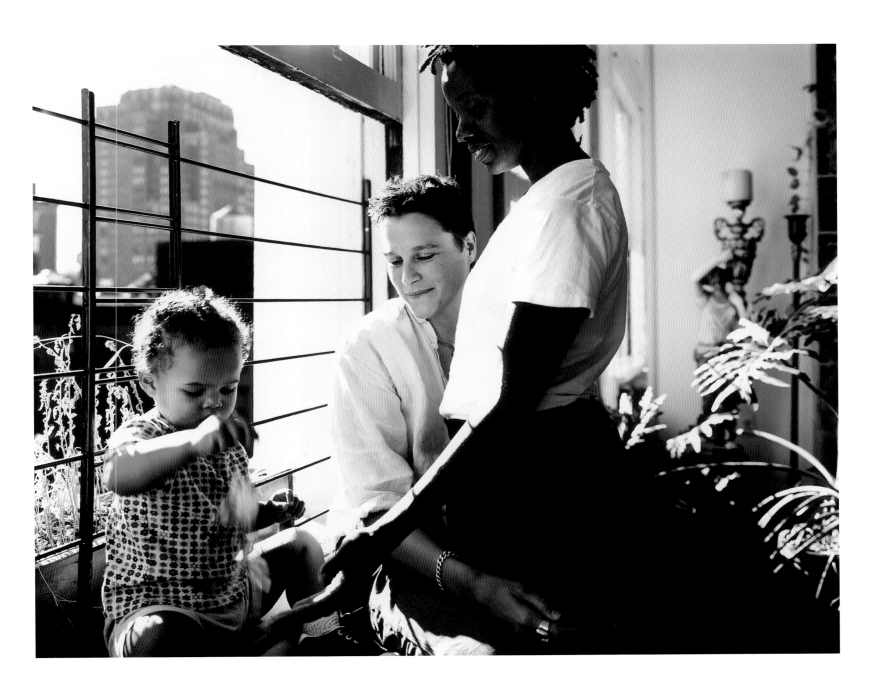

Catherine Opie

PLATE 11 *Catherine, Melanie & Sadie Rain, New York, New York,* from the *Domestic* series
1998
Chromogenic print
40 × 50 inches
Edition of 5
Collection of Gregory Miller, New York

Diane Arbus

PLATE 12 *This is Eddie Carmel, a Jewish
giant, with his parents in the
living room of their home in
the Bronx, New York*
1970
Gelatin silver print
14¹⁵⁄₁₆ × 14¹⁵⁄₁₆ inches
Courtesy of the Fogg Art
Museum, Harvard University
Art Museums, National
Endowment for the Arts Grant

anxious and the reserved father seems to find the photo session an endurance test. Since Arbus usually sought out her more unusual subjects in nudist colonies, cheap circuses, and psychiatric wards, the use of a domestic setting for this kind of vignette is rare in her work. The fairy tale–like scenario of an astonishing stooping giant in a thoroughly mundane parental nest struck a note of pathos in her. This 1970 picture was the first image of the Carmel family that Arbus published, but she had been photographing them sporadically since 1962. In fact she befriended Eddie Carmel, who worked in the insurance business and dreamed of becoming a great actor.[22] In 1967 Arbus explained her interest in "freaks" to a reporter for *Newsweek:* "There's a quality of legend about them. They've passed their test in life. Most people go through life dreading they'll have a traumatic experience. Freaks were born with their

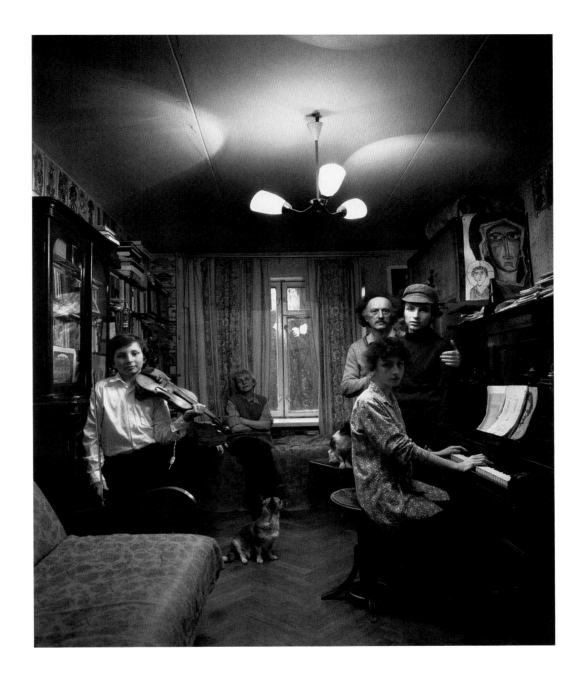

trauma. They've already passed it. They're aristocrats."[23] Thus, despite the seemingly merciless inspection she performs from behind her camera, Arbus wanted these Bronx subjects to be stars in a tragic visual poem.[24]

Whatever the setting, parents and children assume their familial roles. Frédéric Brenner's 1991 photograph of a Jewish household in Leningrad (Plate 13) echoes a type of group portrait in which everyone gathers in a formal room to socialize. It is a wonderful example of the genre, for it conveys the family's love of music, books, and pets; their collective enjoyment of this event; and the different manner in which each parent exerts

Frédéric Brenner

PLATE 13 *Grigoriy Aaronovich and Yevgeniya Yosifovna with their children, David, Liza, and Arkady, and their dogs, Pobeda and Tobias, Leningrad (now St. Petersburg)*
1991
Gelatin silver print
14 × 11 inches
Courtesy of Howard Greenberg Gallery, New York

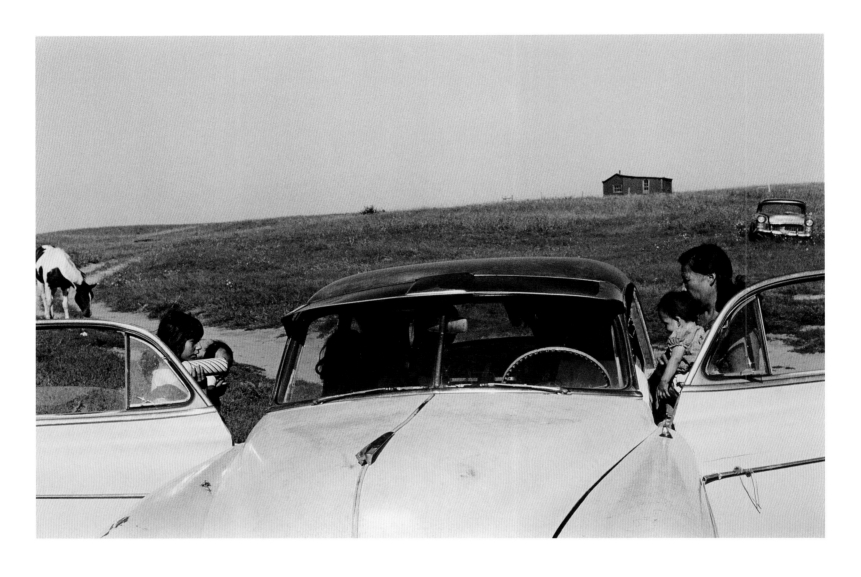

William Gedney

PLATE 14 *South Dakota*
1966 (printed 1971)
Gelatin silver print
11 × 14 inches
Courtesy of Howard
Greenberg Gallery,
New York

an anchorlike presence within the group. But the closeness of this family acquires another layer of meaning when one understands the double lives they have led, enduring the religious restrictions imposed by the Soviet Union's totalitarian regime. Following the collapse of the USSR in 1991, the Gorbachev era would open up Jewish emigration from Russia to Israel. Brenner, a French Jew who devotes his career to documenting Jewish life around the world, made this portrait as part of a project in which he traveled throughout the fifteen republics of the USSR in its final months. When he published the results, he noted how his thinking had shifted over the course of the project: "[It] was no longer just about what it is to be Jewish, but about the cultural background of this diaspora. It became a photographic essay on alienation."[25]

A photograph by William Gedney (Plate 14) and one by Elaine Mayes (Plate 15) demonstrate that you don't need a living room to make a record of family togetherness. Gedney elliptically captured the essence of such togetherness when he photographed a group of Native Americans in South Dakota getting into their car. His picture is hardly a family portrait, but the forms and the actions it depicts reflect a lot about family traits: the car's two open doors are like the wings of a great sheltering bird; a mother and a girl (perhaps an older daughter) are carefully loading the smallest children into the vehicle's interior. Diminished by the expanse of open land, the people and their car become a self-contained universe.

Mayes photographed her anonymous family in San Francisco's Haight Ashbury district in the late 1960s. Having moved there in 1967, she made hippies and rock-and-roll band members her primary subjects. Mayes, who had had an encouraging meeting with Diane Arbus in 1965, subjected these quintessentially mid-sixties subcultures to an Arbus-like sense

Elaine Mayes

PLATE 15 *Group Portrait,* from
*Photographs of
Haight Ashbury*
1970
Gelatin silver print
8⅞ × 9 inches
Museum of Fine
Arts, Boston,
Polaroid Foundation
Purchase Fund

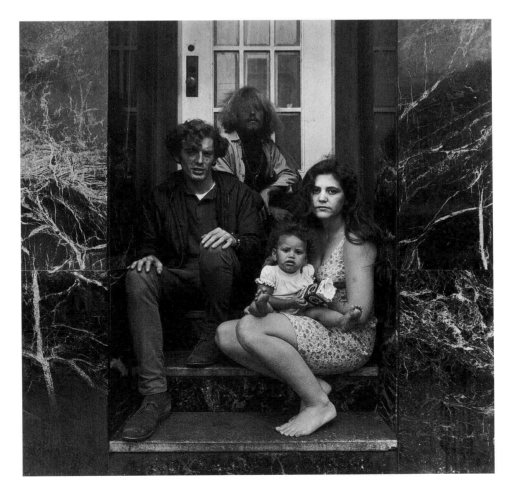

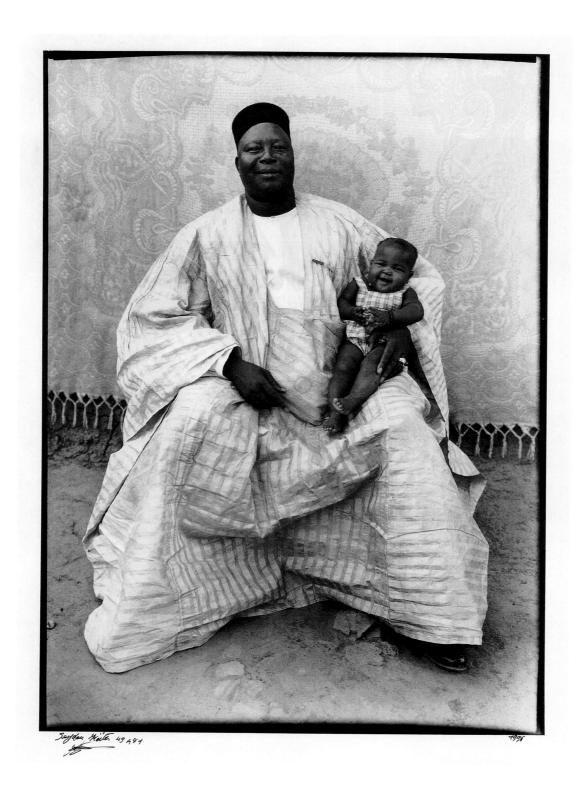

Seydou Keita

PLATE 16 *Untitled (Man Holding Baby)*
1949–51 (printed 1996)
Gelatin silver print
24 × 20 inches
Museum of Fine Arts,
Boston, Horace W.
Goldsmith Foundation Fund
for Photography

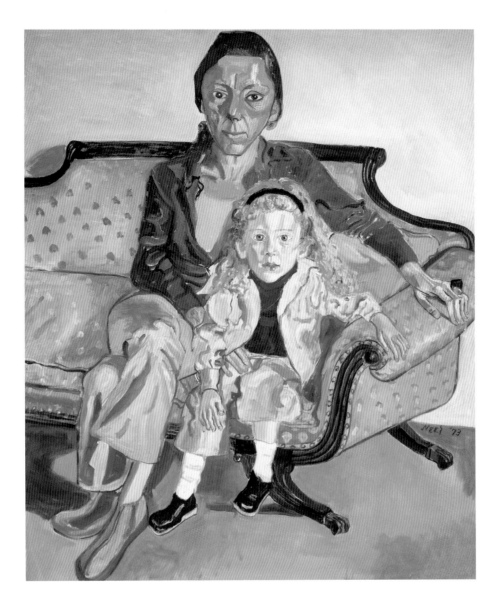

Alice Neel

PLATE 17 *Linda Nochlin and Daisy*
1973
Oil on canvas
55⅞ × 44 inches
Museum of Fine Arts, Boston,
Seth K. Sweetser Fund

of inspection and revelation. Her young, four-person hippie family is framed tightly in a doorway whose wildly veined marble adds an appropriately psychedelic touch. The barefoot woman evokes archetypal images of mother and infant, but it is impossible to know if either of the men is the child's father. Even though Mayes might have stage-managed the strong triangular patterns that seem to bind these figures together, her unkempt subjects exude little warmth. Their serious, standoffish demeanor seems to reflect their decision to break with mainstream culture and establishment values; they project detachment from the grubby pedestal on which Mayes has placed them.

A portrait photograph by Seydou Keita (Plate 16) and a painting by Alice Neel (Plate 17) both capture the amazing closeness that one parent and one child can generate in each other. Keita's photograph of a big man holding a laughing baby girl is one of his most endearing early works. It was produced in the popular photo studio he ran in downtown Bamako in Mali from 1949 to 1962. Keita recalled that he rarely knew the people he photographed, but this man was an exception: "The big guy with the baby, that's Billaly. I remember that day: we did more than four different shots, first alone, then with him holding a baby. . . . I used my fringed bedspread as my first backdrop."[26] Neel's portrait of a prominent

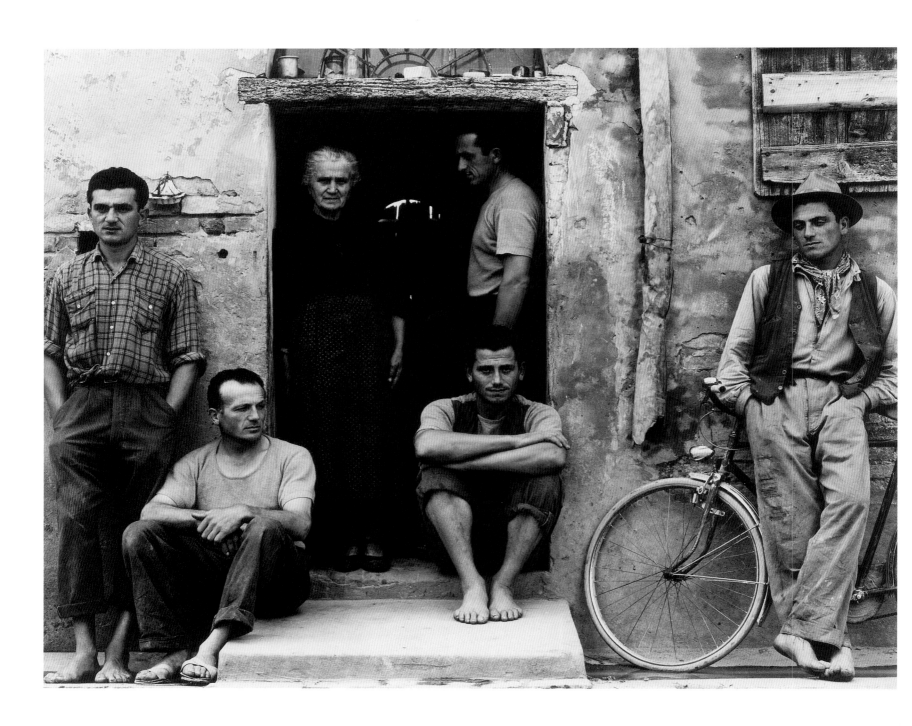

Paul Strand

PLATE 18 *The Family, Luzzara, Italy*
1953
Gelatin silver print
7½ × 9½ inches
Courtesy of Howard
Greenberg Gallery,
New York

art historian and her daughter dates from the moment when the women's movement was having a massive impact on all aspects of American life and culture. As a leading feminist in her field, Linda Nochlin appreciated the honor of sitting for the seventy-three-year-old Neel, who had only recently begun to receive accolades for her long and arduous career. Neel's vigorously brushed picture disarmingly records a relationship in which each figure is allowed to be a strong and independent personality. This mother and daughter assume interlocking poses and gaze at the viewer with a related intensity. Neel eschewed the sentiment and charm that traditionally characterize maternal imagery. As art critic Roberta Smith has observed: "Neel's sitters brim with a potential and self-awareness that is underscored by the artist's own eccentric realism, a combination of hearty light-filled colors and improvisational paint handling anchored in the achievements of van Gogh and Matisse. Neel gave every part of her pictures—furniture, wallpaper, clothing—its own vividness without overwhelming the painting's raison d'être. This is especially visible in the Nochlin double portrait, in which the lush treatment of a sea-green love seat, gently dotted with pink and white, is held in check by the child's open curiosity and the mother's scrutinizing gaze."[27]

This section closes with a comparison of two outdoor, multi-figure portraits of families: an Italian group photographed in 1953 by the American Paul Strand, and a Japanese group photographed in 1986 by a German, Thomas Struth. Despite dramatic differences in the size of the prints, each work has a precisely detailed and exquisitely phrased composition; and both artists worked with a large-format camera. Strand learned his craft from Lewis Hine, a documentary photographer committed to social reform; but he found fame as an American modernist when Alfred Stieglitz devoted an issue of *Camera Work* to his pictures in 1917. Strand's socialist beliefs and aversion to McCarthyism led him to settle in Europe in 1950. Working in France, Italy, Scotland, Egypt, and Ghana, he regularly photographed scenes of preindustrial village life. Through his pictures he expressed an admiration for cultures that are able to strike a meaningful balance between modernity and tradition.

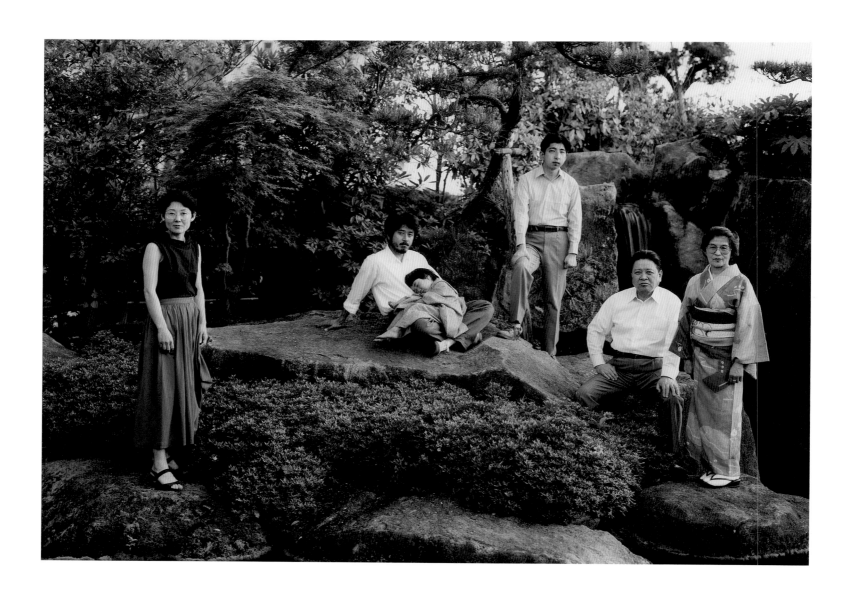

Thomas Struth

PLATE 19 *The Shimada Family,*
Yamaguchi
1986
C-print
26½ × 33½ inches
Courtesy of the artist
and Marian Goodman
Gallery, New York

In his photograph of the Lusetti family (Plate 18), Strand shows six poor Italians—a widow and five sons—at the entrance to their weathered old home. The man sitting in the doorway who is most attentive to the viewer is Valentino Lusetti, who served as Strand's guide during his six-week visit to the rural north Italian town of Luzzara. The photographer had long wanted to make a portrait of a small town. He chose Luzzara because it was the birthplace of the writer with whom he was collaborating on the book: Cesare Zavattini, the film theorist and screenwriter of *The Bicycle Thief* (1948) and *Umberto D* (1952).[28] In Strand's photograph the brothers show individuality in the way they dress and the poses they strike, while remaining in the orbit of their mother, the stoic matriarch guarding the threshold. Keeping the pictorial space tight and visually active, Strand allowed the mysterious, off-center doorway to quietly underscore the serious expressions of his subjects.

Thomas Struth, born sixty-four years after Strand, works in a contemporary intellectual climate that is wary of ideology, particularly modernist optimism about progress and avant-gardism for its own sake. There has been an acute awareness since the 1960s that photographs are not "innocent." The photographer, the publisher or exhibitor, and the author of any accompanying texts all project personal perspectives into the work. Thus a photograph depends on the context in which it is seen; its meaning depends on the way in which it is used and the way in which the viewer responds to it. Mindful of this predicament, Struth, like Bernd and Hilla Becher, his teachers when he was a student in Düsseldorf, takes photographs that are painstakingly devoted to the objective gathering of information. In his attempt to minimize subjectivity and formal manipulation, he produces images that strike some as

anonymous, bland, or clinical. Eschewing the snapshot aesthetic, Struth seeks the "essence" of his medium—"the way that photography is concerned with arresting time, with a process of occasionally halting history."[29]

The Shimada Family, Yamaguchi (Plate 19) is an early example of Struth's ongoing series of family portraits. They are made after the artist has spent a significant amount of time getting to know the sitters. He asks each family to choose the location and each person to work out his or her pose and position within the picture. Struth stands to the side of his camera to dispel any impression that he and the lens are one, and he uses fairly long exposure times. He believes that these measures promote a collective sense of purpose in the sitters while they are confronting the lens. Struth usually makes about forty or fifty negatives per sitting, hoping that one will show that special state when everyone's eyes are intent and "there," as if they are making a collective gaze into a large mirror.[30] The three generations of the Shimada family who posed for Struth in the privacy of their garden did all this to great pictorial effect. In the process they allow viewers to draw a few conclusions about their relationships and cultural attitudes.

Strand arranged the Lusetti family in a composition enlivened by beautiful, abstract linear rhythms. Struth tried slavishly to minimize his involvement in the staging. Yet the results strike a similar note, because both photographers proceed by creating a controlled—and controlling—situation in which to work. Each of them won the respect of the family, and each family wanted to accommodate its visitor. All were committed to a picture that recorded parents and children in a direct and formal arrangement of faces and bodies; all wanted to convey a sense of a family's ties to a particular place.

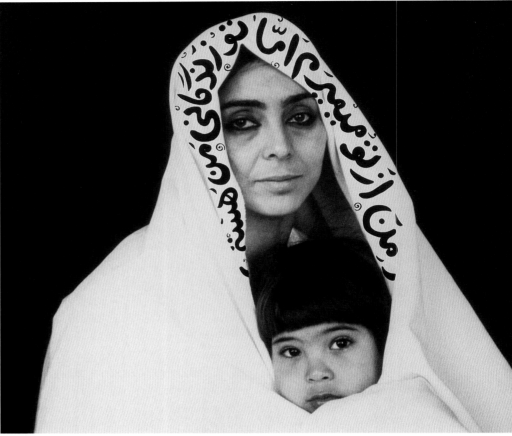

artists' families

Artists' images of their families are often striking. Art making involves self-revelation, and when applied to the artist's immediate relatives it often results in unusually personal expressions. No doubt many in the art world were astonished when the attention-grabbing Pop Art impresario Andy Warhol painted his homely mother in 1974 (Plates 20 and 21). Warhol's world fame derived from his depictions of celebrities such as Marilyn Monroe, Elvis Presley, Elizabeth Taylor, and Jacqueline Kennedy. In the aftermath of a near fatal assault in 1968, Warhol embraced society portraiture, seeking commissions from such glamorous figures as Brooke Hayward (1973) and Halston (1974). His portraits of Julia Warhola, however, are quite a departure from that league. Warhol made at least six paintings of his mother, all equal in size and featuring the same silkscreened photographic image. Four of them had their debut on the cover of *Art in America* in 1975, and were proclaimed in its pages to epitomize his "new 'painterly' style."[31] Though Warhol's audience probably connected these works to his reputation as an oddball, they were in fact born out of private grief, his much-loved mother having died barely two years earlier at the age of eighty.

Both of Warhol's parents were immigrants from a Ruthenian village in the Carpathian Mountains. They lived in a poor part of Pittsburgh, and Andrew, their third and youngest son, was baptized at their Greek Catholic church in 1928. He was a sickly child and a mama's boy. His father, a construction worker, died from illness in 1942. When Warhol made the paintings of his mother, it was not widely known that the hip, openly gay "superstar" shared his Manhattan home with her from 1952 until 1971. She even penned the quaint inscriptions on many of her son's fey illustrations in the pre-Pop 1950s when he rose to prominence as a commercial artist. Warhol's biographers characterize Mrs. Warhola as a loving, nagging, uneducated, wacky, shrewd, manipulative, and intensely religious woman, and a reminder of Warhol's peasant roots. It seems that the artist regretted deeply sending her back to the Pittsburgh clan after she had a stroke, and he certainly frustrated his closest friends by being totally unable or unwilling to share with them his intense feelings about his mother.[32]

For these posthumous portraits, Warhol used a gentle, smiling photograph that radiates good humor. Its thoroughly grandmotherly aura would have made it a perfect logo for an old-fashioned candy business. He silkscreened this benign photographic image on top of sweeping brush strokes and passages of finger-painting that shimmer in nervous agitation. Warhol's paint handling suggests that it was emotionally demanding to reconnect with the woman who had been a constant presence in his private home life throughout his highly public rise to fame. He clearly needed to produce these memorials, but it is revealing that he did not include any of them in the large exhibition that the Whitney Museum of American Art devoted to his portraits in 1979.[33]

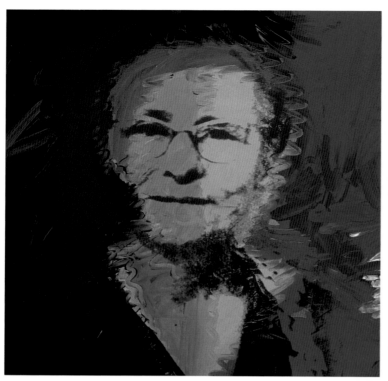

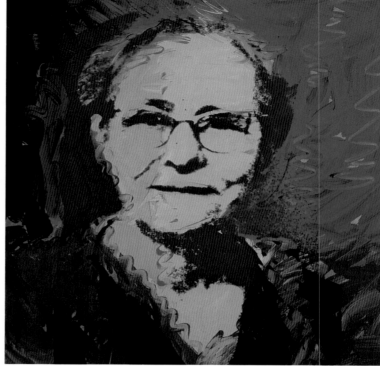

Andy Warhol

PLATE 20 *Julia Warhola*
1974
Silkscreen ink and synthetic
polymer paint on canvas
40 × 40 inches
The Andy Warhol Museum
Founding Collection,
Contribution The Andy
Warhol Foundation for
the Visual Arts, Inc.

Andy Warhol

PLATE 21 *Julia Warhola*
1974
Silkscreen ink and synthetic
polymer paint on canvas
40 × 40 inches
The Andy Warhol Museum
Founding Collection,
Contribution The Andy
Warhol Foundation for
the Visual Arts, Inc.

A recent photograph by Nan Goldin captures her mother laughing explosively (Plate 22); another shows her father goofing around with shaving cream (Plate 23). Although both pictures exemplify the artist's known ability to be simultaneously intimate and direct, the subject matter (seniors) is rare in her work. Reared in Boston, where she went to art school, Goldin moved to New York in the late 1970s. She pursued an artistic career in the downtown, Warholian vein. Using art photography as a medium, she immersed herself in the charged life of punk rock clubs, after-hours bars, artists' lofts, and, most especially, the drag queen circuit. The combination of Goldin's snapshot aesthetic and her personal participation in these scenes allowed her art to skirt sensationalism: her pictures are raw and honest, yet tenderly attentive. Two decades of her work add up to a soulful panorama dominated by nightclubbing, good

and rotten relationships with women and men, the AIDS epidemic, and rehab clinics. Goldin's rapport with friends often leads the viewer to think of them as one large clan, which has been dubbed the "Family of Nan."[34] According to art critic Peter Schjeldahl, "She has pursued a crowded, rumpled existence among the vagabonds of society and taken thousands of photographs documenting her experiences. If her work suggests a genre, it is the family snapshot. But what a family! And some snapshots!"[35]

Goldin made the two jolly portraits of her parents at the time of a mid-career retrospective that opened in New York in 1996 and traveled to museums in Germany, Holland, and Switzerland.[36] Such an event is always a milestone in an artist's life, and in Goldin's case the demanding process seems to have triggered some productive and happy exchanges with

Nan Goldin

PLATE 22 *Lil Laughing,*
Swampscott, MA
1996
Cibachrome print
30 × 40 inches
Edition 1/15
Courtesy of the
artist and Matthew
Marks Gallery,
New York

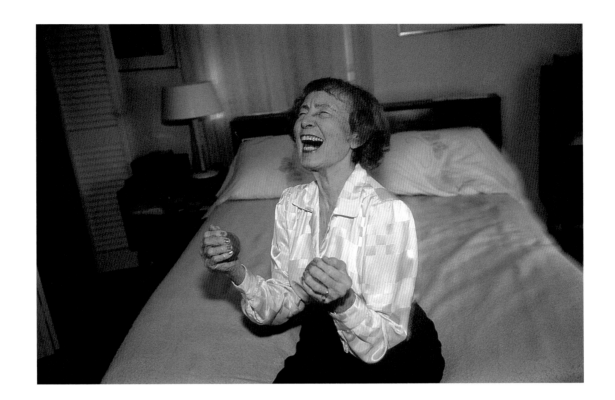

Nan Goldin

PLATE 23 *My Father Shaving,*
Swampscott, MA
1997
Cibachrome print
30 × 40 inches
Edition 1/15
Courtesy of the
artist and Matthew
Marks Gallery,
New York

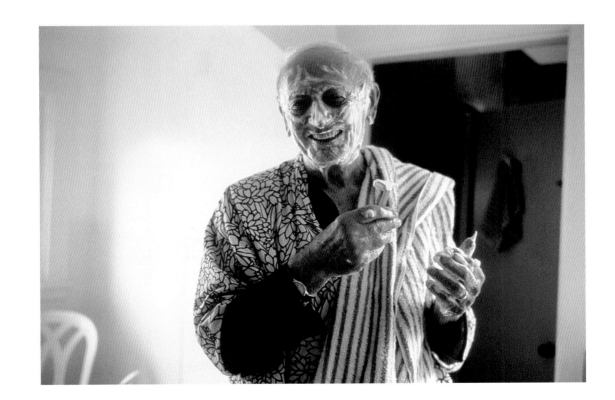

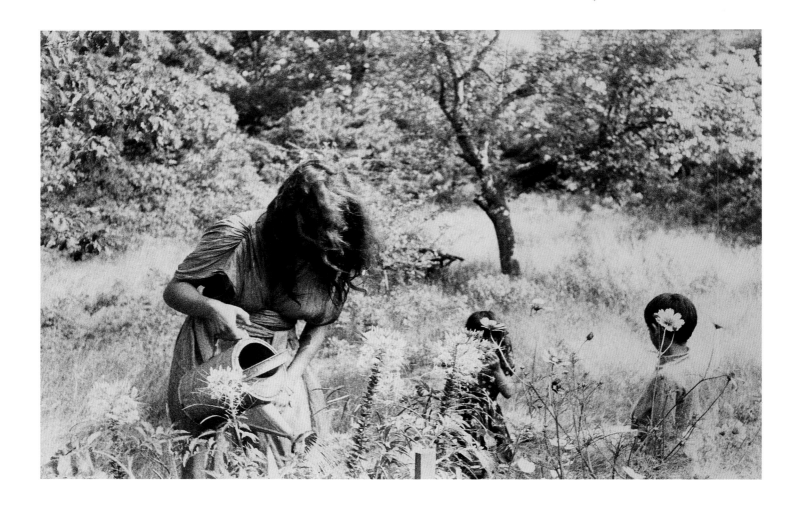

Robert Frank

PLATE 24 *Mary and Children*
Late 1950s
Gelatin silver print
8 × 12⅝ inches
Courtesy of Howard
Greenberg Gallery,
New York

her parents. In an interview published in the *New York Times*, announcing the retrospective, she explained: "For many years, it was hard between me and my parents. But I got clean eight years ago, and matured, and now I really appreciate them. I've exposed them to a wide range of people. At first, they took some pictures out of their copy of . . . [my] book, censored it themselves. They're much more accepting now."[37] The book Goldin refers to was her first, *The Ballad of Sexual Dependency* (1987), which included her most harrowing self-portrait (*Nan After Being Battered,* 1984). Strengthened by experience and international acclaim, Goldin could, in 1996, seize the moment and have fun with her parents. Speaking of *Lil Laughing, Swampscott, MA,* she notes, "Here, my mother's sitting on her bed, and I was making her laugh. She's very ladylike, a great beauty. But I tell her she's worse than a drag queen, the way she criticizes how she looks in photos."[38]

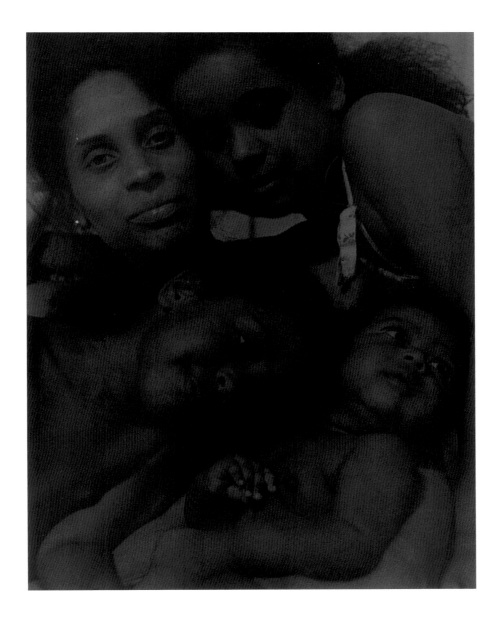

Whereas Warhol and Goldin portrayed their parents while working through delicate biographical issues, some artists produce images of their families that are characterized by an uncomplicated sense of wonderment. Robert Frank's snapshot-like image of his wife and two young children (Plate 24) is a case in point. Frank felt no conventional need to show their faces because his main concern was to equate—simply and poetically—the family and the garden. He chose a composition in which the three figures, standing on a gently sloping hillside, rise up as part of the profusion of beautiful blossoms. The water that his wife pours onto the flowers may be read as an outpouring of blessings: a symbolic expression of both the fertile landscape and the artist's happy family. When Roy

Roy DeCarava

PLATE 25 *Sherry, Susan, Wendy, and Laura*
1983
Gelatin silver print
13¹⁵/₁₆ × 10¹⁵/₁₆ inches
Addison Gallery,
Phillips Academy,
Andover, Massachusetts

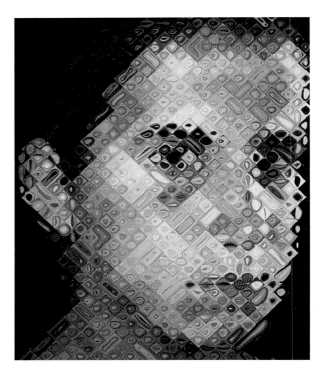

Chuck Close

PLATE 26 *Maggie*
1984
Litho ink on silk paper
19⅛ × 15½ inches
Private collection

Chuck Close

PLATE 27 *Maggie*
1998–99
Oil on canvas
72 × 60 inches
Private collection
(detail at right)

DeCarava portrayed his wife and daughters (Plate 25), he, too, made a picture that brims with love and praise. The four subjects fill the picture frame in all their abundance: mouths, eyes, ears, and hands continually circle back to the mother, Sherry DeCarava. The picture's dark tones evoke tremendous intimacy and affection. The blackness is both a feat of technical mastery and the embodiment of DeCarava's profound yet quietly phrased feelings about racial issues.

Chuck Close chooses his subjects, who are typically depicted in head shots, from his circle of family and friends. Although it is easy to label him a portraitist, that conventional moniker fails to do justice to his conceptually rigorous involvement with process. He made his first signature works in the late 1960s; starting with an ID-like black-and-white photograph

of a face, he would draw a uniform pencil grid over it, then systematically paint that fragmented information, square by square, onto a canvas measuring about nine feet tall. Although the finished pictures were highly realistic and overwhelming with their billboardlike scale, Close's experience while creating them was one of painstaking and abstract involvement in surface minutiae. His works are thus a quirky mixture of approaches: quasi-abstract technical exercises, portraitlike renderings of photographs of heads, and a lyrical engagement with materials and execution.

Close's art from the last three decades provides glimpses of a limited number of people at different stages of their lives. Take, for example, two pictures of his daughter Maggie: one from 1984 shows a happy baby (Plate 26); a second, from

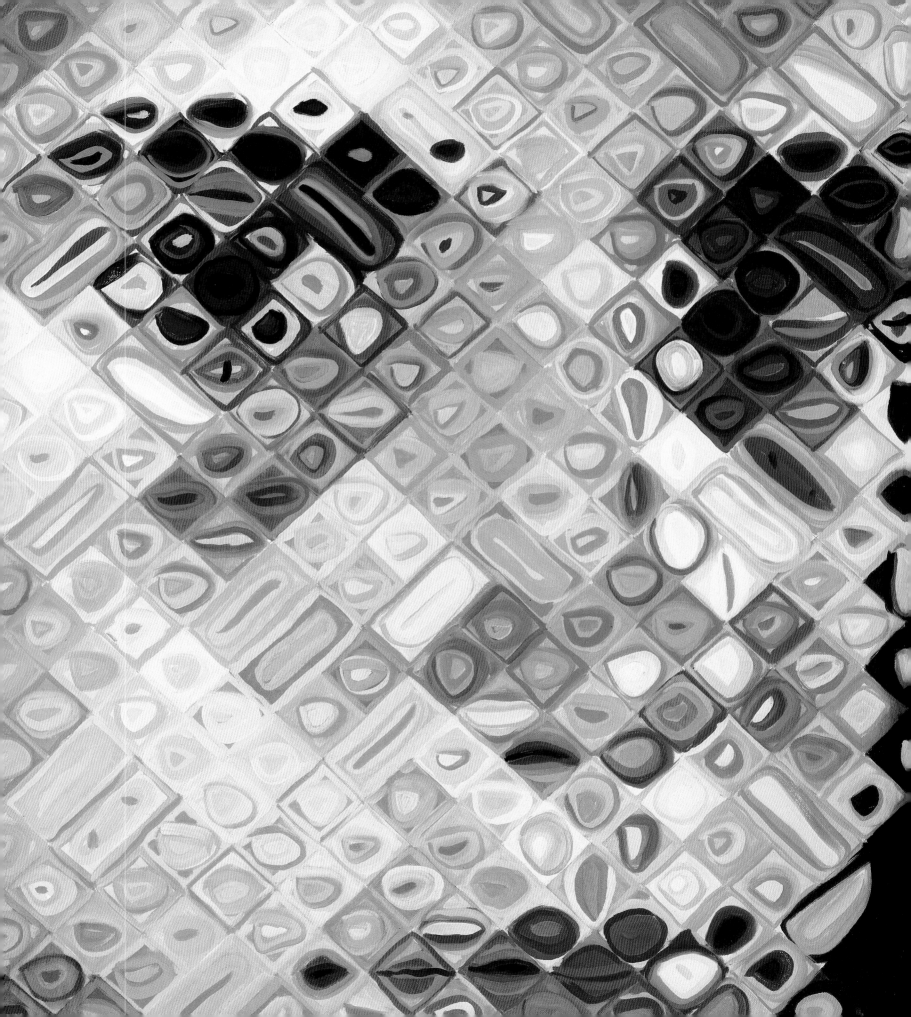

Byron Kim

PLATE 28 *Emmett at 12 Months*
1994
Egg tempera on wood
Twenty-five wood panels;
each 3 × 2½ inches
Courtesy of the artist and
Max Protetch Gallery,
New York

1998–99, presents a confident teenager with a keen, inquiring gaze (Plate 27). The image of Maggie Close as a baby is just over life-size and consists solely of inked impressions of the artist's own skin, made by pressing his fingertips against the white paper support. With consummate control of each imprint, he conjures up a delicate, soft-focus illusion of an infant's plump face. This illusion is particularly magical because there is no visible pencil grid. Fourteen years later, Close painted Maggie's head on a monumental scale, using a conspicuous diagonal grid as the basis of the composition. The task of filling the diamond patterns was evidently a lively and exciting exercise for Close: outlines vibrate, forms fragment into mosaic-like flat patterns, and colors and brush strokes assume an abstract life of their own. In this canvas we can recognize the artist's lifelong appreciation of the painterly exuberance practiced by van Gogh, Pollock, and de Kooning.

Byron Kim's art often resembles "pure" or Minimalist abstraction, but his titles make it clear that he is addressing idiosyncratic information drawn from personal experiences. Kim's visual instincts compel him to make monochrome objects, but at the same time he maintains that "Purity in abstraction is an anachronism."[39] He avoids the grand existential themes of modernist abstraction by devoting his pictures to "small," personal subjects. His verbal references to the bodies and the memories of his family members provide him with content that "adulterates" abstraction and counters the common assumption that it is "an elite tradition." For *Emmett at 12 Months* (Plate 28), Kim examined the subtle natural variations in color on different parts of his son's body. He then selected twenty-five examples and painted a flat monochrome sample of each one on a set of identical rectangular wooden panels. He had found the colors in places as intimate and particular as an upper eyelid, the rim of a nostril, or the bottom of a foot.

By transforming each patch of local color into a monochrome, and then marshalling each rectangle into a grid pattern, Kim creates a paradox. The cool rationality of the arrangement seems to deny the flowing, organic wholeness of Emmett's skin, but the clear exposition of such a diversity of color is an occasion for wonder and joy. The painting wisely, and eloquently, refutes the old racist notion that a person can be reduced to and described by a single color of skin.

Byron Kim

PLATE 29 *Whorl (Ella & Emmett)*
1997
Egg tempera on panel
Left panel: 4½ × 4 inches
Right panel: 4¾ × 4½ inches
Private collection

Four years after making the abstracted "portrait" of Emmett, Kim produced a small diptych inspired by Emmett and his sister, Ella (Plate 29). At first glance, the two beautifully painted elements of *Whorl (Ella & Emmett)* may appear to be nocturnal landscapes, or perhaps fireworks or swirling galaxies. Close inspection reveals that they are in fact tightly rendered close-up views of the backs of the children's heads. In this unconventional double portrait, the artist marvels at the similarities and differences between brother and sister. Such close attention to the precise colors and shapes of each child's hair speaks to the bonds of love between parents and their children.

Many artists who turn to their families for subject matter produce works fraught with emotions and complications. Unwittingly or not, they echo the much-quoted first sentence of Leo Tolstoy's 1877 novel *Anna Karenina:* "All happy families resemble one another; each unhappy family is unhappy in its own way." A gloomy situation certainly prevails in *Figures in a*

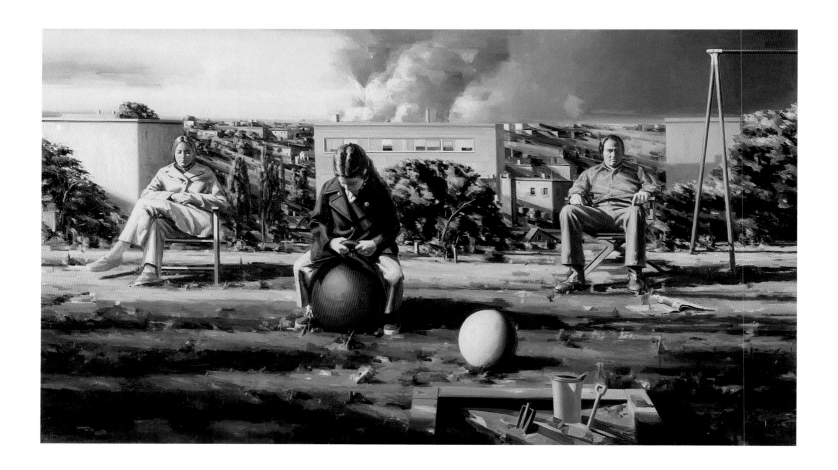

Sidney Goodman

PLATE 30 *Figures in a Landscape*
1972–73
Oil on canvas
55 × 96 inches
Philadelphia Museum of Art, purchased
with the Philadelphia Foundation Fund (by
exchange) and the Adele Haas Turner and
Beatrice Pastorius Turner Memorial Fund,
1974 (detail at right)

Landscape (Plate 30), a painting by veteran Philadelphia realist Sidney Goodman. Despite the anonymity of the title, it is in fact a portrait of the artist, his first wife, Eileen, and their daughter, Amanda. It is a fiendishly inspired and tightly constructed picture: we may not know *why* things are amiss, but there is no denying that silence and disquiet fill the terrain. Each person is overwhelmed by an inability to communicate with the others. The father squints impassively, the mother shuts her eyes, and the girl bows her head and clutches the handle of her "Hippity-Hop" ball. None of them seems to register that their surroundings have grown ominous: massive clouds fill the sky, and slanting staccato shadows create a sense of imminent

trauma. Goodman has staged everything in a foreboding fashion, right down to the sandbox, which, he says, "becomes like a little graveyard."[40] He also insists that he never begins a painting with one specific message in mind; like many artists, he expects each viewer to make a personal interpretation.

David Hockney's 1982 photographic collage of his mother seated in an old Yorkshire graveyard (Plate 31) is a deeply poignant family picture. At the time this was made, the Englishwoman had been widowed for four years, and her forty-five-year-old son was an internationally famous artist who had settled in Los Angeles. The collage reflects several things: a son's outing with his elderly mother; a Yorkshireman's brief

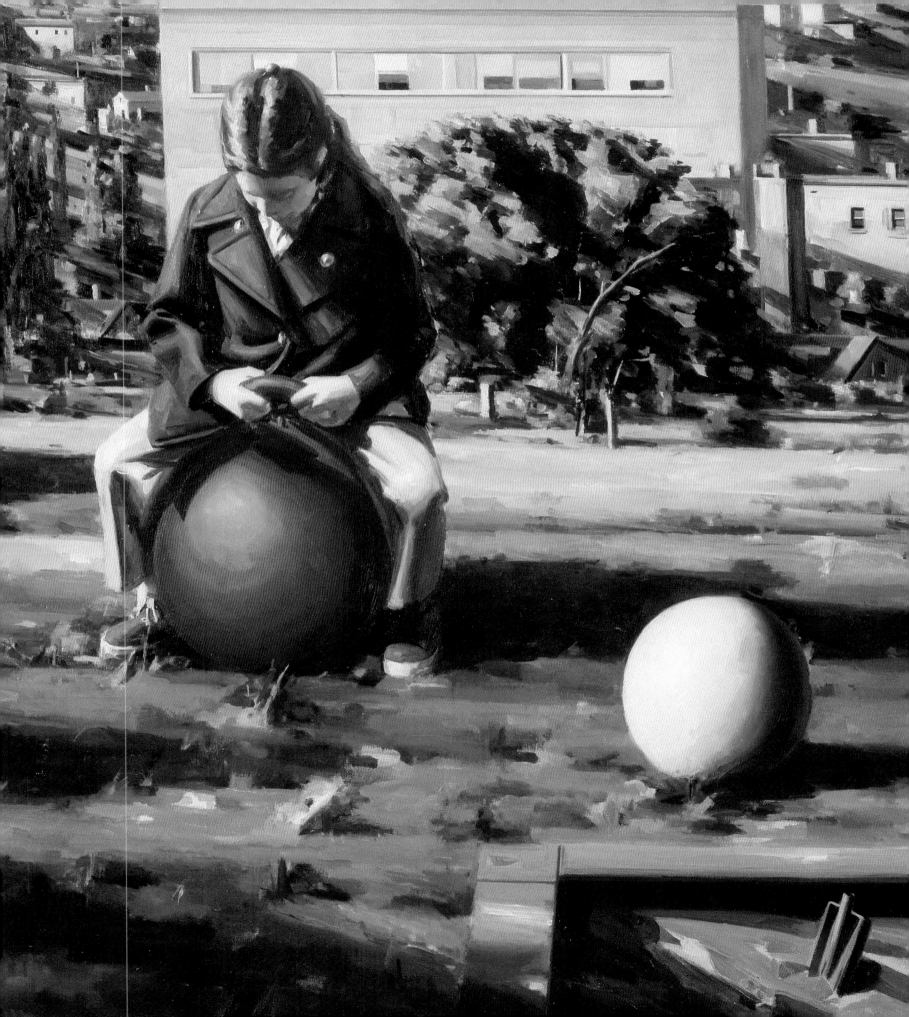

David Hockney

PLATE 31 *My Mother, Bolton
Abbey, Yorkshire,
Nov. '82*
1982
Photographic collage
47½ × 27½ inches
Edition 4/20
Courtesy of the artist

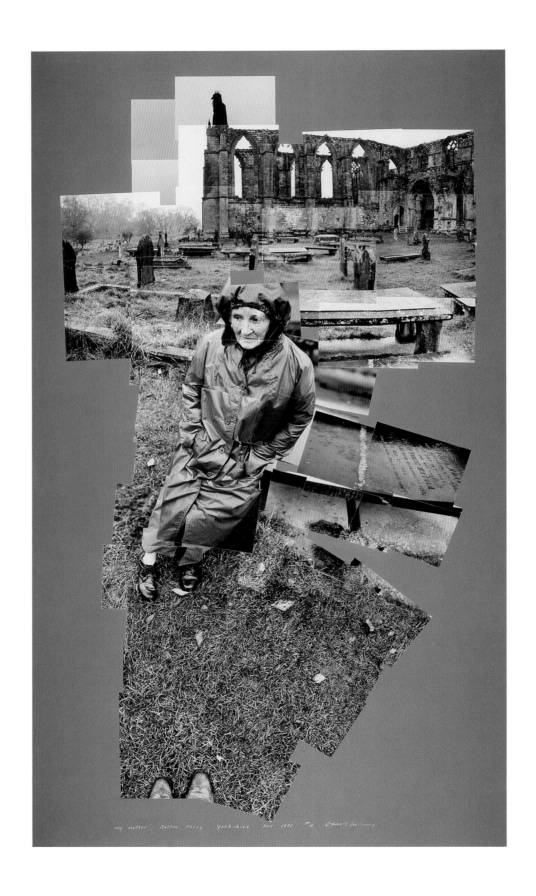

Hung Liu

PLATE 32 *Father's Day*
1994
Oil on canvas with antique
architectural panel
54 × 72 inches
Courtesy of Bernice
Steinbaum Gallery, Miami

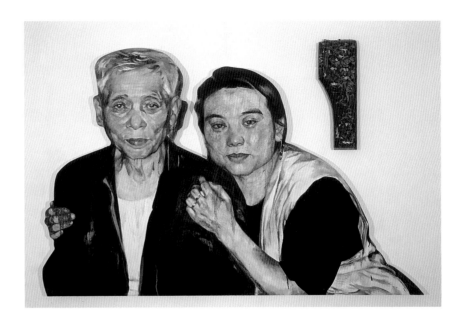

return to his regional origins; and a painter indulging in a very new passion for photography.[41]

Hockney's interest in photography blossomed in September 1982, when he discovered the pleasures of overlapping numerous 35mm color prints to open up the space of a particular scene. In the case of *My Mother, Bolton Abbey,* there is one principal shot of the face from which other pictures fan out in a lively, asymmetrical fashion. Close-up views interrupt the edges and outlines of objects, and there is a vivid sense that the artist has moved around in order to choose points of emphasis. Most importantly, he shows part of his own body, creating a vivid linkage between subject and image maker. Hockney's pair of stylish brogues faces his mother's old-fashioned shoes, and the space between them is perhaps the soul of the picture. Mrs. Hockney has a look of reverie, and the outfit protecting much of her body from the wintry weather underscores her introspection. The ruins and tombs of this famous historic site seem to have worked their melancholic spell on both mother and son; the absent husband/father was surely in their thoughts. Thousands of miles from splashy, newly minted Los Angeles—Hockney's adopted home—the artist finds himself in the chilly Yorkshire mists of his childhood. Only his newfound excitement about photography allows him to

transcend the sadness of the moment: making a stirring picture was a way to remember and move forward.

Hung Liu's painting *Father's Day* (Plate 32) commemorates the artist's reunion with her father in China in 1994. She had not seen him since her infancy, and had not known that he was even alive until earlier that year. In 1946, the year she was born, her father was imprisoned during the Communist take-over of their city, Changchun. Liu excelled at school in Beijing, but in 1968, during the Great Proletarian Cultural Revolution, she began four years of "re-education" as an agricultural laborer. During her time in a commune she directed her artistic leaning into the production of official banners, stage sets, and murals stipulated by the Maoist government. In the 1970s she was able to study art, and eventually majored in mural painting at Beijing's Central Academy of Fine Arts. She left China in 1984, seeking to advance her artistic training in the United States. Liu's career flourished in this country in the 1990s, when she explored the contradictions of her hybrid identity, particularly its multicultural and feminist dimensions. In a recent interview she observed: "For myself, of course I'm Chinese from China. But . . . [America] is my new home. I'm comfortable dealing on a daily basis with an American multi-cultural, multi-racial, or multi-layered high-speed reality. [But] I feel I am not just a

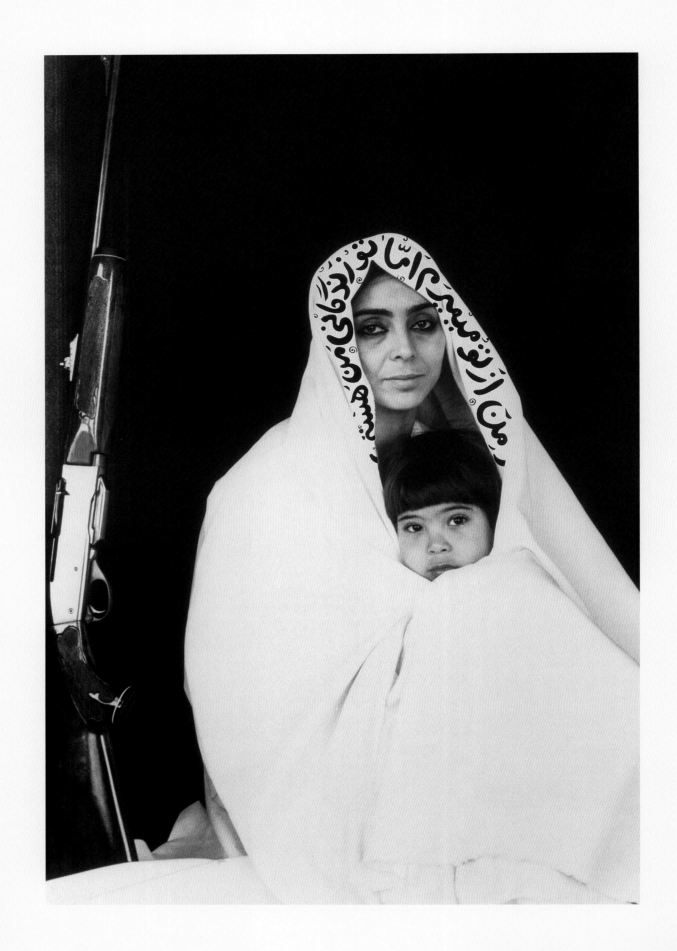

Shirin Neshat

PLATE 33 *My Beloved,* from the
Women of Allah series
1995
Black-and-white
RC print with ink
additions
32 × 21½ inches
Worcester Art
Museum, Worcester,
Massachusetts,
Sarah C. Garver Fund

simple noun, 'Chinese-American.' I think it's more of a verb, like 'Chinese-becoming-American.' It's probably a long process throughout the rest of my life. . . . I never felt comfortable claiming that I represent Chinese culture. . . . I represent only myself and my particular collage of experiences."[42]

Liu found her father in a labor camp near Nanking, and it happened to be Father's Day in America on the very day she met him. The painting shows a daughter holding a father in a loving hug. The contrast between the figures is marked. Liu's thin washes of paint induce a pervasive air of fragility: the frailty of the care-worn man, the meager duration of their acquaintance, and the bittersweet nature of the belated reunion itself. The incorporation of an elegant piece of carved-wood decoration alludes to the Chinese cultural history that produced both the artist and her father. Though clearly secondary to the physical bond that at last connects them, this fragment—the seed of a shared culture—has the potential to strengthen and deepen their ties. (Liu's father died in 1996.)

Shirin Neshat is another artist who experiences life on two distinct cultural registers. She grew up in Iran and traveled to the United States in 1974, at the age of seventeen, to pursue higher education. She was not allowed to visit her homeland again until 1990, at which time she confronted the drastic changes that had been enacted by the Islamic Revolution of 1978, particularly the repressive impact on the lives of women. Neshat recently recalled: "Before I left [in 1974] they were Iranian-Persians, and now they were strict Moslems. Visually everything was black and white, and women had to be in dark clothes [when seen in public]."[43] *My Beloved* (Plate 33)

is a domestic image, showing the artist holding her son close to her body and shielding him within a light-colored chador. Even as this picture conveys a mother's instinct to love and protect, there are two details that sound provocative notes: the rifle propped at Neshat's side and the excerpts from a poem that she has inscribed in Farsi on the surface of the photograph. The poem is by Forugh Farrokhzad, who died at the age of thirty-two in 1967, the first Iranian to write poems from the perspective of a secular, free-spirited woman. Neshat has surrounded her face with Farrokhzad's words: "I die in you . . . but you are my life!"[44]

This picture belongs to the *Women of Allah* series, all of which include images of guns and evoke the female martyr (*shahid*). Neshat raises questions about human rights, independence, violence, self-protection, faith, hatred, conflict, revolution, vigilance, and the cost of peace. Quietly yet deliberately, *My Beloved* brings to the surface several points of concern in Neshat's own life: love for her son, engagement with her cultural and religious heritage, intellectual devotion to women's rights, and unease about the repressive effects of fundamentalism in Iran. Each strand fosters a network of complications in her life: "Everyone will miss some part of my art unless they have a background in both cultures. Although probably only I can fully understand both sides, I try to capture something that can be felt emotionally by all; to draw people into an area that is perhaps confusing or mysterious, but still gives them a charge like I get when I go into a mosque."[45] *My Beloved* is not a tract; rather, it is a meditation on the intricacies of Neshat's ties to her various families, from her son to her homeland.

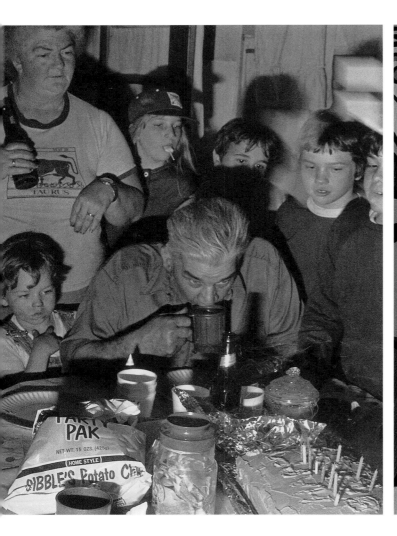

details of Plates 34 and 37

the force of time

Modern life seems to change at a greater speed, contradicting whatever notions we may have of a "natural" sense of chronological progression. A character in a recent crime novel by Donald E. Westlake remarks that, "The world doesn't just *change* these days, it upheaves, constantly. We're like fleas living on a Dr. Jekyll who's always in the middle of becoming Mr. Hyde."[46] Indeed, time takes on a graphic, almost tangible dimension when we envision our lives as taking place within a spiraling succession of birthdays, decades, generations, and historical epochs.

Pictorial family trees and geometric ancestry charts are ways to visually record a line of descent. In the West, such artifacts served largely as instruments for powerful people until the rise of the bourgeois family in the nineteenth century, when the exploration of genealogical identity began to appeal to a broader section of the population. In the mid-nineteenth century, author and French blueblood Alexis de Tocqueville decried the fact that individualism took priority over family ties in the United States, and he pronounced that Americans did not heed the concept of family, ". . . if one takes the word in its Roman or aristocratic sense."[47] Ironically, this was precisely the period when many Americans initiated the ongoing preoccupation with bloodlines and pedigrees. For decades Waspish political agendas and social elitism dominated the field; consider, for example, the Society of Mayflower Descendents and the Daughters of the American Revolution. More recently, however, people of all races and classes have taken an interest in genealogy. The "blockbuster" success of Alex Haley's 1976 book *Roots* inspired many African Americans to trace their ancestors beyond the degrading era of slavery, back to their origins in African villages. And feminism did a lot to raise consciousness about the legal and custom-based biases toward male heirs and patriarchal lines, inspiring new research into the diverse ways in which women create links between generations over time.[48]

Birthdays play an important role in our understanding of both time and genealogy, for they symbolize when and where we began, and how far we've come. Ian Dury, the most lyrical rock and roller of the British punk scene, made a touching personal comment about time when he wrote the line: "All I want for my birthday is another birthday."[49] Larry Fink's photograph *Pat Sabatine's Eleventh Birthday Party* (Plate 34) registers the generic props of many birthday celebrations—cake, candles, hats, and treats. But it also presents, in the harsh light of the photographer's flash, a candid portrait of a group of friends and relatives in rural Pennsylvania. All are united in the moment immediately after the ritual blowing out of the birthday candles. In describing the room they occupy in this photograph, Fink wrote, "The Sabatine kitchen, a holy mess, is stacked high with spaghetti, cans of soda, candy, bingo slips, yesterday's sales, pleasures of all varieties." Jeannie, the "ornery" mother of the family, "is a gal who never learned to read or write, but she's smart as a whip. Cursing and loving, living in the present with no considered longing for the past or the future, she's an angel

Larry Fink

PLATE 34 *Pat Sabatine's Eleventh
Birthday Party, April 1980
(Martin's Creek)*
1980
Gelatin silver print
17⅝ × 11¾ inches
Museum of Fine Arts, Boston,
gift of Janet Singer

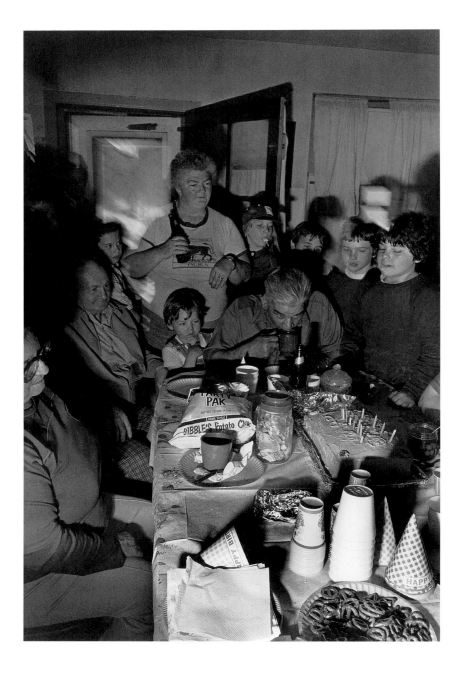

inhabited by the devil. Jeannie loves her kids and is a child herself."[50] Fink began to photograph the Sabatines after completing a six-year project in which he documented society benefits in New York. He wanted to find a balance after attending a surfeit of "black-tie" events, and the Sabatines proved to be his folk remedy. *Pat Sabatine's Eleventh Birthday Party* appeared in Fink's book *Social Graces,* along with pictures of fancy Manhattan parties. He admitted that the book had a political undercurrent—"how the system suppresses and distorts both the rich and the poor"—but denied that he was a satirist: "The

pictures are taken in the spirit of finding myself in the other, or finding the other in myself. They are taken in the spirit of empathy. Emotional, physical, sensual empathy."[51]

Nicholas Nixon instigated a remarkable ritual with his ongoing project *The Brown Sisters,* which is devoted to his wife and her three sisters (Plate 35). Once a year since 1975 he has scheduled a get-together to photograph these four women. Given that Nixon is an only child, and that each of his parents was an only child, the clannishness of his in-laws probably struck him as different and intriguing. The sisters always

Nicholas Nixon

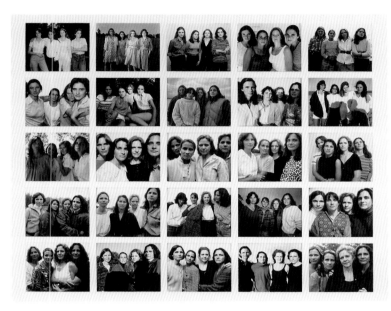

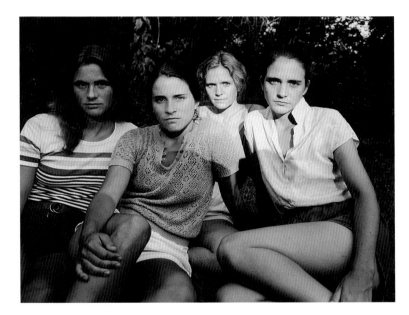

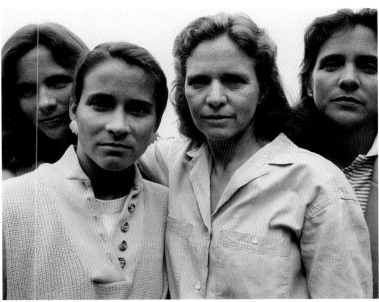

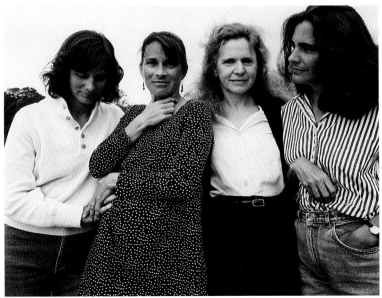

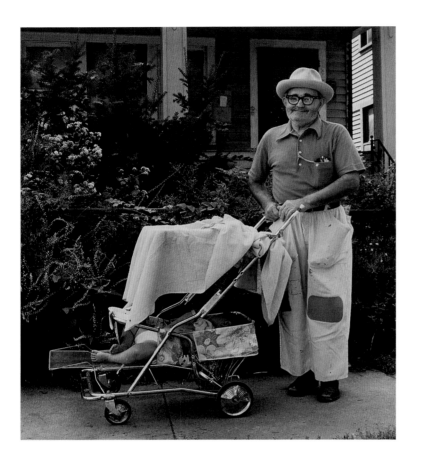

pose for him in the same order: from left to right, they are Heather, Mimi, Bebe, and Laurie. Bebe, light-haired and the oldest of the four, married Nixon in 1971. A mixture of perseverance and obligation must unite the participants and drive the project forward: an artist with his models; some muses with their acolyte; or just five relatives, fairly close in age, now hooked on doing their annual thing. When Nixon presented the first twenty-five images as a grid in a single frame, the collective vibrancy of the pictures came to the fore. It is hard to resist the thought that these women are like a charming graduating class that cannot bear to see its togetherness end. More importantly, however, is the visually overwhelming manner in which time plays a role: clothes and hairstyles change constantly, and allegiances within the group appear to shift, though most viewers cannot know why a given sister may seem more

happy, coy, or thoughtful from one year to the next. Nixon himself refers to his work with the Brown sisters as "an annual rite of passage."[52]

Milton Rogovin has also photographed the same people at different moments in time, but his project is not as programmatically focused as Nixon's. Rogovin worked for many years as an optometrist in a run-down section of Buffalo, New York, known as the Lower West Side, and his customers became frequent subjects of his portraits. Photography has always been his hobby and passion, and a deep-seated social concern inspires him to champion the underdog and respect the dignity of the poor and the disenfranchised. In the early 1990s Rogovin began to assemble a series of works, with the collective title *Triptych,* for which he grouped images of people he had photographed together on numerous occasions, spanning back

Milton Rogovin

PLATE 36 *Triptych,* from the *Buffalo's Lower West Side Revisited* series
1973, 1985, and 1991 (left to right)
Three gelatin silver prints
7¹³⁄₁₆ × 6⁵⁄₁₆; 6⁷⁄₈ × 6¾;
7³⁄₁₆ × 6⅜ inches (left to right)
Hallmark Photographic Collection,
Hallmark Cards, Inc., Kansas City,
Missouri

twenty years. This allowed him to present both the continuity and the evolution in the relationships between couples and between parents and children. The fact that several years separate each photograph makes the trajectory of time especially dramatic in these triptychs. One particularly poignant example (Plate 36) involves a grandfather and granddaughter: one person weakens over time while the other passes from infancy to young adulthood. What remains unchanged is the warmth of their relationship and the artist's admiring, sensitive concern for his subjects.

Diaries—a literary embodiment of time—have been an important source of inspiration for the paintings of Roger Shimomura, a third-generation Japanese American. In seeking to understand his family history and layered cultural background, he has repeatedly studied his family's photo albums and scrapbooks; but the diaries of his grandmother, Toku Shimomura, are what triggered some of his most vivid pictures (for example, Plates 37–39). Born Toku Machida in Saitama Prefecture, in 1888, she trained to be a nurse and served in the Japan Imperial Navy Red Cross during the war with Russia. In 1912 she immigrated to the United States for an arranged "photo marriage" (*sashin kekkon*). Living in Seattle, Mrs. Shimomura worked for many years as a midwife, and died there in 1963. During her twenty-five-year career she delivered more than a thousand babies, including her grandson Roger, in 1939.

In 1997 Roger Shimomura produced thirty paintings collectively titled *An American Diary,* distilling his family's saga during World War II into a format with the same visual clarity and drama as a comic-book novel. The pictures, each

Roger Shimomura

PLATE 37 *American Diary:*
December 25, 1941
1997
Acrylic on canvas
11 × 17 inches
Courtesy of the artist and
Greg Kucera Gallery,
Seattle

December 25, 1941 (Seattle,
Washington)
"Christmas in the time of war. We
spent time at home quietly as all
of the family joyfully got together.
For this we were all thankful. We
had a pleasant Christmas, with
Roger as the center of attention."

Roger Shimomura

PLATE 38 *American Diary:*
May 16, 1942
1997
Acrylic on canvas
11 × 17 inches
Collection of Lawrence
and Karen Matsuda,
Courtesy of Greg Kucera
Gallery, Seattle

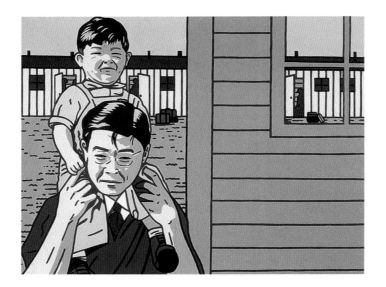

May 16, 1942 (Camp Harmony,
Puyallup Assembly Center,
Washington)
"Fine weather today, although
it showered in the evening. In
the afternoon Kazuo carried
Roger in. I was able to enjoy
him for only for a few minutes.
Today the process of accom-
modating the 8,000 Japanese
from the Seattle area finished.
The camp became very lively."

Roger Shimomura

PLATE 39 *American Diary:*
July 15, 1943
1997
Acrylic on canvas
11 × 17 inches
Courtesy of the artist and
Greg Kucera Gallery,
Seattle

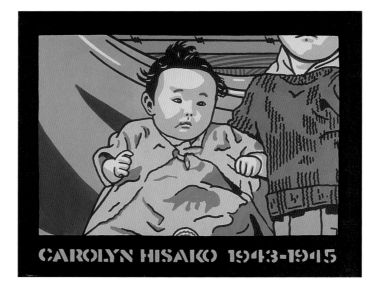

July 15, 1943 (Camp Minidoka,
south-central Idaho)
"The heat was severe today. Aya
(daughter-in-law) started to show
signs of being ready to deliver.
By afternoon she started to have
pains. After feeding her supper
around 5:00 P.M., I sent her to
the hospital. Soon after, around
6:30 P.M., she had an easy deliv-
ery. It was a baby girl that was
named Carolyn Hisako Shimomura.
I immediately made a call on both
of them. I made sure that the news
would reach her mother. Roger
came over to spend the night. I
slept poorly."

accompanied by an excerpt from Toku Shimomura's diaries, unfold into an account of the hardships endured by thousands of Japanese Americans when they were confined to internment camps in the aftermath of the attack on Pearl Harbor. Many of the images show Roger Shimomura as a boy: in one, he is enjoying Christmas at home, too young to understand the anxieties of wartime; in another, he is being carried into an internment camp on the shoulders of his uncle; in a third, he stands beside his baby sister, Carolyn, who was born in Camp Minidoka, Idaho. Family relationships mold each of these compositions. Shimomura's *American Diary* underscores the hardships that ensue on many levels, and the tragedy of cultural misunderstandings, when wars are waged, as was the case with

Japanese Americans in the early 1940s. Shimomura's pictures and his grandmother's diary offer personal accounts of an episode in history when one community of American citizens was exiled from the larger national family. In 1988 President Ronald Reagan formally apologized and authorized reparation payments to survivors of these internment camps.

In their recent collaborative video installation *a small world* (Plate 40), Sanford Biggers and Jennifer Zackin have made wonderful use of home movies from their childhood years, transforming these mundane items into an incisive reflection on recent social trends. Both artists grew up in middle-class settings: Biggers in a black Christian family on the west coast, Zackin in a white Jewish family in the east. Although their

Sanford Biggers
and Jennifer Zackin

PLATE 40 *a small world . . .*
2000
video installation
dimensions variable
Collection of the artists

Shellburne Thurber

PLATE 41 *Edinburg, Indiana:*
My Mother's Portrait
1976
Gelatin silver print
30 × 30 inches
Courtesy of the artist

backgrounds invite a comparison of their differences, the artists themselves have been struck by the remarkable similarities of their early years. Visitors to *a small world* enter a 1970s-style room with shag carpeting, fake wood paneling, and a giant sofa; inside this standard late-twentieth-century American family room, two home movies play silently, side by side. The time-warp environment puts viewers in the mood to enjoy the picture show, and in doing so begin to register the numerous similarities in the imagery of the two films: meals on holidays; children's parties; visits to the beach; trips to Disneyland; and shots of each of them at the piano. Because the artists were so thoughtful in their pairing and sequencing of the movie clips, *a small world* may be read as an optimistic and humanitarian statement: it seems to remind us of the importance of bringing both education and pleasure into the lives of children.

Biggers and Zackin, however, do not want to charm the audience with a single utopian ideal: "We wanted to leave many doors open for viewers to draw their own conclusions.

For this reason we didn't add sound or try to direct opinion down a determined path."[53] These artists were most committed to illuminating a paradox involving race and class in the United States. Although most Americans believe that the attainment of money and possessions can make everyone equal, they remain obsessed with the twin beliefs at the core of Americanism: individual and national destiny. Even if everyone can be united and equal within a given economic class, Biggers and Zackin suggest that notions of personal liberties and national separatism will still be there to perpetuate ethnic and religious differences.

Shellburne Thurber's early photographs (Plates 41–43) demonstrate the powerful manner in which the deceased can live on in the minds of their relatives, particularly in their experiences of domestic spaces. In 1976 Thurber made a visit to her grandmother in Indiana, hoping to forge a better understanding of her mother, who had died of an illness seven years before. The artist was a teenager when her mother became sick, and her time at boarding school and college inevitably

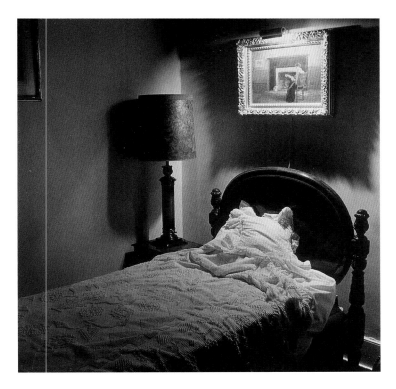

Shellburne Thurber

PLATE 42 *Edinburg, Indiana:*
My Grandfather's Bed
1976
Gelatin silver print
30 × 30 inches
Courtesy of the artist

Shellburne Thurber

PLATE 43 *Edinburg, Indiana:*
My Grandfather's Study
1976
Gelatin silver print
30 × 30 inches
Courtesy of the artist

imposed a certain distance from the distressing events. By visiting her grandmother and the home where her mother had been raised, Thurber was making an indirect approach to the person she had lost. Seeing the mausoleum-like aura that had overtaken the home, she began to understand how hard it was for her grandmother to cope with the deaths of a husband and two children in a short span of time.[54] Becoming a visual archaeologist, Thurber sifted through the memory-laden atmosphere for traces that might prove cathartic. As she remembers it, "A lot of who my mother was had been shaped by her ambivalent and difficult, though loving, relationship with her own mother, who was an extremely strong personality. Interestingly enough, as soon as I appeared on the scene, my grandmother started acting out her drama with my mother with me, so that I began to find out about my mother indirectly."[55] Thurber's response to a painting of her mother as young woman distills the kind of double-take she must have experienced: first the surprise of the encounter, deepened by the marked formality of the room, then the opportunity for a

lingering exchange of glances with the woman in the portrait. The emotional and edgy notes of Thurber's photograph recall the *film noir* aesthetic. She instinctively understood that the dramatic lighting, the mantelpiece ornaments, and the portrait constituted a shrine erected by her grandparents to honor the woman their daughter became.

Specific items of furniture in a family home can easily become surrogates for the person who used them most, as Thurber demonstrates in her haunting photographs of her late grandfather's bed and the armchair in his study. By taking advantage of the light fixtures he had used, she staged an almost spectral evocation of the absent person. Indeed, Thurber admits that she "love[s] theatrical light and its ability to transform space. It has always been important in my photographs."[56] It is also easy to take an anthropomorphic view of the armchair: Thurber's vision seems to turn it into a retiring, slightly rumpled, sedentary, grandfatherly individual. Her sensitivity to domestic haunts is similar in mood and content to the following passage from Anne Tyler's novel *The Accidental*

Albert Chong

PLATE 44 *Throne for the Justice*
1990
Solarized gelatin silver print
41¾ × 32¼ inches
Museum of Art, Rhode Island
School of Design, Providence,
Walter H. Kimball Fund

Tourist: "After his wife [Sarah] left him, Macon had thought the house would seem larger. Instead, he felt more crowded. The windows shrank. The ceilings lowered. There was something insistent about the furniture, as if it were pressing in on him. Of course Sarah's personal belongings were gone, the little things like clothes and jewelry. But it emerged that some of the big things were more personal than he'd imagined. There was the drop-leaf desk in the living room, its pigeonholes stuffed with the clutter of torn envelopes and unanswered letters. There was the radio in the kitchen, set to play 98 Rock. (She liked to keep in touch with her students, she used to say in the old days, as she hummed and jittered her way around the breakfast table.)"[57]

In 1990 Albert Chong, a Jamaican American, responded to the death of his father by initiating what he calls an "ancestral dialogue." He created an altarlike installation, which he chronicled in the form of a large photograph with an eerie aspect (Plate 44). Chong's picture is a striking reminder of a simple truth: the deaths of our closest family members are landmarks that often define the chapters forming the timelines of our own lives. The stately title of this picture, *Throne for the Justice*, alludes to the fact that the deceased was a former justice of the peace in Kingston, Jamaica. Mindful of both Chinese and African contributions to his mixed racial lineage, Chong has taken an interest in Chinese ancestral veneration, Buddhism, Animism, and the Yoruba-derived Caribbean religion Santeria.

Janine Antoni

PLATE 45 *Momme*
1995
C-print
36 × 29 inches
Courtesy of the artist
and Luhring Augustine
Gallery, New York

In 1995 he observed: "My ancestral dialogues are a constant discourse with the spirits of the past. . . . In these images I strive to eliminate the distinctions between art and life, ritual, magic, and my personal brand of mysticism. I seek to bring home the ancestral spirits and seat them on the thrones that have been created for them, upon and about which offerings are made."[58]

To make *Throne for the Justice,* Chong carefully broke off the "petals" of a giant pinecone from San Diego and used them to decorate a simple chair with vibrant flamelike shapes. He placed a photograph of his father on the seat and encircled it with hefty rocks and clusters of cowrie shells, which once served as currency and as shamanistic devices in different parts of Africa, and now symbolize that continent for many black Americans. Chong crowned this still life with a profusion of long dreadlocks shorn from his own head. *Throne for the Justice* embodies Chong's attempt to keep alive "the tenuous link I have with the past." He notes: "I am a walking repository

of cultural, familial, and genetic information. In addition, I now realize that I shared with my father a closer history than my children will share with me. Their upbringing in America creates a cultural identity that, with each generation, will grow more distant from mine and that of my father."[59]

In a work with the ingenious title *Momme* (Plate 45), Janine Antoni explores her urge to return to the womb—a need for the mother that can negate time and worldly interests. At first glance this color photograph seems to be merely a serene portrait of a woman of middle age, who occupies a spare but elegant setting. She wears a vaguely classical, long white dress and gazes at the mysterious light pouring in from the blank whiteness of the window beside her. A small table holds an enigmatic decorative boat and two props that can be read as symbols of time's passage: flowers in full bloom and old family pictures. At some point the viewer registers the curious bulge in the woman's waist: but she's too advanced in life's journey to be pregnant, isn't she? The puzzle is resolved when one

Keith Edmier

PLATE 46 *Beverley Edmier, 1967*
1998
Cast urethane resin, cast
acrylic resin, silicone,
acrylic paint, silk, wool, and
Lycra fabrics, cast silver
buttons, nylon tights
50¾ × 31½ × 22½ inches
Collection of Rachel and
Jean-Pierre Lehmann
(detail at far right)

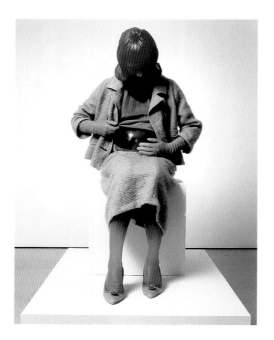

sees that there are three bare feet protruding from her white dress. Antoni, it turns out, has carefully folded herself beneath her mother's dress in a ritualistic enactment of "mom and me." *Momme* shows three generations of women: the artist, who is anxious about leaving and losing her mother; Antoni's mother, who displays a peaceful but rather lonely sense of acceptance; and the mother's mother, who is memorialized in a photograph in a silver frame.

In 1998 Keith Edmier produced an equally odd and wistful work about the uncanny lure of the mother. In the life-size sculpture *Beverley Edmier, 1967* (Plate 46), he portrays his mother during her pregnancy with him. Although tastefully dressed, she has unselfconsciously bared her abdomen, which Edmier has rendered in see-through light red resin. Beverley is thus able to gaze at the fetus, which is, in effect, a self-portrait of the artist. In another startling twist, Edmier has dressed his mother in a replica of the stylish Chanel suit that Jacqueline Kennedy, the First Lady of the United States, wore in Dallas on November 22, 1963, the day her husband was assassinated. The pink costume was prominent in the televised footage of the fatal shooting, and it assumed iconic status after Mrs. Kennedy insisted on wearing it as a tragic, bloodstained emblem when she returned with her husband's corpse to the nation's capital. Beverley Edmier experienced this national trauma firsthand, but it can be only a piece of history for the artist, who was born four years later.

Edmier's invention of a bizarrely nostalgic, *in utero* self-portrait is astonishing, and his technical ability to realize such

a vision derives directly from his former job as a makeup and special-effects artist in the film industry. During that chapter of Edmier's career, his prosthetic handiworks contributed to such mainstream horror movies as *Nightmare on Elm Street 3: Dream Warriors* (1987) and *Leatherface: Texas Chainsaw Massacre 3* (1990). Edmier's vision of his pregnant mother rests ambiguously between warm nostalgia and brooding, slightly sinister theater. It largely reflects the positive iconic power traditionally associated with motherhood and illustrious mothers. But it also hints at the melancholy of the Virgin Mary, who in countless Renaissance paintings receives Jesus with a mixture of joy and foreboding about his destiny. The allusions to Jacqueline Kennedy only intensify this echo of the Virgin's sadness.

Edmier was clearly in tune with a revival of the Gothic sensibility that flourished in the premillennial period. In a 1994 essay discussing the arts of horror and the grotesque, Joyce Carol Oates wrote: "I take as the most profound mystery of our human experience the fact that, though we each exist subjectively, and know the world only through the prism of self, this 'subjectivity' is inaccessible, thus unreal, and mysterious, to *others*. And the obverse—all *others* are, in the deepest sense, *strangers*."[60] Despite a superficially rosy aspect, *Beverley Edmier, 1967* quietly intimates that the ties between son and mother can be construed in grotesque views of the self and the other. Edmier's sculpture also resonates with the anxiety that some people feel about the time before they were born. Vladimir Nabokov played with this concept at the

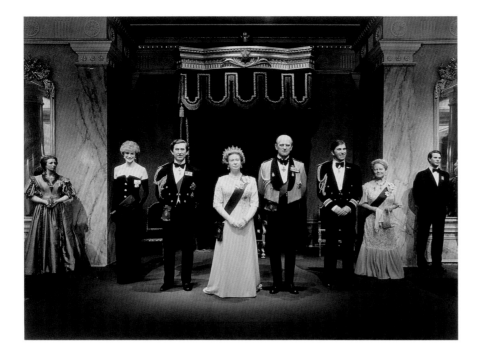

Hiroshi Sugimoto

PLATE 47 *The Royal Family*
1994
Gelatin silver print
20 × 24 inches
Courtesy of Sonnabend
Gallery, New York

beginning of *Speak, Memory,* his book of autobiographical writings: "I know . . . of a young chronophobiac who experienced something like panic when looking for the first time at homemade movies that had been taken a few weeks before his birth. He saw a world that was practically unchanged—the same house, the same people—and then realized that he did not exist there at all and that nobody mourned his absence. He caught a glimpse of his mother waving from an upstairs window, and that unfamiliar gesture disturbed him, as if it were some mysterious farewell. But what particularly frightened him was the sight of a brand-new baby carriage standing there on the porch, with the smug, encroaching air of a coffin; even that was empty, as if, in the reverse course of events, his very bones had disintegrated."[61]

Several of Hiroshi Sugimoto's photographic series deal with environments in which people are transfixed by fabricated illusions and effigies: movie theaters, natural history museums, Buddhist temples, and wax museums. The projected images, dioramas, and sculptures in these places offer spectacles that are able to warp time in some manner. In 1999 Sugimoto observed that "[Memorialization] is the oldest of art forms: to use a gravestone or a symbol as a mark to commemorate those who have died. Burying the dead and marking the place of a tomb are first indicators of culture. It's considered the first act of art . . . and the true beginning of religion. If you don't remember who your mother and father were, then you

aren't human. . . . [Memorialization] is very important because it marks the passage of time and the construction of history. We become aware of ourselves, our parents, our family, and our loved ones."[62]

Sugimoto's *The Royal Family* (Plate 47), a particularly informative example of his work, records a display at Madame Tussaud's in London. The artist finds it significant that wax portraits were invented just a few decades before photography. Moreover, he believes that these media share the key functions of preserving likenesses and recording history. For his wax museum pictures, Sugimoto seeks out "the perfectly staged tableau" with "really high-quality wax figures."[63] Thus *The Royal Family* proves to be a sophisticated reflection on time, the family portrait, and the human urge to fix, freeze, and preserve experiences. The British royal family is an institution and the country's classiest heritage industry; it thrives by projecting timelessness and reassuringly frozen "royal" smiles. At Madame Tussaud's, the bejeweled and uniformed wax likenesses give visitors a highly realistic yet fictionalized encounter with royalty. The airless perfection of Sugimoto's photograph freezes a spectacle that has already been plucked from history and sealed in wax.

The melancholy aspect of tombs and memorials has appealed to countless artists since the Romantic period. Sugimoto's wax museum pictures make an intriguing comparison with the elegiac thread in Walker Evans's oeuvre, particularly

Walker Evans

PLATE 48 *Wooldridge Family Monument,*
Maplewood Cemetery, Mayfield,
Kentucky
1947
Gelatin silver print
7⅞ × 7⁹⁄₁₆ inches
The J. Paul Getty Museum,
Los Angeles

his images of cemeteries. Evans's encounter with a family plot in a rural Kentucky burial ground (Plate 48) inspired an exquisite portrayal of its subject. Taken in the cheery light of a summer day, it is a carefully positioned, tightly cropped view of a group of charming late-nineteenth-century sculptures. These funerary statues of a clan of local worthies are gathered together much as they might have been in churchly worship. The monuments were commissioned by Colonel Henry G. Wooldridge, a bachelor with keen familial instincts. Two statues represent the colonel himself: he stands with his hand on a book in one, and rides a horse in the other. Statues of Wooldridge's mother, four brothers, three sisters, two nieces, two hunting dogs, a deer, and a fox complete the congregation. What is odd and memorable about Evans's approach to the scene was his decision to shoot the statues from behind and to give a prominent visual role to the cheap wire fence separating them from him. He uses the flimsy enclosure to remind us that we are standing in line, as it were, waiting to join this parade that faces the next world. As is often the case with Evans's work, there is a poignant sense of the gulf that separates an ambiguous modern present from a past populated by

mesmerizing aesthetic achievements. His attraction to these statues surely stems from the same part of his sensibility that savored the writings of Henry James, Marcel Proust, and André Gide. For Evans, at that moment in the 1940s, these Kentucky monuments granted him an opportunity to think about previous generations, the Victorian era, and the rush of time.

In 1954 William Faulkner was shown one of Evans's photographs of the Wooldridge monuments and invited to respond to it with a text for *Harper's Bazaar.* The result was a short story, "Sepulture South: Gaslight," in which a grandchild recalls the death and the funeral of his grandfather. The last paragraph indicates that the narrator returned to the family plot "three or four times a year" to gaze at the statues that loomed there, ". . . stained now, a little darkened by time and weather and endurance but still serene, impervious, remote, gazing at nothing, not like sentinels, not defending the living from the dead by means of their vast ton-measured weight and mass, but rather the dead from the living; shielding instead the vacant and dissolving bones, the harmless and defenseless dust, from the anguish and grief and inhumanity of mankind."[64]

details of Plates 58 and 66

words in play

The use of words as an integral part of an art object has two major effects: visually, words assert their own aesthetic power; and verbally, they point the viewer in certain contextual directions. Words can confirm or highlight an image's propagandistic leanings. At the other extreme, they can unhinge visual sense or meaning by positing ambiguous or contradictory thoughts. Somewhere between these poles, artists often use texts as a means to embellish a "picture" with stimulating information without imposing fixed interpretations on the viewer.

Edward Koren's pen-and-ink drawings usually combine images and words, and his works have been widely published as cartoons, children's books, illustrations in collaborative book projects, and advertisements. His signature style features nimble lines that search and improvise before eventually coalescing into unabashedly shaggy characters and settings. Koren's drawing of an auditorium filled with mice (Plate 49) is one that requires a printed caption for its artistic completion.[65] The two characters on stage are making a presentation, but its content cannot be fathomed from the image alone. Once the caption lets us know that this is an enormous family participating in a moment of "sharing," countless visual details come to life and we begin to flesh out the narrative. The mother is delivering delicate news with heartfelt care; the father listens in staunch agreement; and the kids sit through the speech with wide-eyed anticipation.

Koren's cartoon devoted to a huddle of mailboxes (Plate 50) features numerous words within its composition rather than in a printed caption. This picture would have been somewhat humorous without the words, for the bulky sameness of the five metal containers raises notions about generic houses that are standardized "little boxes" and the families that inhabit them. Country and suburban roadsides abound with lined-up mailboxes, and it is common to find them decorated and personalized with songbirds, eagles, flags, rainbows, cats, dogs, or printed slogans. Koren, who lives in rural Vermont, often translates personal experiences into his art. His conceptual twist in this drawing is to envision mailboxes emblazoned with the marital and parenting "problems" of their respective families. Since the 1960s Americans have dealt with these types of issues more openly; moreover, family practices that were once hidden are now flaunted on TV talk shows. Koren comments wittily on how family issues are now so out in the open that they might as well be proclaimed on our mailboxes. He smiles, but he refrains from judgment. His stance as a curious observer of difference, diversity, and social change is the antithesis of that taken by conservative crusaders who champion "family values" as a normative moral standard.

For decades, Duane Michals has extended the expressive repertoire of photography through the imaginative addition of short, handwritten texts to the margins of his images. Photography purists deem this practice a flagrant violation of the print's sacred authority; but Michals sees it as a means to transcend what he feels are the limitations of the medium, namely, a reportorial seeing and describing of external appearances.

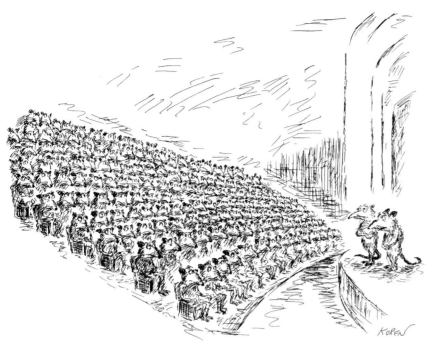

"Your father and I want to explain why we've decided to live apart."

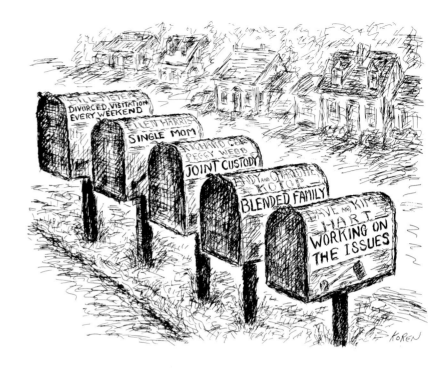

Edward Koren

PLATE 49 *"Your father and I want to explain ..."* 1995
Pen and India ink
on paper
22¼ × 25½ inches
Courtesy of the artist

Edward Koren

PLATE 50 *Mailboxes* 1992
Pen and India ink
on paper
22½ × 29⅛ inches
Courtesy of the artist

In his greater ambition to "deal with all sorts of issues that you can't see," Michals realized he could write words that would begin where his photographic images leave off: "The language gives a voice to the silence of the photograph."[66] Thus, in 1975, at the age of forty-three, he created *A Letter from My Father* (Plate 51) by combining a family photograph he took in 1960 with a new text. The foreground presents a soft-focus profile image of Michals's younger brother Timothy; the background shows the sharply detailed faces of the parents and a brick wall; an aura of isolation prevails and no one seems content. The artist's plainspoken text confesses the sadness he has long felt because his father was unable to express love. In an essay written in 1988, Michals acknowledged that the meld-

ing of words and pictures allows him to confront a viewer's habit of silence, to encourage intimacy, and to trigger personal truths: "I knew my mother and father my entire lifetime and not once did they ever reveal themselves to me. To whom have you revealed yourself? Who shares your secrets? What do you know about yourself to tell?"[67] It is relevant to note that Michals is gay and that he grew up in Pittsburgh in a blue-collar Catholic family of Slovak descent; in background and sensibility he is akin to Andy Warhol, whom he first photographed in 1958 when both were active as New York commercial artists.[68]

Throughout the twentieth century, writers and photographers worked together on documentary projects intended to raise public awareness about social hardship and injustice.

A LETTER FROM MY FATHER

As long as I can remember, my father told me that one day he would write me a very special letter. But he never mentioned what the letter would be about. I used to speculate about what great secret the letter would reveal, what surprise, what intimacy we would

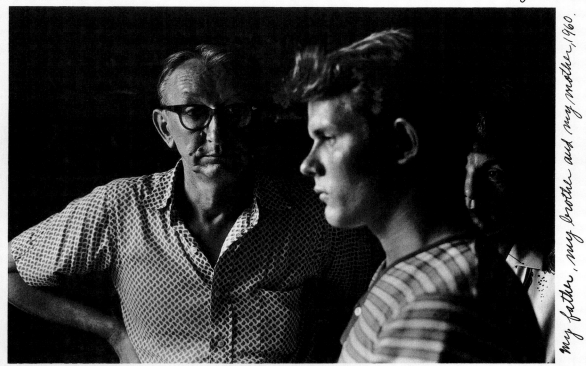

my father, my brother and my mother, 1960.

share. I knew what I hoped the letter would contain. I wanted him to tell me where he had hidden his affections. But then he died, and the letter never arrived, and I never found that place where he had hidden his love.

duane michals 3/25

Of the early pioneers, Lewis Hine showed the least patronizing attitude toward the immigrants and the child laborers that he portrayed. The social documentary school of photography flourished in the United States during the Great Depression, when government-sponsored news stories and magazine reports featured photographs commissioned from Walker Evans, Dorothea Lange, and many others. Since that time, there has been greater awareness about the conflicts inherent in the documentary impulse: the photograph may be more of a sociological illustration than an autonomous artistic statement;

Duane Michals

PLATE 51 *A Letter from My Father*
1975
Gelatin silver print
with text
4¹³⁄₁₆ × 7¹⁄₁₆ inches
Edition 3/25
Museum of Fine Arts,
Boston, Sophie M.
Friedman Fund

it may exploit the subject and skew the visual evidence in order to "capture" a desired truth. Mindful of these dangers, in 1977 Jim Goldberg embarked on a social project involving casual portraits and words; after eight years he published the results as a book, *Rich and Poor* (Plates 52 and 53). Goldberg examined two sectors of San Francisco's population in which he felt himself to be an outsider: the impoverished residents of "transient hotels" and the wealthy circle he met by talking to people from the Board of Trustees of his art school. As part of the project, he asked his sitters to write about themselves on his photographs. Goldberg hoped to uncover "an added dimension, a deeper truth" concerning his subjects, although his ultimate goal was to spark his audience into confronting the abuse of power engendered by consumer capitalism: "Instead of accepting the idea that we are powerless victims, we need to become strategists in constructing more visionary tales for others and ourselves."[69]

Goldberg's photograph of a father and a son in a squalid room is accompanied by the father's admission that he is "rough" and the boy is "fragile." On a second photograph of this same family, the mother wrote, "Poverty sucks, but it brings us together," and on a third she stated that her skinny little boy "always seems to take an amused, philosophical approach to life. He is the kind of son that every mother wishes she had." The wealthy take up the second half of *Rich and Poor*. In one portrait of a prettily coiffed and outfitted girl, the father confesses that he is intrigued by her child-star "sophistication." Although the child's confidence suggests that she is the indulged little princess of this spacious toy-filled realm, the father feigns surprise: "We haven't done anything to promote it, but she seems to think that she is Shirley Temple." In an endorsement printed on the back cover of *Rich and Poor*, performance artist Spaulding Gray noted: "The subjects' personal statements are a beautiful found poetry from everyday life. . . . [These words and Goldberg's pictures] make for a wonderful blend of heart and eye, reminding us once again that the personal is the political." Bill Owens's 1973 *Suburbia* project (see Plate 8) was important in signaling a renewed interest in social documentary; Goldberg's *Rich and Poor* upped the ante by having the subjects speak and write for themselves.

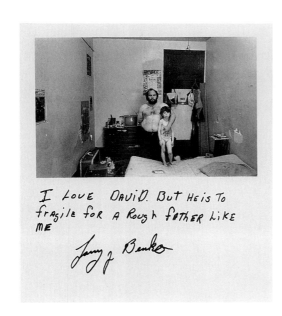

Jim Goldberg

PLATE 52 *I love David. But he is to[o] fragile for a rough father like me.*
1982
Published in *Rich and Poor*, 1985
Gelatin silver print
13⅞ × 10¹³⁄₁₆ inches
Museum of Fine Arts, Boston,
A. Shuman Collection

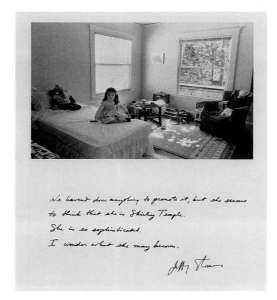

Jim Goldberg

PLATE 53 *We haven't done anything to promote it, but she seems to think that she is Shirley Temple. She is so sophisticated. I wonder what she may become.*
1982
Published in *Rich and Poor*, 1985
Gelatin silver print
14 × 10¹³⁄₁₆ inches
Museum of Fine Arts, Boston,
A. Shuman Collection

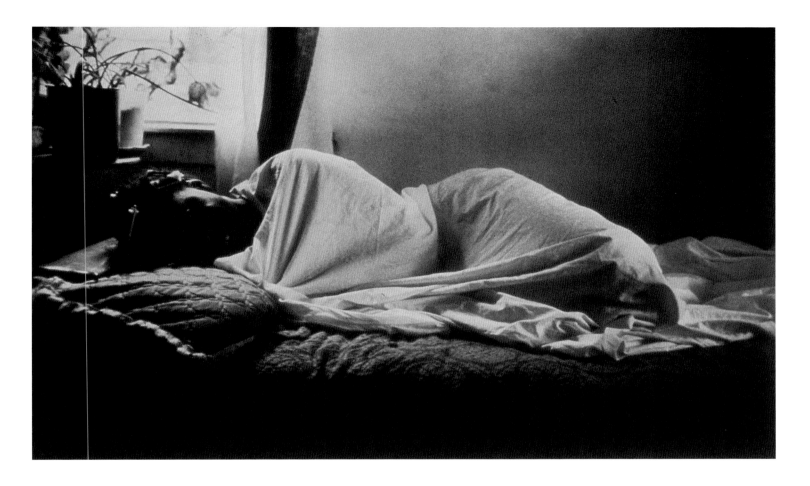

Carrie Mae Weems

PLATE 54 *Alice on Bed,* from *Family Pictures and Stories*
1978–84
Gelatin silver print and text
8½ × 13 inches
Courtesy of the artist and
PPOW Gallery, New York

Alice is the oldest and as the oldest—when momma wasn't home—
cooked our food, washed our clothes and us, cleaned the house,
when necessary even whipped our behinds. She's a no jive kinda
woman, taking no slack from nobody for no reason. And the thing
I like about her is her profound commitment to family. Girl will do
whatever to hold it together. Tough cookie.

Created during the same period as Goldberg's *Rich and Poor,* Carrie Mae Weems's *Family Pictures and Stories* also combines documentary-style portrait photographs and texts. There are, however, several key differences: Weems chose subjects she had known intimately all her life (her family in Portland, Oregon); she wrote the texts as a first-person narrative; she gave her words a conventional, formal presence by having them typeset as captions; and she made audiotapes of conversations with family members for those occasions when the entire project is presented as an installation piece. The artist has noted that *Family Pictures and Stories* came about to some extent as a reaction to the Moynihan Report of 1965, a government study titled *The Negro Family: The Case for National Action.* In particular, Weems wanted to counter the report's criticism of households headed by women and its tendency to blame "broken homes" rather than to see them as symptoms of a larger national failing.[70] Thus, in the text that accompanies the beautiful photograph *Alice on Bed* (Plate 54), Weems makes this comment about her oldest sister: "And the thing I like about her is her profound commitment to family. Girl will do whatever to hold it together. Tough cookie." Her informal image of a tired woman taking a nap, combined with her written opinion, constitutes a piece of "real" family evidence that contradicts the oppressively official conclusions of a government report.

Weems builds up complicated portrayals of her parents in *Family Pictures and Stories,* including depictions of each of them at work (Plates 55 and 56). She captures the friendliness

Carrie Mae Weems

PLATE 55 *Daddy at Work,* from *Family Pictures and Stories*
1978–84
Two gelatin silver prints and text
Each 8½ × 13 inches
Courtesy of the artist and PPOW Gallery, New York

Daddy worked in a hide-house; packing, lifting, sorting cow-hides; for as long as I can remember. Pat, his boss, while grinning and slapping dad on the back, tells, "I gave your dad his first job. Didn't I, Speedy? Your dad started working for me when he first come to Portland. What year was it— '51–'52! Been with me a long time; wouldn't know what to do without him. And I remember when you was just knee high. Now look at you, all grown and a woman." Daddy makes $6.00 per hour.

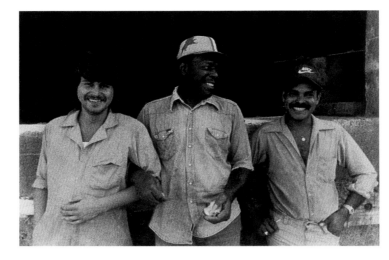

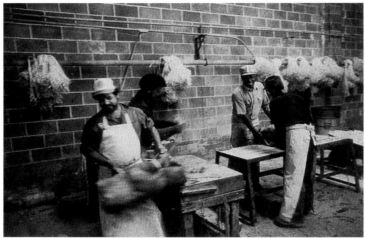

Carrie Mae Weems

PLATE 56 *Mom at Work,* from *Family Pictures and Stories*
1978–84
Gelatin silver print
24 × 36 inches
Courtesy of the artist and PPOW Gallery, New York

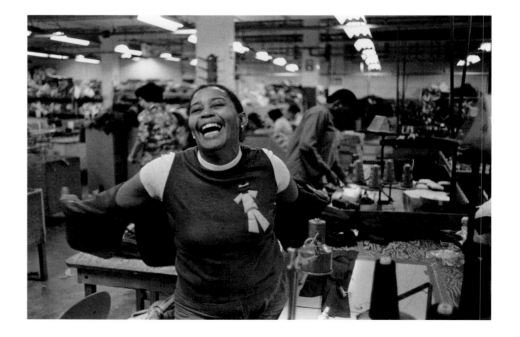

Carrie Mae Weems

PLATE 57 *Dad and Me,* from *Family Pictures and Stories*
1978–84
Gelatin silver print and text
13 × 8½ inches
Courtesy of the artist and PPOW Gallery, New York

Daddy and I have a special thing going, and to this day I use his lap as my private domain. He says, "See Carrie Mae, what I like about you is you can talk that talk to them white folks, and you's smart too, just like your daddy."

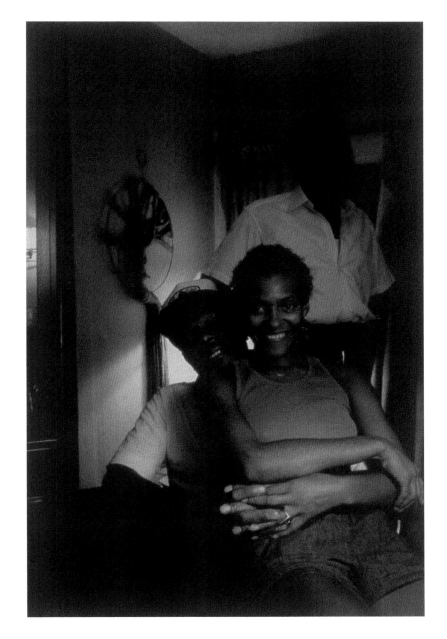

they both enjoy with their coworkers, and stresses the good humor and closeness that is part of her own relationship with her father (Plate 57). Her text for this work states: "Daddy and I have a special thing going, and to this day I use his lap as my private domain. He says, 'See Carrie Mae, what I like about you is you can talk that talk to them white folks, and you's smart too, just like your daddy.'" Mindful that photographs can say different things to different people, Weems uses plainspoken personal words to accompany her straightforward family images. The results recall a photo album that has been given a special extra dimension thanks to the lively voice of the most artistic and politicized member in the family.

In the exhibition and book *Pictures from Home,* Larry Sultan extends the documentary tradition by presenting his findings in the transparent manner of a working journal. Sultan recorded the opinions of the subjects—his aging parents—as he proceeded. He also mixed in his own reactions. The visual materials combine images from old family albums and home movies with new, deliberately staged photographs of the elderly couple enacting archetypal scenes from their marriage. For example, the diptych *Thanksgiving Turkey/ Newspaper* (Plate 58) includes a large color photograph of each parent and two panels of printed text in which the one expresses little frustrations about the other. These pictures and

Larry Sultan

PLATE 58 *Thanksgiving Turkey/Newspaper,*
from *Pictures from Home*
1992
Two color coupler photographs
and two screen-printed
Plexiglas panels
Each photograph 30 × 36 inches
Corcoran Gallery of Art, gift of
the FRIENDS of the Corcoran
Gallery of Art

It's just the day to day stuff that builds
up over time. We're talking over fifty
years. We never, or I should say rarely,
ever argue. We have really nothing to
argue about—never about finances, or
work, or you guys. Never about what
to do or where to go. But she does me
a great disservice on occasion; she
fails to remember that she is my best
friend, that she is the one I talk to and
share the most with. The truth is, that
trust is a fragile thing and can easily
be broken. Our problems begin so
trivially, but my anger builds so damn
fast that it would take a fire hose to
put it out.

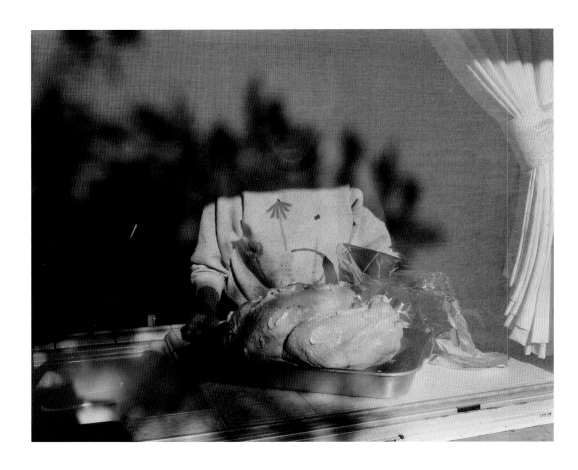

Those newspapers of his drive me crazy. The big investor. I don't think he even reads them. If he kept them in his study that would be fine, but they are all over the dining room table and the living room table and the kitchen counter. They are stacked on the floor by the bed, on the stool in the kitchen, and the living room chair. Do you know we eat on those newspapers? They have become our dining mats. I'm serious. We have this big house and with you kids gone all we have are empty bedrooms. We have no family left. Now it's a house filled with newspapers.

Birth Certificate, 1962 During the fight, her mother threw her birth certificate at her.
This is how she found out her real father's name.

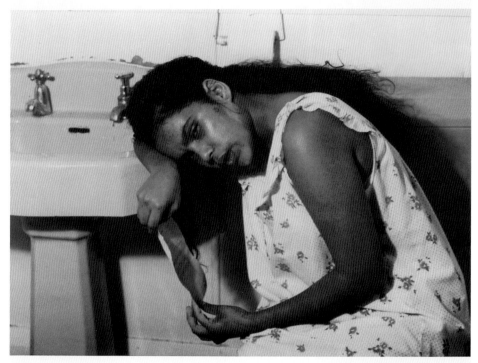

Tracey Moffatt

Tracey Moffatt

PLATE 59 *Birth Certificate, 1962,*
from the *Scarred for
Life* portfolio
1994
Photolithograph
31½ × 23½ inches
Museum of Fine Arts,
Boston, gift of Diego
Cortez in memory
of Harry Brams

their texts manifest several iconic family situations: Thanks-giving as a national family gathering; a father hidden behind his newspaper; a mother in her role as cook; their child, the artist, anxious to better understand his parents through pho-tography and conversation.

Sultan conceived the *Pictures from Home* project during a visit to his parents in Los Angeles in 1982: "One night, instead of renting a videotape, we pulled out the box of home movies that none of us had seen in years. Sitting in the living room, we watched thirty years of folktales—epic celebrations of the family. They were remarkable, more like a record of hopes and fantasies than of actual events. It was as if my parents had pro-jected their dreams onto film emulsion. I was in my mid-thirties and longing for the intimacy, security, and comfort that I asso-ciated with home. But whose home? Which version of family? . . . These were the Reagan years, when the image and the institution of the family were being used as an inspirational symbol by resurgent conservatives. I wanted to puncture this mythology of the family and to show what happens when we

are driven by images of success. I was willing to use my family to prove a point. . . . [But beyond my own project] is the wish to take photography literally. To stop time. I want my parents to live forever."[71] Sultan's commitment to detailing this relation-ship involved remarkable vulnerability on his part, as when, for example, his father expressed complaints such as this: "All I know is that you [Larry] have some stake in making us look older and more despairing than we feel. I really don't know what you are trying to get at."[72]

Often drawing on childhood and adolescent experiences, Australian filmmaker and photographer Tracey Moffatt exam-ines power relations in a variety of family structures: mothers and daughters, Aborigines and Australian whites, and women and men. In treating these difficult subjects she often factors in a little buoyancy via humor, irreverence, and pop culture style.[73] In 1994 Moffatt produced *Scarred for Life,* a portfolio of nine prints combining photographs and texts (Plates 59 and 60). The title has a pulp fiction ring to it, and the individual sheets mimic a particular kind of magazine feature from the

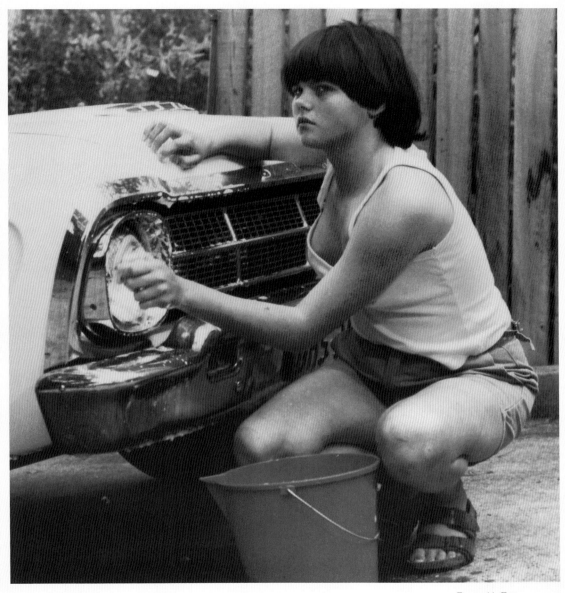

Tracey Moffatt

Useless, 1974

Her father's nickname for her was '*useless*'.

Tracey Moffatt

PLATE 60 *Useless, 1974,* from the
Scarred for Life portfolio
1994
Photolithograph
31½ × 23½ inches
Museum of Fine Arts,
Boston, gift of Diego
Cortez in memory
of Harry Brams

Glenn Ligon

PLATE 61 *The Letter B
(version 1), #1*
2000
Flashe paint and
silkscreen on
primed canvas
48 × 36 inches
Courtesy of the
artist and D'Amelio
Terras Gallery,
New York

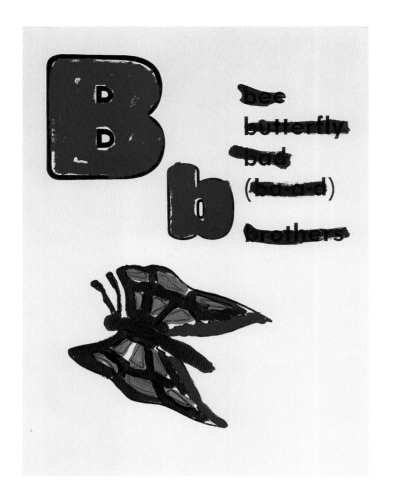

1960s. Moffatt staged the "everyday" photographs and wrote the terse captions inspired by true stories. In her efforts to replicate the feel of old copies of *Life* magazine, she chose thin paper, washed-out colors, and a "drab layout."[74]

Using artifice in *Scarred for Life,* Moffatt re-creates reality in order to confront human failings. Though some of the prints have the bitter ring of sick humor, the project as a whole nails the ways in which ethnicity, class, and gender all complicate the painfulness of family deceptions (Plate 59) and cheap jokes (Plate 60). According to the artist: "A person can make a passing comment to you when you are young and this can change you forever. You can be 'scarred for life,' but this isn't necessarily a bad thing. The photographs can be read as both tragic and comic—there is a thin line between both. . . . In whatever 'family' version you are born into, be it with blood family or adopted family or whatever is the first world we ever know, it's a battle from the second we open our baby eyes. This is a part of the wonderful hideous fabric of life, and it is why we are what we are. But you can't blame your family for a damn thing, better still you have to thank them with all your heart."[75]

Glenn Ligon frequently incorporates "found" words into his art. For a group of paintings made in 1990, he selected short phrases from a 1928 essay by Zora Neale Hurston and repeated each one on a given canvas until the tall, white background was filled with a solid block of black stenciled text. One canvas repeats the phrase, "I do not always feel colored"; another proclaims, "I feel most colored when I am thrown against a sharp white background." Ligon explores the roles of position and perspective in shaping an individual's views about race. Thus, growing up in a one-color community differs significantly from living in a mixed neighborhood, and moving between these worlds changes one's perception of self.

In a recent group of paintings, Ligon refers to images from black-themed American coloring books published in the early 1970s. Whereas illustrated children's books show relationships between words and images, coloring books provide the opportunity for direct personal experience, and manipulation, of these relationships. Ligon's *The Letter B (version 1), #1* (Plate 61) is based on a coloring-book page that mixes some ordinary "b" words ("bee" and "bad") with other examples

Glenn Ligon

Dad (version 1), #1
2000
Oil crayon and silk-
screen on primed
canvas
48 × 36 inches
Courtesy of the
artist and D'Amelio
Terras Gallery,
New York

that reflect a black vernacular (''ba-a-d'' and ''brothers''). Moreover, two words in this picture allude to the famous maxim of boxer Muhammad Ali: ''Float like a butterfly, sting like a bee.'' Ligon began this project when he was an artist-in-residence at the Walker Art Center in Minneapolis; after discovering the old coloring books, he photocopied some of the pages and took them to coloring sessions at daycare centers in the Twin Cities. He later made his own large paintings based directly on the coloring the children had done on their sheets. In the case of *The Letter B,* the profusion of blue fits with the ''b'' theme; it also evokes the African American blues legacy, although the child who colored the original drawing was probably too young to have intended that reference. *Dad (version 1), #1* (Plate 62) is an intriguing work because the child who did the coloring made the adult a rich brown and the youngster a gaudy pink. Was this simply a response to a black man (Ligon) joining the coloring class? Did it reflect the experience of a child whose father's skin is darker than his or her own? Was there a preference for one color?

Ligon's ''Coloring'' project revisits the liberationist moment when African Americans asserted a sense of self-worth and beauty in politics, popular culture, and the classroom. His pictures reveal the various family threads united by that movement. Thus, he recently observed, ''Any representation of a black person, from Malcolm X to a boy swinging on a tire, was supposed to be inspiring because it meant that our histories, stories, and heroes mattered. Just seeing an image of something that hadn't been depicted before [in children's books] was a revolution. There was immense social upheaval behind the creation of those coloring books; they weren't just about giving kids something to do to pass the time.''[76] The white background of these pictures serves as Ligon's metaphorical benchmark for color and coloring; it is worth noting that one of his early text-based paintings repeated the phrase, ''We are the ink that gives the white page a meaning.'' He also indicates that this project gave him new perspectives on the delight children bring to their creative expressions: ''I have gotten a lot of pleasure trying to make something as inventive, sensual, and satisfying as a child's drawing, but there is also something inherently melancholic in the act of copying, in the attempt to

SELL THE
HOUSE S
ELL THE C
AR SELL
THE KIDS

keep the spirit of childhood endlessly alive by trying to reproduce it. . . . What I have done is meet the kids' drawings and the images on the coloring-book pages halfway. They are not 'mine' and they are not 'not mine.' "[77]

Chris Wool's painting on paper *Apocalypse Now* (Plate 63) is verbally brusque and visually hard-hitting. Made in New York City in 1988, the work was inspired by Francis Ford Coppola's 1979 movie of the same name, set in Vietnam in the late 1960s. That, in turn, was based on a short novel from 1902, *Heart of Darkness,* for which British writer Joseph Conrad drew on his experiences in Belgium's corrupt "Congo Free State" in 1890. The words that provide the composition of Wool's rhythmic black-on-white painting come from a hastily scribbled note shown in close-up in Coppola's movie. It is a letter that an American special agent, who has become unraveled in the course of his assassination mission in Southeast Asia, wanted to send to his wife: "SELL THE HOUSE. SELL THE CAR. SELL THE KIDS. FIND SOMEONE ELSE. FORGET IT! I'M NEVER COMING HOME BACK. FORGET IT!!!" Wool's editing of that message lays bare the underbelly of the American Dream. Painted in the late 1980s, his picture may reflect the despair that many individuals felt at the height of the Reagan-Bush era, when the United States struggled through the Iran-Contra affair, the AIDS epidemic,

a "war on drugs," and an economy skewed by insider trading. More generally, it captures the hopelessness of any person who feels cut off from family or society. Viewers must make their own interpretations of Wool's message, in the same way that they have to grapple with the inscriptions in Shirin Neshat's *My Beloved* (see Plate 33). The many viewers who cannot read the Farsi script on Neshat's photographs can only engage with its abstract, patterned, and decorative aspects. The issue applies to Wool's *Apocalypse Now:* the picture's strident rhythms and urgent delivery create a strong visual statement, independent of one's ability to read the text.

The three remaining works in this section hold an abundance of letters, characters, and words on their surfaces. In scope and ambition they all echo literary forms of expression, although each object differs physically, stylistically, and conceptually from the others. A quilt by Faith Ringgold (Plate 64) narrates a story; a work by Tim Rollins + K.O.S. (Plate 65) displays the last fourteen chapters of a Victorian novel; and a photographic project by Zhang Huan (Plate 66) incorporates a sagalike accumulation of Chinese calligraphy.

Faith Ringgold's *Tar Beach* brings together a written narrative, a painting of a city scene, and a decorative quilt with flowery borders—each made by the artist. Ringgold began to

compose works in this original vein in 1983, calling them story quilts. She comes from a long line of women with a gift for needlework: her mother, Willi Posey, was a dressmaker and designer in New York, and the heritage spans back to Ringgold's great-great-grandmother, Susie Shannon, a slave who made quilts as part of her "house girl" duties on a plantation. These assemblages are a sophisticated vehicle for Ringgold's commitment to African American and feminist concerns, which have contributed to her artistic voice since the late 1960s. As the artist observed in 1986, "In making quilts I am able to communicate ideas I would not be able to communicate in any other way. They are a platform for mixing art and ideas so that neither suffers."[78]

Tar Beach is a story of childhood told by a certain Cassie Louise Lightfoot. It recalls the delights of rooftop family dinners on warm summer nights while also revealing that the eight-year-old narrator is worried about tensions between her parents. The painting at the center of the quilt offers a lively aerial view of the tar-covered roof and the grand expanse of the George Washington Bridge above the Harlem skyline. Cassie and her little brother, Be Be, lie on a mattress while their parents play cards with a friendly couple from the building next door. The importance of dreams and hopes lies at the heart of this story. Reclining under the stars and the city lights makes Cassie "feel rich, like I owned all that I could see." She especially loves the "sparkling beauty" of the long bridge, which her father helped construct. In fact, she imagines that she can fly over it, claim it, own it, and "wear it like a giant diamond necklace." Cassie says she first learned to do this when "the stars fell down around me and lifted me up." She resolves

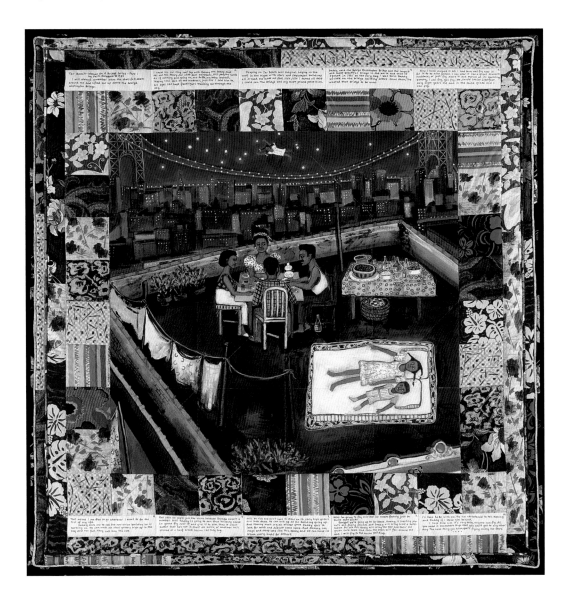

Faith Ringgold

PLATE 64 *Tar Beach,* Part I from the
Woman on a Bridge series
1988
Acrylic on canvas,
bordered with printed,
painted, quilted, and
pieced cloth
74⅝ × 68½ inches
Solomon R. Guggenheim
Museum, New York, gift
of Mr. and Mrs. Gus and
Judith Lieber
(detail next page)

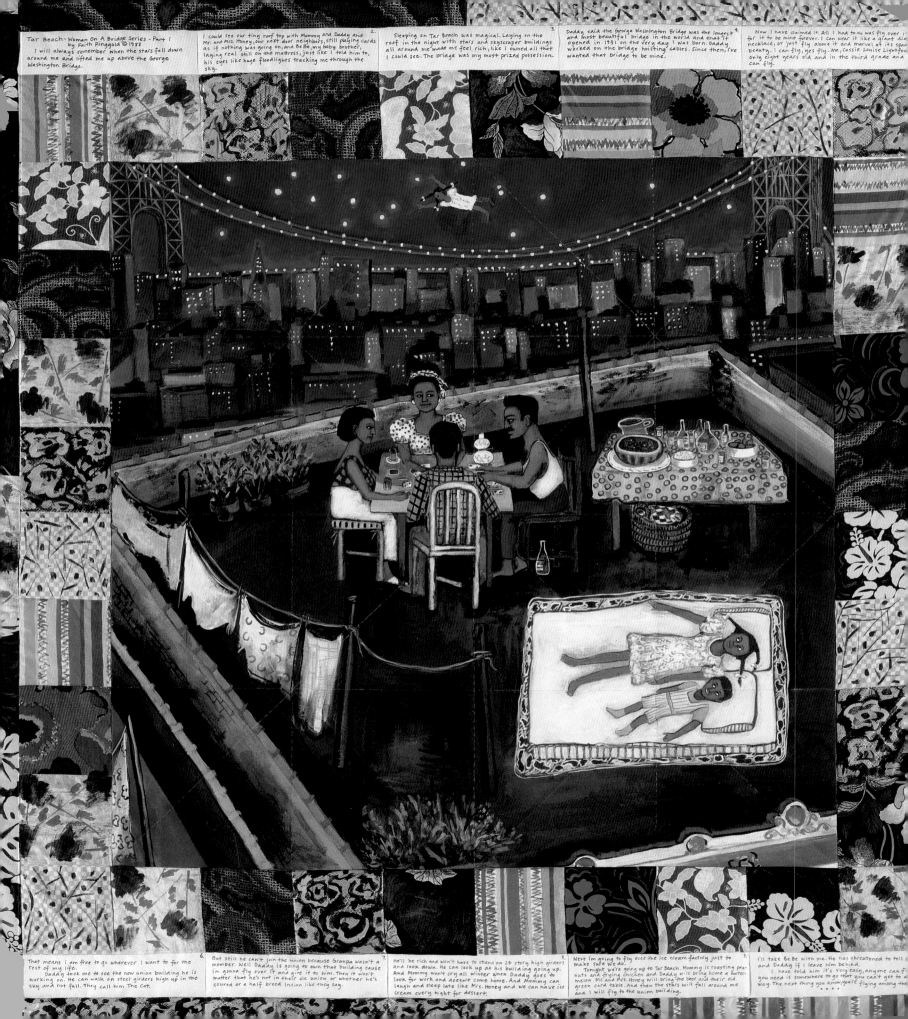

Tim Rollins + K.O.S.

PLATE 65 *The Interior of the Heart*
1987–88
Acrylic, watercolor, and
bistre on book pages
mounted on canvas
90 × 102 inches
Rose Art Museum, Brandeis
University, Waltham, Massa-
chusetts, gift of Sandra and
Gerald Fineberg, Boston

to fly to the union building and give it to her father: "Then it won't matter that he's not in their ole union or whether he's colored or a half-breed like they say." And she teaches her brother the power of dreaming: "Anyone can fly. All you need is somewhere to go that you can't get to any other way. The next thing you know, you're flying among the stars." In 1991 Ringgold used photographs of various sections of *Tar Beach* to make a children's book; deftly juxtaposing them with the quilt's ten panels of text, she produced a very successful publication.

In 1982 Tim Rollins, a twenty-seven-year-old teacher in the Special Education department of a junior high school in New York's South Bronx, decided to invite some of his troubled and disadvantaged students to collaborate with him in making art. The shifting roster of teenage pupils calls itself Kids of Survival, and the collective is known as Tim Rollins + K.O.S. After attending art school in New York, Rollins had worked as an assistant to conceptual artist Joseph Kosuth, and in 1979 he was a cofounder of Group Material, an artists' collective whose projects are "dedicated to social communication and political change."[79] Rollins's work with K.O.S. always develops from materials that the group has read and discussed—mostly literary classics (including Kafka's *Amerika,* Orwell's *Animal Farm,* and *The Autobiography of Malcolm X*) and occasionally politically resonant comics such as *The X-Men.* The pages of the books they study usually become a physical part of their paintings. For example, the last one hundred and forty pages of Hawthorne's 1850 novel *The Scarlet Letter* were glued onto

canvas to create the grid and ground of *The Interior of the Heart* (Plate 65).

Rollins + K.O.S. develop visual elements that symbolically reflect the themes and concerns of the given text. In the case of Hawthorne's story, set in early Puritan Boston, it is "the letter A, in scarlet, fantastically embroidered with gold-thread" that Hester Prynne must wear "upon her bosom."[80] Hester is an attractive, compassionate single mother who refuses to name the man she slept with. Hawthorne pointedly notes that, whereas the Puritan community reads and reviles her beauty as an outward sign of innate sinfulness, a "Papist" would have been reminded of the Madonna and Child when confronted by Hester and her baby; the attractive pair recalls "the image of Divine Maternity, which so many illustrious painters have vied with one another to paint."[81] D.H. Lawrence, the modernist author who crusaded heartily against Victorian propriety and repression, was a fan of this book: "[It] isn't a pleasant, pretty romance. It is a sort of parable, an earthly story with a hellish meaning. . . . No other book of Nathaniel Hawthorne is so deep, so dual, so complete as *The Scarlet Letter:* this great allegory of the triumph of sin."[82]

In 1988 Rollins spoke eloquently about the relevance of this text to the Kids of Survival: "Just as Hester is wrongly condemned to a life of poverty and silence, so is the South Bronx, and too many of its individuals. The kids are really into signifying and identity. This is the major impetus behind graffiti—this verifying of an identity in a hostile, leveling environment. And so, our *Scarlet Letter* is about taking an unjust stigma and

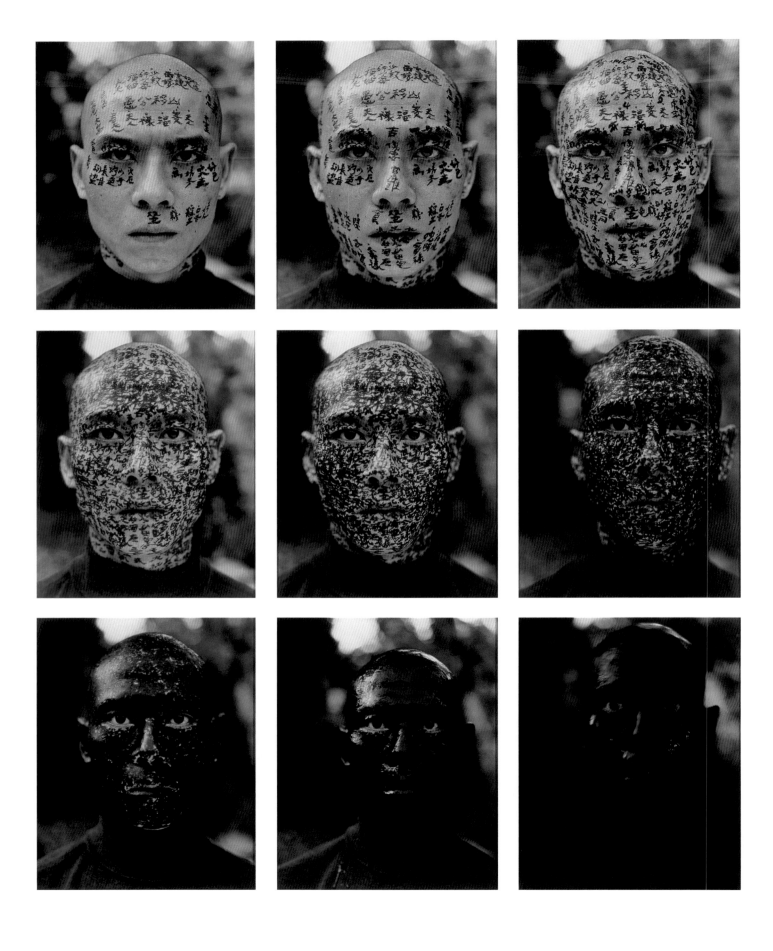

Zhang Huan

Family Tree
2001
Nine color photographs
Each 50 × 40 inches
Collection of Martin Z.
Margulies, Miami

turning it into a transcendent emblem of pride. As in all of our works, we take our interpretations and offer them up, just like prayers. Our works are as futile and powerful as prayers."[83] The group's vivid, highly individualized renderings of the letter A recall tattoos and commercial logos in addition to graffiti. When compared to the boldness of the red devices, the grid of book pages is a field of desiccated, Puritanical plainness. In *The Interior of the Heart,* Tim Rollins + K.O.S. realize a simple yet compelling visual effect that inspires us to contemplate this Victorian literary response to early American puritanical moral codes, and then to consider certain conditions of society and family life that prevail today.

Zhang Huan's *Family Tree* (Plate 66), an imposing ensemble of nine photographic self-portraits, symbolically evokes the personal, cultural, and spiritual ties connecting any individual to the community from which he or she emerges. The artist's body serves as a surface on which to gather this collection. Zhang enlisted a fellow artist to paint the inscriptions and hired a photographer to record the process. The first image shows the artist outdoors, with a few Chinese characters generously spaced about his face, shaved scalp, and neck. The calligrapher continued to work until night fell and until Zhang's head and neck had become so blackened by the writing that it was impossible to read any of the characters. *Family Tree* dramatically hints at the complications of Zhang's relationships with his family, fellow citizens, and homeland—complications that his biography confirms. He grew up in a poor worker's family in the countryside of Henan province. He struggled through high school and had to take the entry exams at the local art school three times. His success in traditional European painting styles led him to Beijing's Central Academy, but in 1992 he veered off track and became a radical performance artist. Living in a polluted, low-rent suburb of Beijing, he and his colleagues staged, in his words, "a punk rendition of critical realism," sometimes provoking oppression and censorship from the state.[84] By the beginning of this century, Zhang's work had brought him international attention, and he and his wife, poet Hu Junjun, settled in Queens, New York.

The stories painted on Zhang's skin in *Family Tree* are diverse and not easily summarized. Many of the words and characters deal with broad themes and are resonant with associations: birth and life; good fortune and high rank; robber; heavenly person; parents; and guest. The handful of characters at the center of his forehead says *Yu Gong Yi Shan* (The Fool Moves the Mountain). This phrase, which was popularized by Mao's communist government, encapsulates the story of an old man whom people ridiculed because he wanted to move a mountain; he eventually succeeded because he was dedicated to his goal and moved a little bit of the mountain every day.[85] One might say that a mountain of sayings and stories has been patiently moved onto the artist's face, character by character.

Zhang may have made this work to celebrate the stories and the associations—too abundant to list without losing legibility—that bind him to his culture. His body receives the inscriptions with a ritualistic sense of splendor, as if he is developing a new skin or revealing armor not normally visible. But the images also suggest a process of self-negation: the loss of an external persona to a tarlike covering of writing. And there is irony in a heritage so immense that it renders the individual inconsequential. The progression of these nine images recalls a comment the artist made about one of his performance works, namely, that the achievements of any one person are "absurd and pointless" when compared with the vastness of history and the immensity of the universe.[86] In the same statement he noted his interest in ancient Chinese philosophy: "There are higher mountains beyond mountains, and there are more capable men besides us. People in our modern times are inconsequential when facing the universe, nature, and death, and [they] do too much thinking without producing anything meaningful." Zhang seems to make a Buddhist gesture of prostration through the pictures and the words of *Family Tree.*

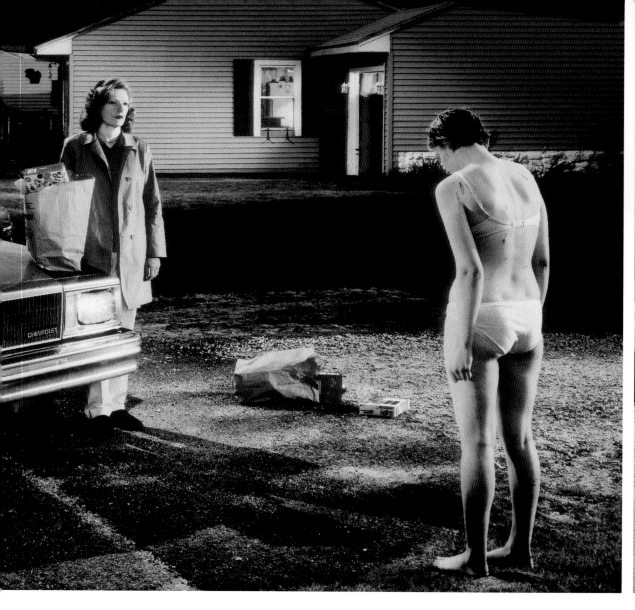

details of Plates 70 and 65

allegorical expressions

The Western tradition of allegory, derived from the philosophical thinking of the Classical era, gives visibility and liveliness to abstract ideas. By the seventeenth century, allegory had evolved into a genre that allowed artists to use one image or subject to make a different, more complex secondary statement. A figure and its decorative attributes might personify a season, a country, a virtue, or a vice. A carefully staged scene from everyday life might harbor a veiled political commentary or a moral warning. Allegory began to decline in the late eighteenth century, when rationalist, positivist, and modernist thinkers shunned it as an old-fashioned, arbitrary, and overly literary pursuit. Its lowest ebb came in the mid-twentieth century, during the heyday of modernist abstraction. In recent decades the resurgence of figurative art and the rise of cultural self-consciousness, via pluralism and postmodernism, have created a climate favorable to allegorical expressions, particularly ambivalent or open-ended examples. Thus Sidney Goodman's painting, *Figures in a Landscape* (see Plate 30) can be enjoyed simply as a realistic depiction, or more rewardingly, as an allegory of the unhappy family or the landscape of mental isolation. Although the works considered below are not allegories in the traditional sense, they exemplify the genre's commitment to the sophisticated exploration of ideas that are not explicit in a given image.

In his spare still-life painting titled *Family Group* (Plate 67), Paul Cadmus embraces tradition in several ways. He exhibits his lifelong adherence to the academic practices codified during the Renaissance, which is underscored by the use of the venerable and exacting medium of tempera. Although Cadmus's metaphorical transformation of commonplace objects is mindful of Surrealism (in particular the paintings of René Magritte), it is equally indebted to two sixteenth-century masters of the bizarre, Hieronymus Bosch and Giuseppe Arcimboldo. However, *Family Group* is first and foremost a commentary on modern life. By envisioning a father, a mother, and a squawking child as an acrid group of color-coded toiletry products, Cadmus invites viewers to contemplate the gender stereotyping, the conformity, and the cult of consumerism that prevailed in America in the 1950s and early 1960s. Though averse to being labeled, Cadmus acknowledged that sexuality played a role in his work: "I have never hidden my homosexual nature but I care for reticence. Flaubert's rule for artists: 'Be regular and ordinary in your life, like a bourgeois, so that you can be violent and original in your work. My . . . [version is]: 'Be reticent in your life so that you can be outspoken in your work.'"[87] *Family Group* may look whimsical, but it harbors sharp satire. Cadmus's goal as an artist was to expose "malignity" for the greater moral good: "We are still open and susceptible to attacks upon our foibles and even upon our so-called fundamental baseness."[88]

Richard Cleaver's sculptures are hand-built ceramic objects in which orderly forms are encrusted with mesmerizing details, including painted imagery, gilding, pearls, and beads. Typically, a glistening shrinelike structure inspires the viewer

Paul Cadmus

PLATE 67 *Family Group*
1964
Egg tempera on
Whitman board
14¾ × 19¾ inches
Modern Art
Museum of Fort
Worth, gift of the
American Academy
of Arts and Letters,
Childe Hassam
Fund

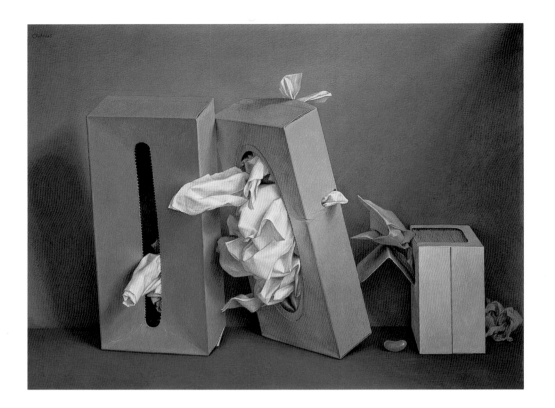

to explore a wealth of clues concerning a veiled story or scenario: ''Much of my imagery is developed out of the subconscious, therefore interpretations are very welcome, and never wrong.''[89] *House on Fire* (Plate 68) is from a group of works called ''Biographical Icons,'' in which Cleaver muses about landmarks in his own life and the lives of his family. This sculpture, for example, ''was inspired by a mortgage-burning party given by my parents in 1984, celebrating the end of twenty years of monthly payments. . . . I am commenting on

the inherited suburban values of the post–World War II years. My parents regrettably sacrificed personal needs in order to do the 'the right thing.' . . . The family is being engulfed by trees and roots symbolizing fertility and growth (the pearls are seeds or tears).''[90] Cleaver portrays his parents when the mortgage began, accompanied by two idealized, sleeping children. The faces of his father and his mother are hinged, and they open to reveal the same subjects aged by twenty years. The dramatically engulfed family conveys Cleaver's sense that

Richard Cleaver

PLATE 68 *House on Fire*
1998
Ceramic, wood,
freshwater pearls,
glass beads, 22K gold
leaf, oil paint
30 × 24 ×13 inches
Collection of Martha L.
Kearsley
(alternate view on left)

1964~1984

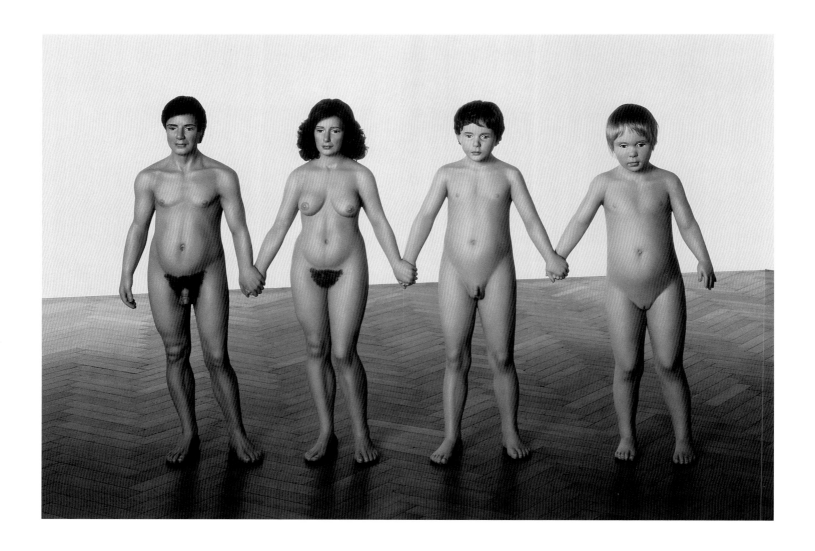

Charles Ray

PLATE 69 *Family Romance*
1993
Mixed media
54 × 85 × 11 inches
Collection of Eileen
and Peter Norton,
Santa Monica

these domestic circumstances involved both joyful fertility and a strained sense of entrapment. Thus *House on Fire* may be read as both an allegory of time and an allegory about the choices people make in their lives.

For his sculpture *Family Romance* (Plate 69), Charles Ray produced a set of anatomically correct but inappropriately scaled mannequins. These shrunken adults and oversized kids stand together, naked, bewigged, holding hands, and apparently lost in thought. Ray's effort to equalize the respective heights of each member of this well-fed, sensible-looking,

white nuclear family teeters between the uncanny and the ludicrous. His "romance" invites numerous imaginative readings, from the dynamics of power within the nuclear family to the various technologies that can now manipulate "reality" for pleasure and profit. Ray's people might be harmless characters in a comical and absurd product of the entertainment industry (there was, after all, the 1989 movie from Disney Studios, *Honey, I Shrunk the Kids*). Alternatively, they might be a freaky, fantastical foretelling of cloned or genetically engineered specimens. Ray got the idea for this sculpture while visiting Forest Lawn

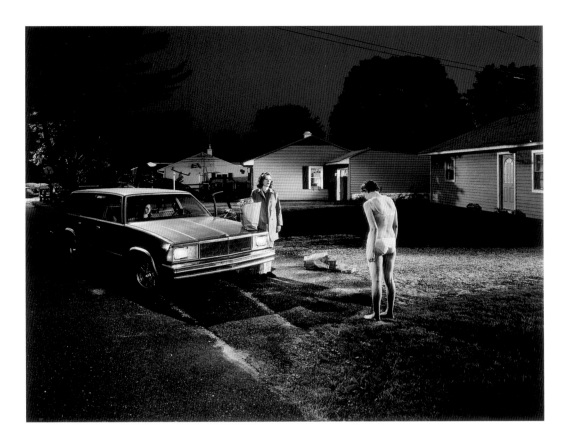

Gregory Crewdson

PLATE 70 *Untitled (penitent girl)*,
from the *Twilight* series
2002
Digital Chromogenic
Fujicolor Crystal Archive
print mounted on aluminum
48 × 60 inches
Collection of Ann and
Steven Ames

Cemetery in his native Los Angeles. He was struck by two sculptures that happened to be near each other: one showed a woman on a globe, the other a baby on a globe; and although these had been made by different artists at different times, they were similar in scale and composition.[91]

It was a feat of ingenuity on Ray's part to calibrate the bodies in *Family Romance* so that they might hold hands convincingly. By forcing an explicit equality among the members of this family, the artist draws attention to the inequalities that typically prevail between parents and children, spouses, and siblings. Moreover, the facial expression and body language of each project the same bland feeling of mental detachment. Ray seems to have programmed them to withstand the stares of the public, knowing that they will challenge and confuse each viewer's sense of his or her own body. It is worth noting the deliberately boring and generic aspects of the nudity, especially in light of the cultural milieu of the early 1990s, when nudity and artistic freedom were targets for conservatives. In the United States, for example, right-wing lobbyists convinced the government to drastically diminish funding for the arts. With hindsight, we can imagine Ray's *Family Romance* as symbolizing that particular battle, which played out on the fields

of a mythical middle-America, whose "family values" had suddenly become political fodder.

Gregory Crewdson's recent photograph *Untitled (penitent girl)* (Plate 70) in some respects evokes the reality that Charles Ray radically subverted in *Family Romance*. A mother is confronting a scantily clad daughter, who, judging by the grass clippings on her back, has been "up to no good." Ironically, the compositional perspective makes the figure of the girl loom larger than that of her parent, even as she hangs her head in submission. Various incidental details embellish the picture's undercurrents of wrongdoing and penitence: a second girl witnesses the scene from inside the car; the mother has dropped a bag of groceries that includes a box of Life cereal; the episode occurs in full view of the neighboring houses; and beams of light (car headlights on the left side and an unidentified source on the right) fix the penitent in her place. The photograph is from Crewdson's *Twilight* series, large-scale narrative works devoted to that window of time when daylight recedes and the ordinary becomes subject to strange, magical transformations. The artist heightened the effects of the natural settings in which these pictures were made, particularly through the manipulation of artificial light, deftly introducing eerie notes

John O'Reilly

PLATE 71 *Eakins' Student as Balthazar Carlos* 1996 Polaroid montage 6⅞ × 5⁵⁄₁₆ inches Collection of the artist

into the reassuringly banal realm of suburbia. Here, the careful orchestration of multiple sources of light conjures up a paranormal luminosity: it may be that the mother has more to worry about than the girl's behavior.

Crewdson generally makes pictures that hint lavishly at narrative while resisting any resolution. He recently observed: "We just know in one way or another the images are disruptive or transforming."[92] Several critics have made note of the fact that Crewdson's father was a Freudian psychologist who saw his patients at an office in their Brooklyn home. Thus, the odd conjunction of everyday domesticity and the subconscious dream worlds of strangers is a thread running from the artist's early family life to his adult work. The novelist Rick Moody made this comment about Crewdson's origins: "A childhood of overhearing the dreams of his neighbors had already made

the actual magical, made the space of the urban and the suburban into an unearthly and terrifying arena of possibility."[93] For all its exquisitely staged, quasi-Hollywood narrative perfection, the scene in *Untitled (penitent girl)* hovers between fact and fiction, frozen in time. It is an artistic distillation of the episodes of shock, shame, humiliation, and anger that families usually experience as teenagers become adults and parents grapple with the consequences of their children growing up.

John O'Reilly's small, exactingly crafted photomontages constitute a set of experiences that would be impossible in reality. Trained in painting in the 1950s, O'Reilly worked as an art therapist at Worcester State Hospital, in Massachusetts, from 1964 to 1991. By combining details cut from his own photographs with details of reproductions of art-historical landmarks, O'Reilly seeks to resolve the real and the ideal: he

John O'Reilly

PLATE 72 *With Whitman*
1981
Tinted photograph
and halftone
montage
4⅞ × 5⅛ inches
Courtesy of the
artist and Howard
Yezerski Gallery,
Boston

assuages the difficulty of life with the quasi-religious comfort he derives from art. In a recent interview he observed: "Great art is for me as an adult what [the Catholic] religion was to me as a child. It is full of love and solace; it is full of fear and anger. . . . The beauty I know of religious experience is pitted against the anger I feel about religious hypocrisy and denial."[94] His photomontages often feature self-portraits as a metaphorical means to personalize the subject matter, and even when that is not the case, his own experiences inform the work. For example, O'Reilly thinks that he made *Eakins' Student as Balthazar Carlos* (Plate 71) as a subconscious response to his relationship with his divorced parents and certain medical anxieties from his past. The image of the reclining nude reproduces a photograph taken by the American artist Thomas Eakins around 1884; the people above him are King Philip IV of Spain and his new young Queen, Mariana of Austria, shown as they are reflected in a mirror in Velázquez's enigmatic painting *Las Meninas* (c. 1656, Prado Museum). O'Reilly, who is tall and thin, relates to the lonely young man, whose draped, tomblike space is dwarfed by the ghostly couple. He recalls an instance in the early 1960s when he had to have a risky emergency operation: although his parents traveled to visit him while the operation was underway, they were not able to stay

until he regained consciousness; O'Reilly's only contact with them was the note they left for him. The eerie, funereal air of *Eakins' Student as Balthazar Carlos* encompasses an intriguing network of associations between O'Reilly's family experiences and the people in his picture. His title transforms Eakins's student into Philip IV's son, who died in his teens (the late prince's bedroom would become the studio where Velázquez painted *Las Meninas*). Melding seventeenth-century and nineteenth-century images into his own art, O'Reilly invents a transcendent image of a son who is both dominated by his parents and isolated from them.

When O'Reilly features a self-portrait in his work, he is building his own world and choosing his own family. This is particularly evident in *With Whitman* (Plate 72), in which the artist imagines spending time with the most innovative and controversial American poet of the Victorian period. Whitman, who died in 1892, looks craggy and magisterial, while O'Reilly is slightly nervous. The beatific young woman in a painting by Jean-Baptiste-Camille Corot appears to watch over them. Whitman's artistic and personal commitment to being a "simple separate person" within a true democracy was a tremendous inspiration throughout the twentieth century: his progressive humanitarianism motivated labor reform, radical poetry, and

Charles LeDray

PLATE 73 *Family*
1985–88
Fabric, thread,
leather, ribbon,
buttons, embroidery
floss, horsehair, shirt
label
11½ × 8¼ × 7 inches
Private collection,
Courtesy of Sperone
Westwater Gallery,
New York

many aspects of 1960s liberalism, including sexual freedom and gay liberation. O'Reilly's audience with Whitman has the serious air of revelation or confession. The fact that the artist is shirtless signals informality and intimacy, underscoring Whitman's iconic status as a champion of closeness between men.

If one encountered Charles LeDray's *Family* (Plate 73) outside the confines of the art world, without the benefit of descriptive labels and captions, it would be easy to mistake it for a group of much-used old toys from the Depression era. LeDray had no formal training as an artist, except for two uncompleted classes in drawing and painting at the Cornish School of Art in Seattle in the 1980s. He is now a sculptor known for the technical skill and the emotional sophistication he brings to his handmade miniature objects, which include, for example, a wide array of meticulously hand-sewn men's outfits that measure about ten inches across the shoulders, and a nine-inch music stand carved from human bone.[95] *Family* is one of LeDray's early sculptures, predating his move to New York in 1989. His first works focused on soft toys, particularly teddy bears. They have a poignant air: some seem merely sad, while others, deformed or dismembered, are quite distressing. In 1991 the art critic Jerry Saltz wrote: "Each one is loaded with love, labored over, cared for, but slowly you get the feeling that LeDray has lavished so much attention on these weird

dolls in order to protect them from some awful environment, some concealed fate; that these pygmy sculptures are surrogates for a self which has felt the storm of anger and the hand of violence. . . . LeDray gets the hurt of childhood to live in these voodoo doll sculptures. . . . They're so small and fragile that you know you've got to treat them gently. They're like infants in this way—they inspire that kind of love and protectiveness."[96]

Thus *Family* is an adult's reflection on the dreams and the fantasies of childhood. LeDray alludes to the significance of toys as a means to transcend real situations and escape to longed-for alternative realms. Like the runaways Huck and Jim in Mark Twain's 1884 novel *Adventures of Huckleberry Finn*, LeDray's two bears and their horse escape together. As Twain observed at the age of seventy-one: "It is a pity we cannot escape from life when we are young."[97]

Kerry James Marshall sees himself as a history painter, someone inspired to tell African American history in a manner that parallels the grand nineteenth-century paintings by Jean-Auguste-Dominique Ingres, Eugène Delacroix, and Théodore Géricault. *Souvenir II* (Plate 74) is part of his *Mementos* project: paintings, sculptures, photographs, prints, and a video installation that look back to the Civil Rights movement of the 1960s. The four *Souvenir* paintings are large unstretched canvases that hang freely, like banners or tapestries, and depict

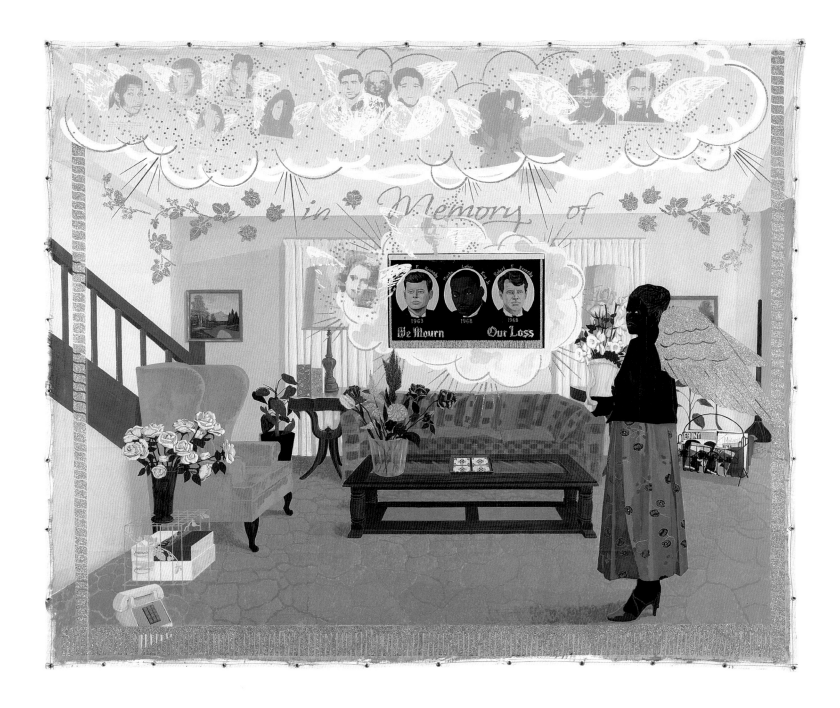

Kerry James Marshall

PLATE 74 *Souvenir II,* from *Mementos*
1997
Acrylic and collage on canvas
108 × 120 inches
Addison Gallery, Phillips
Academy, Andover,
Massachusetts, gift of the
Addison Advisory Council
in honor of John ("Jock") M.
Reynolds's directorship of
the Addison Gallery of
American Art, 1989–1998

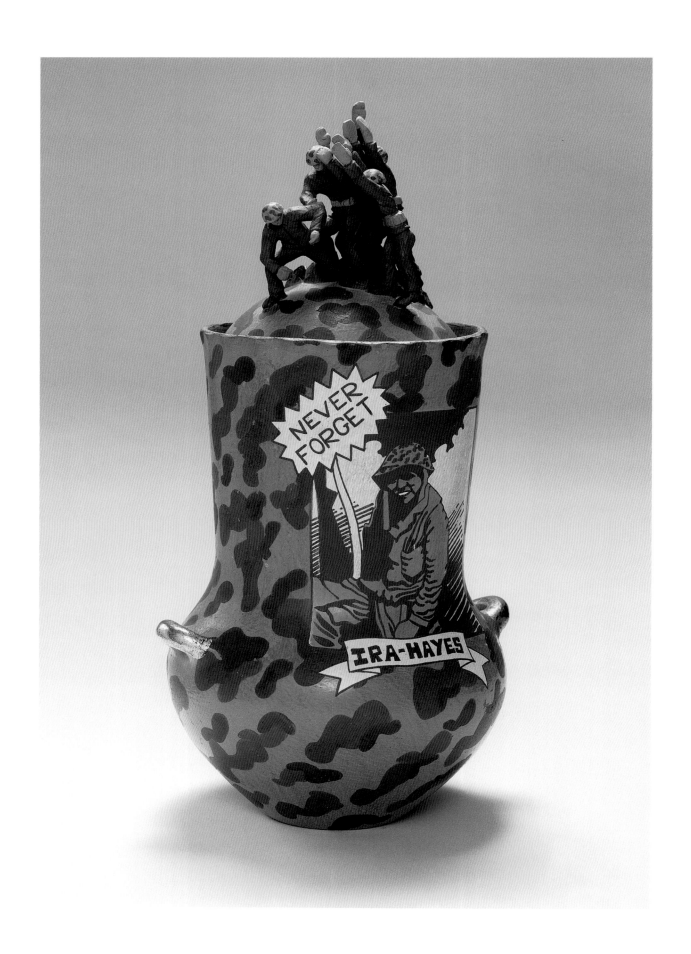

Diego Romero

the living rooms of black families. Marshall transformed each room into a symbolic funeral parlor: two of the pictures honor people who died in the struggle for Civil Rights, and two honor notable African American musicians, writers, and artists who died during the same period. A black angel presides over the scene in each painting, casting a challenging and steady gaze at those who look into her space, politely commanding respect for the solemnity of the occasion. In the living room of *Souvenir II,* a gold-edged banner honoring the late President John F. Kennedy, Doctor Martin Luther King Jr., and Senator Robert F. Kennedy—a popular commemorative decoration during this wrenching, profoundly sad time—hangs over the sofa. Above and beside this banner Marshall introduces the spirits of other figures who died nobly in this period, without achieving the martyrlike national status of King and the Kennedy brothers. These people include Medgar W. Evers, Malcolm X, members of the Black Panthers and the Freedom Riders, and four girls killed in the bombing of a Baptist church in Birmingham, Alabama, in 1963. Marshall was born in Alabama in 1955, and his family left town for Los Angeles when the city was torn by strife in 1963 (see Plate 6). What is remarkable about *Souvenir II* is the seriousness and compassion of its address: the room, the face of the angel, and the assembly of spirits all incite us to try to understand the goals and the history of the Civil Rights movement. In the process, it is natural to think about issues of equality in one's own family settings, from the living room to the seat of government.

In his series *Never Forget,* ceramicist Diego Romero commemorates famous Americans from Native communities. For example, *Iwo Jima Pot* (Plate **75**) honors Ira Hayes, who served in the Pacific with the U.S. Marine Corps during World War II. Romero, who grew up in Berkeley, California, works in an eclectic, politically charged style that was partly shaped by his training at art schools in Los Angeles in the early 1990s. His work differs markedly from that of his father, Santiago Romero,

who was a traditional painter from Cochiti Pueblo. *Iwo Jima Pot* may be read as an allegory of a double cultural identity: it is the expression of someone seeking to sustain a traditional Native consciousness while participating in an ever-changing industrial, capitalist society. The basic form and materials of the pot reflect Native ceramics, and the decoration alludes to American Pop Art and popular culture. The figures on the lid and the use of gilding recall sports trophies, and the soldier's portrait follows comic book practices of illustration. Ira Hayes became famous after participating in the raising of the Stars and Stripes over the western Pacific island of Iwo Jima in February 1945. Associated Press photographer Joe Rosenthal captured the moment when six men, including Hayes, worked in concert to plant the flagpole. According to Romero, "Hayes was an instant hero as the 'Indian who raised the flag,' even though he considered his role in the event to be minor. Severe depression, isolation, and alcoholism followed, resulting in his death at age thirty-three in 1954."[98] The artist is ambivalent about the price that Hayes paid for being turned into a media-hyped hero. Preferring to remember Hayes as a Native warrior, Romero pointedly omits the flag and the flagpole from the top of this thought-provoking "trophy."

Although they grew up on opposite sides of the globe, Diego Romero and Yinka Shonibare exemplify a generation of artists who deal critically with the hybrid status of their lives. Romero's art is not "pure" in the modernist sense, for he mixes styles and welcomes narrative and literary allusions; and he is not "Indian" in the sense of belonging to a culture that is confined to an Indian Reservation. Yinka Shonibare was born in England, spent parts of his youth in Nigeria, and now lives and works in London. He, too, is conscious of being hard to define, especially since Nigeria's shift from a British colony to an independent African state, and he has been variously described as "Anglo-Nigerian, or Nigerian, or British-born Nigerian."[99] Shonibare speaks both English and the West African language

Yinka Shonibare, diagram for the
installation of *Nuclear Family*, 1999.
Courtesy of the Seattle Art Museum.

called Yoruba. As a result, he says, "My thoughts are very hybrid, if you like, very mixed. Sometimes I think in English, sometimes in Yoruba. And these things manifest themselves in my work."[100]

Shonibare's *Nuclear Family* (Plate 76) draws attention to a variety of things once thought to be "normal" and fixed according to tradition. It typifies his self-styled "revolt against what is familiar."[101] Shonibare questions various assumptions pertaining to race, class, and gender; and he does so with humor, parody, and playfulness. *Nuclear Family* takes an archetypal symbol of convention—the heterosexual couple with a boy and a girl—and then modifies it according to a wide range of contemporary issues. The family wears clothes cut in a style favored by upper-class Victorians. These patricians, however, have lost their heads, like the aristocrats killed during the French Revolution. The outrageous colors of their clothes break sharply with Victorian standards of propriety, and the extroverted fabrics connote an aesthetic more prevalent in African costume. Through these alterations Shonibare suggests that the nuclear family is not as standard as it is supposed to be; indeed, compared to Charles Ray's *Family Romance* (see Plate 69), this group enacts random casualness rather than overt order and unity.

The textiles that Shonibare uses for his sculptures offer a stunning instance of cultural layering: "I like the idea of layering things that are not meant to go together. But then somehow they do [go together], because that's what culture is: a layering of many different things."[102] These wax print fabrics are now worn in many parts of the world as symbols of African nationalism. Shonibare saw them worn in Lagos to celebrate

postcolonial independence, and he sees them worn today in London as something believed to be an authentic product with "traditional" African origins. In fact, these printed fabrics derive from Indonesian batiks. Dutch and English designers began to adapt this style in the late nineteenth century. The versions produced in European factories were exported to African markets, which have come to embrace them as the visual antithesis of the taste of the European colonialists. Shonibare feels that mannequins dressed in these fabrics are "expressing a desire for exotic passions on the one hand, while engaging in depraved economic power relations on the other. The origins of the fabric are a metaphor for Western transactions, without which the myth of [it being authentic] African fabric could not have been developed in the first instance."[103]

Simryn Gill's project *A Small Town at the Turn of the Century* (Plates 77–80) comprises thirty-nine large photographs taken in the artist's former hometown of Port Dickson, on the west coast of Malaysia. On a basic level, the project represents "a very affectionate look at a place which, in a sense, formed my way of looking at the world."[104] More importantly, Gill set herself the conceptual task of making a record of a town in a way that would speak to its subjects and then continue to speak—perhaps in a different "register"—to audiences in far-flung towns. This mindfulness about the reception of her work no doubt derives from Gill's own international and cross-cultural experiences. She is of Punjabi descent; although born in Singapore and raised in Port Dickson, her education took place in India and the United Kingdom. She currently lives in Australia and returns frequently to Malaysia.

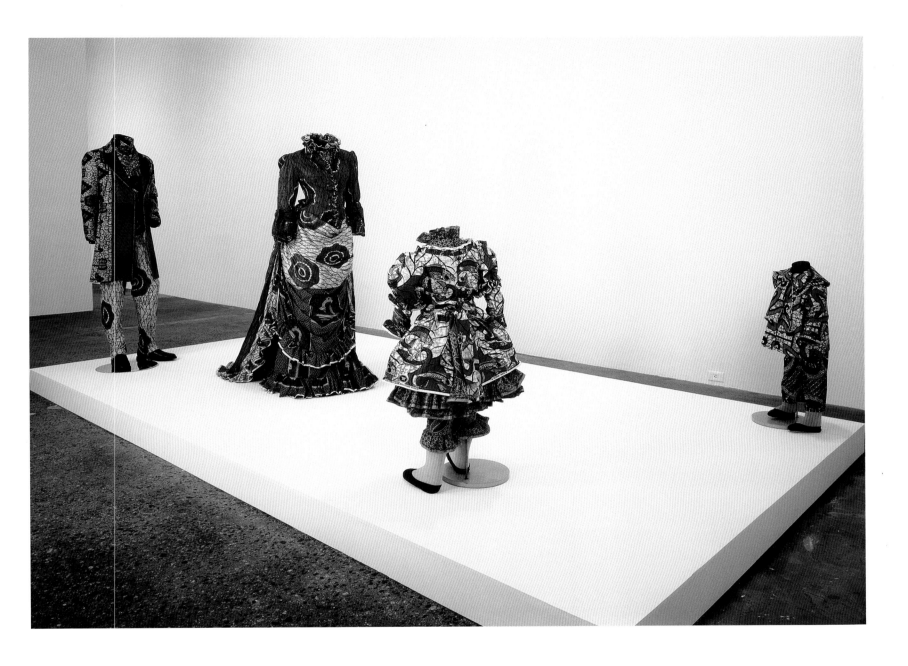

Yinka Shonibare

PLATE 76 *Nuclear Family*
1999
Mixed-media installation:
wax-printed cotton textile,
mannequins
Pedestal: 96 × 180 × 5 inches
Collection of Seattle Art
Museum. Gift of Agnes Gund
and Daniel Shapiro in honor
of Mr. and Mrs. Bagley
Wright

Describing the origins of *A Small Town at the Turn of the Century,* Gill has written: "For many years now I've wanted to go back and to really look at Port Dickson, but it's been a tricky thing to do. I didn't want to do it through a kind of longing or nostalgia, or a this-is-where-I-am-from type of statement. This is just a town, like many, many others around the world. A place that I am terribly familiar with—but that's because I am from there."[105] The most important question she faced was this: "How can I make a work which simultaneously records closeness and distance, familiarity and exoticness, close friends and just some Asian people, all at the same time?"[106] Gill's solution to this dilemma was to photograph people in everyday locations—at home, at work, on a golf course, in a bar—while asking them to depersonalize themselves by covering their faces. To this end she constructed headdresses, made out of tropical fruits and vegetables, that mask the face and perhaps the ethnicity of the subject. Thus *A Small Town at the Turn of the Century* shows people, settings, and plant materials that are all "local" to Port Dickson and yet allows the individuals some shielding from the outsider's gaze.

As a New Englander, with no experience of Malaysia, I find Gill's images of the woman on the rubber tree plantation (Plate 77) and the man fishing with a net (Plate 78) rather exotic. No doubt the splendid and colorful headdresses in these pictures reinforce that impression. The image of a young woman standing beside a house (Plate 79) feels more familiar to me. However, there is a temptation to put on art historian's glasses and find exotic echoes of the body language of certain Asian sculptures or the alluring, colorful women in Paul Gauguin's Tahitian tableaux. The photograph of the kid sitting on a doorstep (Plate 80) feels most familiar: the clothes, the doormat, the pumpkinlike headdress fit right in with my "local" experiences. Gill has been successful in her bid to engage a wide variety of audience responses, including a warm, insightful one from a critic in Kuala Lumpur. When selections from *A Small Town at the Turn of the Century* were exhibited there, Karim Raslan wrote: "Simryn Gill's wry, tongue-in-cheek artwork satirizes our preoccupations with identity in a particularly South-East Asian manner. . . . In exploring identity, racial and religious purity, as well as hybridity, Simryn encourages a multiplicity of responses. Her work is playful. We can enjoy the photographs: we can laugh or we can smile. . . . However, if we really want to, we can also stop and take stock as we follow her highly personalized trajectory of ideas and insights. Hopefully, more Malaysians will do just that, because Simryn makes us address the continuing uncertainties that plague our national psyche."[107]

■ ■ ■

Thinking through the notion of family today is a complicated pursuit, and I believe that the art in *Family Ties* portrays some of the intricacy involved. The spirit underlying this project echoes throughout Sarah Vowell's wide-ranging yet thoroughly personal essay about her mixed racial heritage, "What I See When I Look at the Face on the $20 Bill" (reprinted in this publication). In an attempt to know more about the experiences of her Cherokee ancestors, she explored their political disenfranchisement in the early nineteenth century. Tracing President Andrew Jackson's role in the historical narrative, she describes a personal journey of understanding that is painful and yet lightened by her humorous, bittersweet acceptance of the past. Most remarkable is Vowell's disarming way of connecting the personal and the political: the ability to tie her previously casual acceptance of Cherokee roots to a malefactor whose deeds she now remembers whenever she looks at a twenty-dollar bill.

"Family" encompasses a multitude of different social units and groups, and in every instance it functions to contain and reconcile many opposing forces: women and men; births and deaths; blood relatives and people connected by marriage; ancestral past and present circumstances; the individual and the group; freedom and duty; joys and sorrows. According to one definition of family, "Valuation of all members is almost never equal; therefore, family as a whole embodies and symbolizes order of a particular sort—hierarchy."[108] It is not easy to understand or accept all the differences, hierarchies, and changes that affect our various families in the course of time. I find it fitting, then, to conclude with brave words, and to do so I respectfully paraphrase some thoughts by art historian Linda Nochlin: Family is a complex, mercurial, and problematic concept. It is mixed in its messages and resists fixed interpretation or positioning. The term "family" fights back against efforts to reduce it to some simple essence that is supposedly universal, natural, and above all, unproblematic; it withstands attempts to subdue its full meaning.[109]

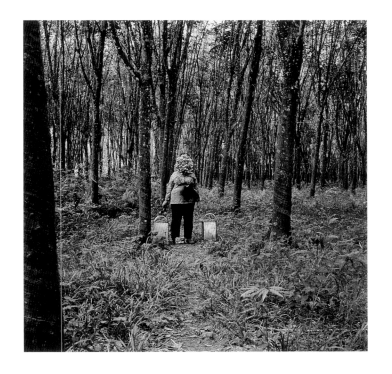

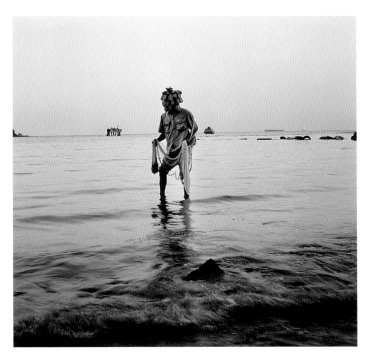

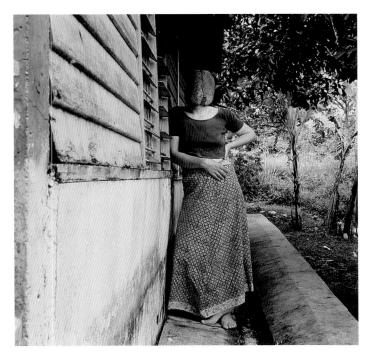

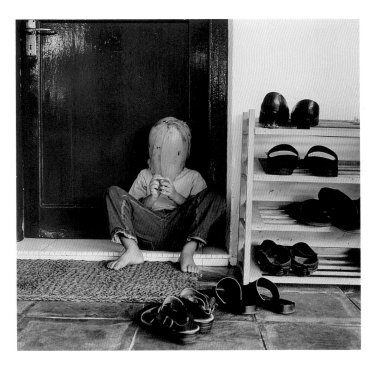

Simryn Gill

PLATES 77–80 *Nos. 19, 29, 16, and 10,* from *A Small Town at the Turn of the Century*
1999–2000
Chromogenic development print
Each 36 × 36 inches
Edition of 5
Courtesy of the artist and
Barbara Flynn, Sydney
and New York

Notes

1. Tim Heald, *Old Boy Networks: Who We Know and How We Use Them* (New York: Ticknor & Fields, 1984), p. 108.

2. Ibid., p. 136. The comment was made during a televised interview in 1969.

3. "Nuclear family," *Encyclopaedia Britannica* (2003), from Encyclopaedia Britannica Online, <http://www.eb.com>.

4. Robert M. Milardo and Steve Duck, eds., *Families as Relationships* (Chichester, England, and New York: John Wiley & Sons, 2000), p. xi.

5. Gill Jagger and Caroline Wright, eds., *Changing Family Values* (London: Routledge, 1999); and Elisabeth Beck-Gernsheim, *Reinventing the Family: In Search of New Lifestyles* (Munich: C. H. Beck'sche Verlagsbuchhandlung, 1998; reprint, Cambridge, England: Blackwell Publishers Ltd., 2002).

6. Caryn James, "The Year in Review: Finally, Families That Look and Act Like Us," *New York Times,* December 29, 2002, sec. AR, p. 32.

7. For more information, see Jeffrey Ruoff, *An American Family: A Televised Life* (Minneapolis: University of Minnesota Press, 2002).

8. Quoted in Charles Childs, "Bearden: Identification and Identity," *Art News* 63 (October 1964), p. 62.

9. Bearden began to use the "conjure woman" as a protagonist in the mid-1960s. For a discussion, see Mary Schmidt Campbell's essay in *Memory and Metaphor: The Art of Romare Bearden, 1940–1987,* exh. cat. (New York: The Studio Museum of Harlem, 1991), pp. 39–41.

10. Quoted in Childs, "Bearden," p. 62.

11. Arbus's photograph and text were published in Diane Arbus, "Two American Families," *Sunday Times Magazine* (London), November 10, 1968, p. 56. For a reproduction, see Doon Arbus and Marvin Israel, eds., *Diane Arbus: Magazine Work* (New York: Aperture, 1984), pp. 106–107.

12. Quoted by A. D. Coleman in a 1971 memorial essay on Arbus, reprinted in A. D. Coleman, *Light Readings: A Photography Critic's Writings, 1968–1978* (New York: Oxford University Press, 1979), p. 77.

13. David Halberstam, *Firehouse* (New York: Hyperion, 2002), p. 8.

14. Ibid., p. 7.

15. Bill Owens, *Suburbia* (San Francisco: Straight Arrow Books, 1973), unpaginated.

16. Artist's statement (1991), quoted in Trevor Fairbrother and Kathryn Potts, *In and Out of Place: Contemporary Art and the American Social Landscape,* exh. cat. (Boston: Museum of Fine Arts, 1993), p. 21.

17. Barney, telephone conversation with the author, December 17, 2002.

18. Tobias Wolff, *This Boy's Life* (New York: Harper & Row, 1989; quoted from Perennial Library edition, 1990), p. 259.

19. William Klein, *Rome: The City and Its People* (Paris: Editions du Seuil; Milan: Feltrinelli, 1958–59; English edition, New York: Viking Press, 1960).

20. An early American instance of this format is Charles Willson Peale's well-known painting *John and Elizabeth Lloyd Cadwalader and Their Daughter Anne* (1772; Collection of Philadelphia Museum of Art).

21. Opie, telephone conversation with the author, April 30, 2002.

22. See Bosworth, *Diane Arbus,* pp. 193–94. Bosworth notes that Eddie Carmel had played a monster in a few television and film projects.

23. Quoted in Coleman, *Light Readings,* pp. 77–78.

24. These words about Arbus are indebted to Peter Schjeldahl's essay "Arbus in the Dark," *The Village Voice,* January 24, 1995, p. 75.

25. Frédéric Brenner, *A Moment Before: Jews in the Soviet Union* (New York: International Center of Photography, 1992), unpaginated.

26. Keita speaking in 1995–96 with André Magnin, quoted in Thomas Meissgang, ed., *Flash Afrique,* exh. cat. (Vienna: Kunsthalle Wien, 2001), p. 68.

27. Roberta Smith, "Diane Arbus and Alice Neel, with Attention to the Child," *New York Times,* May 19, 1989.

28. For a discussion of the book that Strand and Zavattini published in 1955 (*Un Paese*), see Sarah Greenough, *Paul Strand: An American Vision,* exh. cat. (Washington, D.C.: National Gallery of Art, 1990), pp. 47–48.

29. Struth speaking with Benjamin H. D. Buchloh, quoted in *Thomas Struth, Portraits,* exh. cat. (New York: Marian Goodman Gallery, 1990), p. 32.

30. For more information about this procedure, see ibid., pp. 30–31.

31. From the caption for the cover image, *Art in America* 63 (January–February 1975), p. 3.

32. For more information about Julia Warhola, see the numerous references indexed in Victor Bokris, *Warhol* (London: Frederick Muller, 1989).

33. See *Andy Warhol: Portraits of the 70s,* exh. cat. (New York: Whitney Museum of American Art, 1979). Robert Rosenblum illustrates one of the paintings in his essay.

34. The phrase is a pun on the title of a famous photography exhibition, *The Family of Man,* organized by Edward Steichen in 1955 for the Museum of Modern Art, New York. See, for example, Max Kozloff, "The Family of Nan," *Art in America* 75 (November 1987), pp. 39–43.

35. Peter Schjeldahl, "Nan Goldin," *Vogue* (U.S.), March 1995, p. 394.

36. The exhibition was curated by Elisabeth Sussman and David Armstrong for the Whitney Museum of American Art, New York. The catalogue is *Nan Goldin: I'll Be Your Mirror* (New York: Whitney Museum of American Art, 1996).

37. Goldin interviewed by Camille Sweeney, *New York Times Magazine,* September 22, 1996, p. 73.

38. Ibid.

39. Statement by Byron Kim and entry by Ron Platt in *Face to Face: Recent Abstract Painting,* exh. cat. (Cambridge, Mass.: MIT List Visual Arts Center, 1996), p. 14.

40. Goodman in a 1990 interview, quoted in John B. Ravenal, *Sidney Goodman: Paintings and Drawings, 1959–95,* exh. cat. (Philadelphia: Philadelphia Museum of Art, 1996), p. 256 n. 10.

41. Prior to 1982 Hockney held photographs in fairly low regard—even though he had used them as preliminary studies for more than a decade—and believed they did not warrant sustained attention because of the camera's mechanical and instantaneous manner of recording: "You'd never look at a photo for more than thirty seconds unless there were a thousand faces and you were looking for your mother"(quoted by Ann Hoy in *David Hockney: A Retrospective,* exh. cat. [Los Angeles: Los Angeles County Museum of Art, 1988], p. 55). Amusingly enough, it was his mother who inspired one of his most successful early photographic works.

42. Liu in an interview with Kathleen McManus Zurko, quoted in *Hung Liu: A Ten-Year Survey, 1988–1998,* exh. cat. (Wooster, Ohio: The College of Wooster Art Museum, 1998), p. 41.

43. Neshat in a 2001 interview, quoted by John B. Ravenal in *Outer & Inner Space: Pipilotti Rist, Shirin Neshat, Jane & Louise Wilson, and the History of Video Art,* exh. cat. (Richmond: Virginia Museum of Fine Arts, 2002), p. 52.

44. The excerpt from the poem is quoted by Susan Stoops in *Mask or Mirror? (A Play of Portraits),* exh. cat. (Worcester, Mass.: Worcester Art Museum, 2002), p. 31. "My Beloved" is the title of a lyrical poem in which Farrokhzad talks about a lover. For more information on the poet, see Michael C. Hillman, *A Lonely Woman: Forugh Farrokhzad and Her Poetry* (Washington, D.C.: Three Continents Press and Mage Publishers, 1987).

45. Neshat in conversation in 1995, quoted by Dana Friis-Hansen in *Transculture: La Biennale di Venezia* (Tokyo: The Japan Foundation, 1995), p. 148.

46. Donald E. Westlake, *The Ax* (1997; New York: Warner Books, 1998), pp. 88–89.

47. Quoted from Tocqueville's *Democracy in America* (1835, 1840); see Patrice Higonnet's essay on Tocqueville in Marc Pachter, ed., *Abroad in America* (Washington, D.C.: National Portrait Gallery, Smithsonian Institution, 1976), p. 56.

48. For a recent overview of these issues, see the essays by Laurel Thatcher Ulrich and Maureen A. Taylor in D. Brenton Simons and Peter Benes, eds., *The Art of Family: Genealogical Artifacts in New England* (Boston: New England Historic Genealogical Society, 2002).

49. From Dury's "You'll See Glimpses," released on a single by Stiff Records in 1980.

50. Larry Fink, *Social Graces* (New York: Aperture Books, 1984), p. 5.

51. Ibid.

52. Foreword to *Nicholas Nixon: The Brown Sisters,* exh. cat. (New York: The Museum of Modern Art, 1999), unpaginated.

53. E-mail correspondence between Biggers, Zackin, and the author, 2003.

54. Thurber in conversation with the author, January 28, 2003.

55. Quoted by Nora Donnelly in *Home: Photographs by Shellburne Thurber,* exh. cat. (Boston: The Institute of Contemporary Art, 1999), p. 14.

56. Quoted by Deborah Martin Kao in *Renovation: Photographs by Shellburne Thurber of The Boston Athenaeum,* exh. cat. (Boston: The Boston Athenaeum, 2002), p. 10.

57. Anne Tyler, *The Accidental Tourist* (New York: Alfred A. Knopf, 1985), p. 8. Thurber mentioned this novel to me in passing when we discussed my plans and thoughts for *Family Ties.*

58. Artist's statement for *Tracing Cultures,* exh. cat. (San Francisco: The Friends of Photography, 1995), p. 26.

59. Ibid.

60. Joyce Carol Oates, "Reflections on the Grotesque," reprinted in *Gothic: Transmutations of Horror in Late-Twentieth-Century Art,* exh. cat. (Boston: The Institute of Contemporary Art, 1997), p. 38. Edmier's work was included in this exhibition.

61. Vladimir Nabokov, *Speak, Memory: An Autobiography Revisited* (rev. ed., 1966; reprint, New York: Capricorn Books Edition, 1970), p. 19. Nabokov first wrote this passage for the essay "Past Perfect," published in *The New Yorker,* April 15, 1950.

62. Quoted by Tracey Bashkoff in *Sugimoto: Portraits,* exh. cat. (New York: The Solomon R. Guggenheim Museum, 2000), p. 29.

63. Ibid., p. 28.

64. Joseph Blotner, ed., *Uncollected Stories of William Faulkner* (New York: Random House, 1979), p. 455. When *Harper's Bazaar* published Faulkner's "Sepulture South: Gaslight" in December 1954, it featured a full-page reproduction of a photograph by Evans showing the backs of the statues (similar but not identical to the one reproduced here as Plate 48). The connection between Evans and Faulkner had been established six years earlier when Evans contributed a series of photographs to *Vogue* ("Faulkner's Mississippi," October 1948); he combined them with passages he had chosen from Faulkner's novels.

65. This cartoon first appeared in *The New Yorker,* February 6, 1995, and was later included in Edward Koren, *Quality Time: Parenting, Progeny, and Pets* (New York: Villard Books, 1995). *Mailboxes* appeared in the October 26, 1992, issue of *The New Yorker.*

66. Michals interviewed by Marco Livingstone in 1998, quoted by David B. Boyce in "Duane Michals: Unlimited 1958–2000," *Art New England* 24 (December 2002–January 2003), p. 17.

67. Duane Michals, "I am much nicer than my face, and other thoughts about portraiture," in *Album: The Portraits of Duane Michals, 1958–1988,* exh. cat. (Pasadena, Calif.: Twelvetrees Press, 1988), unpaginated.

68. Michals's most well-known portrait of Warhol is the 1958 diptych *Andy Warhol and his mother Julia Warhola;* for an illustration, see ibid.

69. From Goldberg's "Afterword," in *Rich and Poor: Photographs by Jim Goldberg* (New York: Random House, 1985), unpaginated.

70. Noted by Andrea Kirsch in *Carrie Mae Weems,* exh. cat. (Washington, D.C.: The National Museum of Women in the Arts, 1993), p. 11.

71. Larry Sultan, *Pictures from Home* (New York: Harry N. Abrams, 1992), p. 18.

72. Ibid.

73. In addition to producing art for museums and galleries, Moffatt has directed music videos for bands such as INXS.

74. Quoted by Marta Gili in *Tracey Moffatt* (Barcelona: Centre Cultural de la Fundació "la Caixa," 1999), p. 107.

75. Ibid., pp. 107–108.

76. Quoted by Olukemi Ilesanmi and Joan Rothfuss in *Coloring: New Work by Glenn Ligon,* exh. cat. (Minneapolis: Walker Art Center, 2001), p. 32.

77. Ibid., p. 31.

78. Quoted by Thalia Gouma-Peterson in *Faith Ringgold: Change—Painted Story Quilts,* exh. cat. (New York: Bernice Steinbaum Gallery, 1987), p. 9.

79. For more on Group Material, see Fairbrother and Potts, *In and Out of Place,* pp. 40–47.

80. *The Scarlet Letter,* in Norman Holmes Pearson, ed., *The Complete Novels and Tales of Nathaniel Hawthorne,* vol. 1 (New York: Random House, 1993), p. 484.

81. Ibid., p. 482

82. D. H. Lawrence, *Studies in Classic American Literature* (1923; reprint, New York: Penguin Books, 1986), pp. 89 and 108.

83. Quoted by Trevor Fairbrother in a 1988 interview, reprinted in Russell Ferguson, et al., eds., *Discourses: Conversations in Postmodern Art and Culture* (New York: The New Museum of Contemporary Art; Cambridge, Mass.: MIT Press, 1990), p. 162.

84. Interviewed by Val Wang, "Zhang Huan," *Chinese-art.com Contemporary* (online journal, vol. 2, no. 6, 1999).

85. I am very grateful to Nancy Berliner, curator of Chinese Art at the Peabody Essex Museum, for making these translations.

86. The artist commenting on his performance *To Raise an Anonymous Mountain by One Meter* (Beijing, May 1995), in *Zhang Huan: Performances on Video,* exh. cat. (Auckland, New Zealand: Artspace, 1999), p. 17.

87. Letter written by Cadmus in 1992, quoted in Justin Spring, *Paul Cadmus: The Male Nude* (New York: Universe Publishing, 2002), p. 63.

88. Cadmus, "Credo" (broadside published by Midtown Galleries, New York, 1937), reprinted in Lincoln Kirstein, *Paul Cadmus* (San Francisco: Pomegranate Artbooks, 1992), p. 142.

89. Cleaver, correspondence with the author, 2002.

90. Ibid.

91. Discussed by Paul Schimmel in *Charles Ray,* exh. cat. (Los Angeles: Museum of Contemporary Art, 1998), p. 87.

92. Gregory Crewdson, "Dreamhouse," a portfolio of pictures for the *New York Times Magazine,* November 10, 2002, p. 50.

93. Rick Moody, "On Gregory Crewdson," *Twilight: Photographs by Gregory Crewdson* (New York: Harry N. Abrams, Inc., 2002), p. 6.

94. Quoted by Simona Vendrame in "John O'Reilly: Conversation with Simona Vendrame," *Tema Celeste,* no. 72 (January–February 1999), pp. 64–66. For further discussion of the artist's idiosyncratic layering of art and religion, see the essays by Klaus Kertess and Francine Koslow Miller in *John O'Reilly: Assemblies of Magic,* exh. cat. (Andover, Mass.: Addison Gallery of American Art, Phillips Academy, 2002).

95. For more about his work, see *Charles LeDray: Sculpture, 1989–2002,* exh. cat. (Philadelphia: Institute of Contemporary Art, University of Pennsylvania, 2002).

96. Jerry Saltz, "It Don't Come Easy," *Arts Magazine* 66 (April 1992), p. 23.

97. Quoted by Alfred Kazin in the afterword to Mark Twain, *The Adventures of Tom Sawyer* (1876; New York: Bantam Classic Edition, 1981), p. 221.

98. Caption by Diego Romero in David Revere McFadden, *Changing Hands—Art without Reservation, 1: Contemporary Native American Art from the Southwest,* exh. cat. (New York: American Craft Museum, 2002), p. 123.

99. Shonibare answering questions from Pamela McClusky, curator of African and Oceanic Art, Seattle Art Museum, January 12, 2001, in preparation for an Acoustiguide recording.

100. Ibid.

101. Shonibare, "Gallantry and Criminal Conversation," *Documenta 11, Platform 5: Exhibition Catalogue* (Kassel: Hatje Cantz, 2002), p. 584.

102. McClusky interview, 2001.

103. Shonibare, "Gallantry and Criminal Conversation," p. 584.

104. Gill, correspondence with the author, 2002.

105. Simryn Gill, "A Time & a Place" (master's thesis, University of Western Sydney, 2001), excerpts provided by Gill.

106. Ibid.

107. Karim Raslan, "Snapshots of who we really are," *Sunday Star* (Kuala Lumpur), April 21, 2002, p. 28.

108. Kathryn Allen Rabuzzi, "Family," in Mircea Eliade, ed., *The Encyclopedia of Religion* (New York: Macmillan Publishing Company, 1987), p. 277.

109. Linda Nochlin, *Representing Women* (New York: Thames and Hudson Inc., 1999), p. 7. In addition to a few small adjustments, I have substituted the word "family" where Nochlin used the word "woman."

what i see when i look at the face on the $20 bill Sarah Vowell

Being at least a little Cherokee in eastern Oklahoma where I was born is about as rare and remarkable as being a Michael Jordan fan in Chicago. I mean, who isn't? Both my parents are Cherokee to varying degrees, and I'm between an eighth and a quarter. It goes without saying that my twin sister, Amy, is, too. Except that I have dark eyes and dark hair and she's a blue-eyed blond, and so our grandfather nicknamed me Injun and her Swede.

"Those roles were assigned to us, Indian and Swede," Amy says, "because of the way we looked. But it was also more like the things we were told about ourselves." She mentions that when we were children, I was the one given the Cherokee language book and she was told she resembled our Swedish grandmother who died before we were born. She continues, "I think I was probably six or seven before I realized that I was Cherokee, too."

We're a little French and Scottish and English and Seminole, too, typical American mutts. But the Cherokee and Swedish sides of the family were the only genealogies anyone in the family knew anything about. Here's what we knew about ourselves: Ellis Island, Trail of Tears. And I think, to a kid, "Trail of Tears," the Cherokees' forced march from the East to Oklahoma where we were born, seemed enormously more interesting, just as a name. Even the smallest children know what tears mean, and I think in my earliest understanding of where I came from, I pictured myself descended from a long line of weepers with bloodshot eyes. The Trail of Tears took place

in 1838–39, when the U.S. Army wrenched sixteen thousand people from their homes in Georgia, North Carolina, and Tennessee, rounded them up in stockades, and marched them away, across hundreds of miles. Four thousand died.

Every summer when we were children, our parents would drive us to a place about half an hour from where we lived called Tsa-La-Gi, which is the Cherokee word for Cherokee. It's the tribe's cultural center. There's a re-created precolonial village, a museum, and—this was our favorite part—an amphitheater which staged a dramatic recreation of the Trail of Tears. Every summer we watched Chief John Ross try like mad to save the Cherokee land back east. We saw his hothead rival Stand Watie rage off to the Civil War. We especially loved the Death of the Phoenix, a noisy, magenta-lit interpretive dance in which the mythic bird would die only to rise again.

Amy took it to heart: "The play was really tragic. I have a reverent feeling toward it. And I think it's because this play was so serious and told such a detailed story that it took this place of significance. It was really important. It really mattered."

The amphitheater show so influenced my thinking that even though my dad and my grandfather used to show me photographs of Cherokee leaders like Stand Watie in books, when I imagine Stand Watie now I still picture the actor at Tsa-La-Gi.

So all my life I knew I wouldn't exist but for the Trail of Tears, and it struck me as a little silly that most of the things I knew about it were based on an amphitheater drama I haven't seen for twenty years. I had read some books about the Trail but

I wanted to see it, feel it, know how long the distance was. I wanted the trek to be real. I enlisted Amy, who, unlike me, has a license. Perhaps she'd like to do all the driving? A historical tragedy and five fourteen-hour days behind the wheel? Who could pass that up? And so I fly from Chicago, she from Montana, and one spring morning we find ourselves in a rental car on our way to northwestern Georgia, the homeland of the Cherokee before they were shoved out to Oklahoma, the place the Trail of Tears begins.

The Cherokee territory once encompassed most of present-day Tennessee and Kentucky, as well as parts of Alabama, Georgia, Virginia, and the Carolinas. Even before contact with Europeans in 1540, they were a protodemocratic society. They built these enormous council houses, big enough to fit the entire tribe inside, so everyone could participate in tribal decisions.

We're barely on the road an hour when we spot them: Injuns. Ceramic ones, three feet tall, at a shack on the side of the road. Amy drives past them, we do a double take, and we don't even discuss whether or not to stop, she just backs up immediately and parks.

"Are you of Native American descent?" I ask the proprietor.

"I'm a Mexican. I'm from Texas," he answers.

"And what brought you to Calhoun, Georgia?"

"The work."

The eight little Indians he's selling are of the kitschy, teepee-toting, Plains Indian, squaws and braves variety. Which are probably easier to sell than the stereotypical image of a Cherokee—a tired out old woman tromping through the Trail of Tears in rags. Who wants that as a lawn ornament?

"Who buys these Indian statues?" I ask.

"People here from Calhoun. People around here from Georgia love Indians."

"Well, after they got rid of them?"

He laughs and says, "That's right. That's true. You're telling the truth there."

The Cherokees, who had always taken an interest in the more useful innovations of white culture, not to mention married whites at a fairly fast clip, were always a nerdy, overachiever, bookish sort of tribe. By the early nineteenth century, they launched a series of initiatives directly imitating the new American republic. In one decade, they created a written language, started a free press, ratified a constitution and founded a capital city.

New Echota was that capital. Now it stands in the middle of nowhere—a Georgia state park with a handful of buildings across from a golf course. It was founded in 1819. To call it the Cherokee version of Washington, D.C., is entirely applicable, given the form of government the tribe established there. For the Nation sought to emulate not just the democratic structures of the United States government by dividing into legislative, judicial, and executive branches, but the best ideals of the American republic. In 1827, they ratified a constitution based on that of the United States. Its preamble begins, "We, the Representatives of the people of the Cherokee Nation in Convention assembled, in order to establish justice, ensure tranquility, promote our common welfare, and secure to ourselves and our posterity the blessings of liberty . . ."

Unlike Washington, New Echota is cool and quiet and green. Site manager David Gomez shows us around the grounds. Amy and I are unprepared for the loveliness of the place, for its calm lushness, its fragrance. Everywhere, honeysuckle is in bloom. I tell him I like it here.

"It's nice," he agrees. "It's peaceful and the atmosphere is right for what was going on and the story that we tell here. It's a story that's sad in a lot of ways, but there were a lot of great things happening with the Cherokee Nation."

The Cherokee, along with the other Southeastern tribes who suffered removal to Oklahoma—the Chickasaw, the Creek, the Choctaw, the Seminole—are one of the so-called Five Civilized Tribes. It was in 1822 that the Cherokee hero Sequoyah developed an alphabet, inventing the sole written language of any North American tribe. Only six years later, Cherokee editor Elias Boudinot founded the *Cherokee Phoenix,* a bilingual, English-Cherokee newspaper published at New Echota. Many Cherokee, especially the large population of mixed-bloods, practiced Christianity. And, because many of these lived as "civilized" Southern gentlemen of the early nineteenth century, they owned prospering plantations, which meant they owned black slaves. More than any other Native American tribe, the Cherokees adopted the religious, cultural, and political ideals of the United States. Partly as a means of self-preservation. By becoming more like the Americans, they hoped to coexist with this new nation that was growing up around them, but they weren't allowed to. Georgia settlers wanted their land. And their gold, which was discovered near New Echota in 1829.

Gomez says, "They were really progressing so fast at this time period. The printing operation was going with their newspaper here. Things were moving so fast for them for a short while here that it looked very promising, but because of the gold and the big demand for land, their fate had really been already sealed for them in earlier years."

The tribe allowed Christian missionaries to live and work

among them, and to teach their children English. The most beloved of these was the Presbyterian Samuel Worcester, who built a two-story house at New Echota, which functioned as a post office, school, and rooming house. It still stands, and David Gomez walks us through, warning us of the steep steps: "You wouldn't want to have a broken leg on the rest of your trail."

The state of Georgia, which of all the Southern states treated the Cherokee with the most hostility, passed a number of alarming laws in the 1820s and '30s undermining the sovereignty of the Nation. One of these laws required white settlers within the boundaries of the Nation to obtain a permit from the state of Georgia. Samuel Worcester refused to apply for such a permit, arguing that he had the permission of the Cherokee to live on their lands and that should suffice. Georgia arrested Worcester and imprisoned him for four years. Worcester appealed to the Supreme Court, and the case, *Worcester v. Georgia,* became a great victory for the tribe. The Court, under Chief Justice John Marshall, ruled that the Cherokee Nation was just that—a sovereign nation within the borders of the U.S., and therefore beholden only to the federal government, i.e., not under the jurisdiction of Georgia state laws.

"And the Cherokee Nation was elated," Gomez points out. "They thought, 'All right, the highest court in the land of the United States—this government that we're trying to copy—they ruled in our favor. This is going to be good.' Of course, Andrew Jackson, who was pro-removal from the early years—he campaigned on that issue—decided he wasn't going to back the Supreme Court ruling."

On hearing of the ruling, the president is said to have replied, "John Marshall has made his ruling. Now let him enforce it." Think about that, what that means: a breakdown of the balance of power in such boasting, dictatorial terms. Jackson is violating his own oath of office, to uphold the Constitution. In the twentieth century, when people bandy about the idea of impeachment for presidents who fib about extramarital dalliances, it's worth remembering what a truly impeachable offense looks like. Didn't happen of course. I refer you to the face on the twenty-dollar bill.

The state of Georgia was thrilled when Jackson thumbed his nose at the Court, and immediately dispatched teams to survey the Cherokee lands for a land lottery. Soon white settlers arrived here. According to Gomez, "They showed up two years later in 1834, with the land lottery deed and with Georgia soldiers saying, 'I've got this land from the lottery. Get off of it.' "

Another small constitutional violation that was part of the land grab: Georgia seized the Cherokee printing press, so they couldn't publicize their cause and win political support in states up north.

No one annoyed Jackson like Principal Chief John Ross. Ross was a Jeffersonian figure in almost every sense. A founding father of the Cherokee Nation in its modern, legal form, it was Ross who cribbed from Jefferson in writing the Cherokee constitution. Like Jefferson, he preached liberty while owning slaves. An educated gentleman planter, Ross was only one-eighth Cherokee—just one-eighth, even I'm more Cherokee than that—but he was their chief from 1827 to 1866. Toward the end of his life he corresponded with Abraham Lincoln; in his early years, he was such a believer in the inherent justice of the American system that he lobbied relentlessly in Washington, D.C., believing that once Congress and the president understood that the Constitution applied to this virtuous, sibling republic, they would treat the tribe fairly, as, equals.

Once the state of Georgia began evicting the Cherokee, and John Ross among them, Ross wrote, "Treated like dogs, we find ourselves fugitives, vagrants, and strangers in our own country."

The tribe was divided about what to do: stay and fight or demand cash for the land and head west. No one exploited this split more than Andrew Jackson.

The majority of the tribe wanted to stay put and supported Ross. But around a hundred men—including *Phoenix* editor Elias Boudinot and his brother Stand Watie; a hundred in a tribe of sixteen thousand—met at Boudinot's house in New Echota in 1835 and signed a treaty with the U.S. government. They had no authority to do this. Called the Treaty of New Echota, it relinquished all Cherokee lands east of the Mississippi in exchange for land in the West. They figured, Georgia was already seizing Cherokee land; this might be the only way the Cherokee would get something for it.

John Ross, whom the Georgia militia arrested so that he could not protest, was stunned. He accused the treaty party of treason. The rest of the sixteen thousand Cherokee signed a petition calling the treaty invalid and illegal. Congress ratified the treaty by only one vote, despite impassioned pleas on behalf of the Cherokee by Congressmen Henry Clay and Davy Crockett. The tribe was given three years to remove themselves to the West.

We're now standing at the site of Elias Boudinot's house, where the infamous New Echota treaty was signed. Gomez says, "The spring of '38 rolled around, and nobody was going anywhere. The state of Georgia and the federal government thought they were going to have some problems and you had about seven thousand troops come in to forcibly remove the

Cherokees from their farms, from their houses, and initially rounded them up in stockades and moved them up into eastern Tennessee and northeastern Alabama to three immigration depots where they were moved out onto the Trail of Tears as everybody knows it. Technically this is the starting point for the Trail of Tears. For the individual Cherokees, it really started at their front door wherever they were rounded up from."

Amy and I want to step on it, this patch of grass where the treaty was signed, but we hesitate. "It's not a grave," Gomez tells us. But that's what it feels like. We tiptoe onto it, this profane ground. And then we tiptoe away.

As Amy and I travel the Trail of Tears I wonder if we should be embarrassed by certain discrepancies between our trail and theirs. We're weak, we're decadent, we're Americans. Which means: road trip history buffs one minute, amnesiacs the next. We want to remember. Except when we want to forget.

We register at the Chattanooga Choo Choo. Yes, yes, *the* Chattanooga Choo Choo, track 29! It's a hotel now, a gloriously hokey, beautifully restored Holiday Inn, in which the lobby is the ornate dome of the old train station, and the rooms are turn-of-the-century rail cars parked out on the tracks. We're in giggles the entire night for the simple reason that the phrase "choo choo" is completely addictive. We try to work it into every sentence: "What should we do for dinner? Stay here at the Choo Choo?" We end up going out for barbecue, saying, "This is good, but I can't wait to get back to the Choo Choo." We watch *The X-Files* in our train car, commenting, "Is it just me, or is this show even better in the Choo Choo?" I send email from my laptop just so I can write, "Greetings from the Chattanooga Choo Choo Exclamation Point."

Sadly, we check out of the Choo Choo and drive across town to Ross's Landing. It used to be where John Ross's ferry service carried people across the Tennessee River. But in 1838, it was one of the starting points for the water route of the Trail of Tears.

And anchored there, at the river, like some ghost ship, in the very spot where Cherokees were herded into flatboats by the U.S. military, is a U.S. Coast Guard boat. I stand on the sand and read a weathered historical marker: "Established about 1816 by John Ross some 370 yards east of this point, it consisted of a ferry, warehouse and landing. Cherokee parties left for the West in 1838, the same year the growing community took the name Chattanooga."

I'm sure there's no connection at all between those two points. That sounds so nice. They "left for the West." Bye-bye! Bon voyage!

Ross's Landing also functions as Chattanooga's tourist center. Up the hill from the river is the gigantic Tennessee Aquarium and an IMAX theater. The place is crawling with tourists—a crowd so generic and indistinguishable from one another they swirled around us as a single T-shirt.

One hundred and sixty years ago, thousands of Cherokees came through this site. In the summer of 1838, they were forced onto boats and faced heat exhaustion, and then later a drought that stranded them without water to drink. In the fall, they headed west by foot, eventually trudging barefoot through blizzards. Either way, they perished of starvation, dysentery, diarrhea, and fatigue. A quarter of the tribe was dead.

Here, in the shadow of the aquarium, the Trail of Tears is remembered by a series of quotations from disgruntled Native Americans, carved into a concrete plaza. One of the citations, from a Cherokee named Dragging Canoe, is from 1776: "The white men have almost surrounded us, leaving us only a little plot of land to stand upon. And it seems to be their intention to destroy us as a nation."

Good call.

We're moving diagonally across the sidewalk, and happily step on the words of Andrew Jackson, from 1820: "It is high time to do away with the farce of treatying with Indian tribes as separate nations."

Amy looks up from the brochure she's reading and says, "These cracks in the sidewalks, they are symbolic of broken promises."

"Are you making that up?"

"No. It says right here, 'Some of the pavement is cracked to symbolize the broken promises made to the Indians.'"

Most Americans have had this experience, most of us can name things our country has done that we find shameful, from the travesties everybody agrees were wrong—the Japanese internment camps or the late date of slavery's abolition—to murkier, partisan arguments about legalized abortion or the *Enola Gay.* World history has been a bloody business from the get-go, but the nausea we're suffering standing on the broken promises at Ross's Landing is peculiar to a democracy. Because in a democracy, we're all responsible for our government's actions, because we're responsible for electing the government. Even if we, the people, don't do anything wrong, we put the wrongdoers in power.

Another piece of the sidewalk quotes a letter from Ralph Waldo Emerson to President Martin Van Buren (who, playing George Bush to Jackson's Ronald Reagan, enforced his predecessor's removal policy) in 1838. "A crime is projected that confounds our understandings by its magnitude. A crime that really deprives us as well as the Cherokee of a country. For

how could we call the conspiracy that should crush these poor Indians our government, or the land that was cursed by their parting and dying imprecations our country any more? You, sir, will bring down the renowned chair in which you sit into infamy if your seal is set to this instrument of perfidy. And the name of this nation, hitherto the sweet omen of religion and liberty, will stink to the world."

The path ends with a quotation from an unknown survivor of the Trail of Tears who said, "Long time we travel on way to new land. People feel bad when they leave old nation. Womens cry and make sad wails. Children. And many men. And all look sad like when friends die. They say nothing and just put heads down and keep on go towards west. Many days pass and people die very much. We bury close by trail."

That last passage, especially the part about "when friends die," brings Amy and me to tears. And we just stand there, looking off toward the Tennessee, brokenhearted. Meanwhile, there are little kids literally walking over these words, playing on them, making noise, having fun. We sort of hate them for a second. I ask a teacher who's with a group of fourth graders why she isn't talking to them about Cherokee history. She says normally she would, but it's the end of the school year, this trip is their reward for being good. It seems reasonable.

I ask Amy if she thinks these kids should share our sadness. She says, "I think it's a sad story. It's sort of like the Holocaust. You don't have to be Jewish to think that's definitely a sad part of history. And I think the Trail of Tears is America's version of genocide. Really, it started right over there."

Still, I can't take my eyes off those children. I envy them. I want to join them. I wanted to come on this trip to get a feel for this trail that made us; standing at Ross's Landing, it hits me how crazy that is—how crazy I was. Suddenly the only thing I get out of it is rage.

Why should we keep going?

I don't know. I seriously don't. I know it's an interesting story and I'm supposed to be interested in my past, but what good comes of that? I'm feeling haunted, weighed down, in pain. This might have been a mistake. It isn't a story where the more you know, the better you'll feel. It's the opposite. The more I learn, the worse I feel. This trip is forcing me to stand here next to a stupid aquarium and hate the country that I still love.

There are only so many hours a human being can stomach unfocused dread. I was tired and confused and depressed and I needed the kind of respite that can only come from focused resentment. In the Trail of Tears saga, if there's one person you're allowed to hate, it's Andrew Jackson, the architect of the Indian removal policy. And since the trail passed through

Nashville anyway, we stop at his plantation, the Hermitage. We get a private tour from Hermitage employee Carolyn Brackett. The house and museum are closed to the public when we arrive because of astonishing tornado damage. All the trees are down. Part of me wanted to destroy Andrew Jackson and everything representing him. Seeing all those hacked-up trees made me feel like Someone had beaten me to the punch.

Inside, there's no display mentioning Indian removal because, remarkably, there is no display about Jackson's presidency. Carolyn Brackett showed us around the house, a columned antebellum mansion that looks like a cross between Graceland and Tara. Unfortunately for my spite spree, I liked Carolyn Brackett a lot and I felt bad for her. She would point into the library and say Jackson subscribed to a lot of newspapers before his death, and I'd say, "Was one of them the *Cherokee Phoenix*?" Brackett wasn't sure.

Brackett points into a room and says, "All of the rooms that have original wallpaper, all of the paper was conserved and had to be cleaned with an eraser the size of a pencil eraser. So that was quite an undertaking." She points to a painting of Jackson that "was finished nine days before his death. I think he shows the wear and tear of his life in that portrait."

He looks like he's sticking his head out a car window.

Brackett agrees, "I guess he wasn't worrying about his hair much by then."

Brackett guides us past the flower garden planted by Jackson's wife, Rachel, and into the family graveyard. There are a few piddly headstones and one Greco-Roman monstrosity with an obelisk rising from the center.

"He actually had this designed for Rachel and left room for other family members," Brackett says as she leads us onto Jackson's grave.

I pull a book out of my backpack, a book with the subtitle *Andrew Jackson and the Subjugation of the American Indian.* Carolyn Brackett and Amy exchange a worried look.

I tell her that I'm standing here on Andrew Jackson's grave and that as a person of partly Cherokee descent, I wouldn't mind dancing on it. I read her a letter that Jackson wrote about the removal of the southeastern tribes. It says, "Doubtless it will be painful to leave the graves of their fathers, but what do they more than our ancestors did nor than our children are doing? To better their condition in an unknown land our forefathers left all that was dear in earthly objects. Our children by thousands yearly leave the lands of their birth to seek new homes in distant regions." And then it ends, "Can it be cruel in the Government, when, by events which it cannot control, the Indian is made discontent in his ancient home to purchase his lands,

to give a new and extensive territory, to pay the expense of his removal, and support him a year in his new abode. How many thousands of our own people would gladly embrace the opportunity of removing to the West on such conditions?"

There's something nutty about Old Hickory in this passage. Just the fact that he compares the *removal* of Indians from their land with the *opportunity* of his generation to just go out west. I ask Brackett if she can help me understand his mindset.

"Probably not," she sighs. "The interesting thing about that era was that they really felt that they were preserving. This is how they justified it in their own minds. That this was inevitable. It was sort of the early thought of manifest destiny. They never really seemed to think that we were going to settle the country all the way to the West, all the way to California. So if they just kept moving everybody further away, they'd eventually get to a point where there wasn't going to be any settlement, which, of course, didn't happen."

A few minutes after we pull out of the Hermitage's driveway, we're on the highway that cuts through Nashville. I regard even the most garish of the Opryland billboards with what can only be called warmth. Like a lot of people born in the South and the southern backwater states of Texas, Arkansas, and Oklahoma, Amy and I watched the *Grand Ole Opry* on television as children. While other kids our age spent the 1970s banging their heads to Kiss doing "Rock and Roll All Nite," we were humming along with "The Tennessee Waltz." Nashville, not Washington, was our cultural capital, home to heroes like George Jones, Ernest Tubb, and Loretta Lynn.

Carolyn Brackett had told us that most of the visitors to the Jackson plantation were spillover tourists from Nashville's country music attractions. Watching the billboards go by, I'm beginning to realize that maybe that is not such a coincidence. My heart sinks. I want to hate Andrew Jackson because it's convenient. I need one comforting little fact, one bad guy in a black hat to aim my grief at. But there's another Andrew Jackson nagging at me, the adjective, the one who lent his name to Jacksonian democracy, a fine idea.

Jackson was the first riffraff president. Washington, Jefferson, Madison, Monroe, and the two Adamses all came from patrician colonial families. They were gentlemen. Jackson, on the other hand, was a bloodthirsty, obnoxious frontiersman of Irish descent, a little bit country, a little bit rock 'n' roll. And no matter what horrific Jackson administration policy I point out, I can't escape the symbolism of Jackson's election. The American dream that anyone can become president begins with him.

My sister and I disapprove of what Jackson did to our people, but the fact is, Jackson is our people too. We also come from that *Opry*-watching segment of the population which the nicer academics euphemistically refer to as "working class" and the nastier television comics call "white trash." This is a race which a friend once described to me as "being Scotch or Irish plus at least three other things." Which is us. It wasn't anything anyone in our family ever talked about, it was just something I sensed. I first confronted it when I was eleven and read *Gone with the Wind.* I had the exact same reaction to the book as the young protagonist in Dorothy Allison's novel *Bastard Out of Carolina:* "Emma Slattery, I thought. That's who I'd be, that's who we were. Not Scarlett with her baking-powder cheeks. I was part of the trash down in the mud-stained cabins . . . stupid, coarse, born to shame and death."

Andrew Jackson was partly about being born to shame and death and becoming president anyway. That part of his biography is thrilling just as the similar glory chapters in the biographies of Elvis and Bill Clinton are thrilling. I don't know how it felt to be a poor redneck out in the middle of nowhere when Jackson got elected, but I do know what it felt like the day a man certain Easterners dismissed as a cracker beat that silver spoon George Bush. Personally, I felt like they just handed my Okie uncle Hoy the keys to Air Force One.

That Jackson's election was a triumph of populism still does not negate his responsibility for the Trail of Tears. If anything, it makes the story that much darker. Isn't it more horrible when a so-called man of the people sends so many people to their deaths? One expects that of despots, not democrats.

We drive on into Kentucky, toward Hopkinsville. When the Trail of Tears passed through southern Kentucky in December of 1838, a traveler from Maine happened upon a group of Cherokees. He wrote, "We found them in the forest camped for the night by the roadside . . . under a severe fall of rain accompanied by heavy wind. With their canvas for a shield from the inclemency of the weather, and the cold wet ground for a resting place, after the fatigue of the day, they spent the night. Several were then quite ill, and an aged man we were informed was then in the last struggles of death. . . . Even aged females, apparently nearly ready to drop into the grave, were traveling with heavy burdens attached to the back—on the sometimes frozen ground, and the sometimes muddy streets, with no covering for the feet except what nature had given them. We learned from the inhabitants on the road where the Indians passed, that they buried fourteen or fifteen at every every stopping place."

John Ross's wife died in a place like this—in winter—of pneumonia. She had one blanket to protect herself from the weather, and she gave it to a sick child during a sleet storm.

It gets worse. I always knew the Cherokee owned slaves, that they owned them in the East and that they owned them in the West. Only in the course of this road trip did it occur to me that the slaves got to Indian territory in the same manner as their masters—on the Trail of Tears. Can you imagine? As if being a slave wasn't bad enough? To be a slave to a tortured Indian made to walk halfway across the continent?

We stopped in Hopkinsville because it was on the map, but pulling into town we saw signs for a Trail of Tears Memorial Park we didn't know about. It seemed like a good idea to go there.

A Shelley Winters ringer named Joyce is sitting on the porch of the little museum, drinking soda. She's one of the volunteers who run the place. When I ask her about the park's origins, she tells us, "Hopkinsville was a ration stop along the way on the Trail of Tears. The Cherokee camped here. They were here for a week or so. While they were here, two of their chiefs died and they're buried up on the hillside. You should start here and walk up to the grave area. There are three bronze plaques on each one of the posts. The first two will give you the story of the Trail of Tears. The last one, just before you go into the grave area, tells you about the two chiefs, Whitepath and Flysmith."

The plaque nearest the graves says that Whitepath was one of the Cherokee who fought under Andrew Jackson in 1814 at the Battle of Horseshoe Bend. Jackson even gave Whitepath a watch for his bravery. In that battle, a Cherokee saved Jackson's life. Which underscores the level of Jackson's betrayal of the tribe. Had a Cherokee not saved his life then, Whitepath and Flysmith might not be buried here beneath our feet.

The graves are on a little hill. You can hear the highway down below, but still it's serene. Up until this moment, all the graves along the trail had been metaphorical. All through Tennessee, Amy and I kept saying, "We're driving over graves, we're driving over graves." But even then, we just imagined them there, under the blacktop, off in the woods. But here, the skeletons suddenly had faces, specific stories. The graves were real.

After Hopkinsville, we drive past farms that look so cliché they're practically pictographs—barns straight out of clip art, the cowiest possible cows. For whole minutes at a time, I convince myself that we're on a normal road trip. But we're not. We're on a death trip, and I can't go more than a few miles without agonizing and picking apart every symbolic nuance of every fact at my disposal. Which Amy might have found charming in Georgia since she hadn't seen me or my obsessions in months, but halfway through Tennessee—right about the second I see her wince in the company of Carolyn Brackett —I can practically hear her silent prayers that I shut up.

I don't know how old we were when we switched roles. As children, she was the loud one, the one with the mood swings, and I was the dutiful, silent observer. At every Trail of Tears site we visit, Amy wants to be the hospitable guest. She says please and thank you, wants to look around in peace. I can see her squirm every time I ask a question. After I cornered Joyce at the Hopkinsville site, she scolded me, "Sarah, it looked like she was on her break."

Back in the car, I try and keep quiet. Joyce had mentioned she gives a lot of tours to school groups. Which sounds like a lot of responsibility. She didn't make a big deal out of it, saying that the students "ask intelligent questions." I wondered if they have a hard time emotionally reconciling the facts of the Trail of Tears. She said, "No, I don't think there's any emotional stress for them at all."

Amy swerves a little when, after half an hour of cow-gazing hush, I burst out, "I think working there would be like working at the Holocaust Museum or working on some restored plantation, work that involves displaying and reliving some kind of senseless evil. I can't imagine having to go there every day. The thing I like about this trip is that it's going to be over fast."

"I don't know, Sarah." It's always a bad sign when Amy says my name. "I don't know how Joyce deals with it. I'm sure she doesn't obsess about it, because otherwise, she would just go crazy." Amy glances away from the road a second to give me the eye, complaining, "I think you catch people off guard. She was just sitting there drinking her Coke and eating her crackers and then you showed up."

"We showed up, Amy," I remind her. "Do you think asking these people questions and prying into what they do, do you think that's wrong?"

"I don't think it's wrong at all to ask people what they think. I just wonder how it would be different if you sent them a letter and said, 'Hey, Joyce, how is it working here?' If she had time to think about it and think about what goes through her mind every day instead of just saying, 'Hey, do you work here? Can you answer some questions?' Because she obviously really, really cared. I mean she was proud of that little place and she should be. And how does she know if the kids have to emotionally grapple with the thing. She just trots them around, shows

them this, shows them that, and then they get on the bus and go home."

I bring up another qualm. I get a new one every ten minutes, and this one has nothing to do with blaming America or blaming Andrew Jackson or blaming the Cherokees who signed the Treaty of New Echota. I'm starting to blame myself, because I have this tiny, petty thought—an embarrassingly selfish gratitude for the Trail of Tears, because without it, my sister and I wouldn't exist.

Amy rolls her eyes. "I don't think four thousand people needed to die so that we could be sitting here today. But it's a fact of not just life, but of our life, so I think we need to come to grips with that—*Sarah.*"

It took the Cherokee about six months to walk to Oklahoma. We're doing it in five days. Every ten minutes, we cover the same amount of ground they covered in a day.

We drive with the sun in our eyes. On back roads, through Kentucky. We duck into a remote, depressed section of downstate Illinois. A plaque marks a spot where thousands of Cherokee camped, unable to cross the Mississippi because of floating ice. We cross in under a minute. I know we're going fast but it doesn't feel fast. We plod through most of Missouri, stopping at yet another Trail of Tears State Park. There's actually a name for what we're doing: Heritage Tourism. Which sounds so grand—like it's going to be one freaking epiphany after another. But after a while we just read the signs without even getting out of the car. At the end of every day, we fall into our motel beds, wrecked.

In the morning, we trudge through Arkansas. We're stuck for two hours behind a Tyson chicken truck, unable to pass. We cruise through the Pea Ridge National Military Park, a Civil War battleground we visited once as children. It was here our great-great-grandfather Stephen Carlile fought—and lost—under Stand Watie's Confederate regiment of Cherokees. Watie, by the way, was the last Confederate general to surrender; he kept on fighting for two months after Appomattox; fighting was one thing he knew how to do.

We have another one of those twin moments where Amy wonders what it was like for Stand Watie to come back and fight in a spot he passed through on the Trail of Tears and I'm making myself sick trying to reconcile the fact that oppressed Indians could live with owning slaves, to die for slavery's cause.

We're not the only ones touring the park. We're just another car on the road. A lot of Americans do stuff like this every summer—traipse their kids around historic landmarks as a matter of course. Our dad brought us here, hoping to instill a sense of history in us. And even though there's really not that much to see except for a couple of cannons and a field of grass, it worked. We're back, aren't we? Amy and I came to see this history—and this country—as ours. Though as a kid I would've been too carsick and sleepy to imagine that I would someday willingly come back to Pea Ridge of my own accord.

It's just a short hop to Fayetteville. We have lunch with two old roommates of mine, Brad and Leilani, who take us to a little Trail of Tears marker next to a high school parking lot. It says that a thousand Cherokees camped on this spot in the summer of 1839.

The sign's facing a semicircular arrangement of boulders. Anyone who's ever been to high school would recognize it instantly as the place students go to sneak cigarettes or get stoned. And once again it's striking how the two American tendencies exist side by side—to remember our past, and to completely ignore it and have fun. Look at how we treat all our national holidays. Don't we mourn the dead on Memorial Day with volleyball and sunscreen? Don't We the People commemorate the Fourth of July by setting meat and bottle rockets on fire? Which makes a lot of sense when you remember that a phrase as weird and whimsical as "the pursuit of happiness" sits right there—in the second sentence of the founding document of the country.

The most happiness I find on the trip is when we're in the car and I can blare the Chuck Berry tape I brought. We drive the trail where thousands died and I listen to Berry's nimble guitar, to the poetry of place names as he sings "Detroit Chicago Chattanooga Baton Rouge," and I wonder what we're supposed to do with the grisly past. I feel a very righteous anger and bitterness about every historical fact of what the American nation did to the Cherokee.

But at the same time I am an entirely American creature. I'm in love with this song and the country that gave birth to it. Listening to "Back in the U.S.A." while driving the Trail of Tears, I turn it over and over in my head—it's a good country, it's a bad country, good country, bad country. And of course it's both.

When I think about my relationship with America, I feel like a battered wife: Yeah, he knocks me around a lot, but boy, he sure can dance.

Fayetteville's not far from the Oklahoma state line. A sign greets us that reads, "Welcome to Oklahoma, Native America."

Amy says, "I don't remember the signs used to say that."

I tell her that, no, I think they used to say, "Oklahoma is O.K." Which is about right: It's *okay.*

We're now in the western Cherokee Nation. And the maddening thing—the heartbreaking, cruel, sad cold fact—is that

northeastern Oklahoma looks *exactly* like northwestern Georgia. Same old trees, same old grassy farmland. The Cherokee walked all this way—crossed rivers, suffered blizzards, buried their dead—and all for what? The same old land they left.

We breeze through Tahlequah, the Cherokee capital. Even though the Trail of Tears officially stops there, our trail won't be over until we get to our hometown—Braggs. It's about twenty minutes away and we plan on spending the evening with our aunts and uncles there. I put in a tape of a teen brother band from Tulsa singing "MMMbop," the first song in the traditional end of Trail of Tears Hanson medley. Of course we don't get to bop for long.

The road out of Tahlequah is called the POW-MIA Highway. The fun doesn't stop! God bless America, and history, too. We finished mapping the Trail of Tears two minutes ago and now we run smack dab into Vietnam, a war, as I recall, that brought the word "quagmire" into popular use. What's next? A billboard screaming, "Honk if you have misgivings about how the FBI handled Waco!"

We turn left onto the two-lane highway that leads to Braggs, my own private quagmire. This is the nineteen miles of road that connects our hometown to the county seat, Muskogee. Amy and I have been on it hundreds if not thousands of times, though only I know its topography with the intimacy that comes from leaning over every inch of it, carsick. I can't help but wonder if the grass grows so close to the shoulder because of my personal fertilizer crusade: I was a little Lady Bird Johnson of puke.

"It's not that far, is it?" Amy asks. "It seemed like it was forever when we were kids to get to Muskogee, didn't it? Because we always got stuff when we got to go there—pizza and movies. What else did we get?"

I got to throw up on the side of the road.

Amy looks up. "Braggs Mountain. Not much of a mountain," she says, a Montanan now.

Not much of a town. We're here. A sign at what could loosely be called the city limits announces, "Welcome to Braggs. Rural Living."

Our aunt Lil and uncle John A.'s house in Braggs smells exactly as I remember it, like cookies. They welcome us with hugs and food. Our aunt Jenny and uncle Hoy, our funniest relatives, are there to see us, too. We sit around the kitchen table in stitches just like always. I've missed this.

After supper, Lil, Jenny, Hoy, and Amy go out and sit on the porch and leave Uncle John A. and me inside to talk. At seventy-four, my mother's brother is my oldest living relative. He's a World War II veteran. I asked him about his great-grandfather Peter Parson, who came to Oklahoma on the Trail of Tears when he was twelve years old.

John A. says that Peter was brought on the trail by two Presbyterian ministers. "He grew up here. And he was a stonemason. Some of his work is still around Tahlequah. If you're going up to the Village tomorrow," meaning the Cherokee Heritage Center called Tsa-La-Gi, "you'll see two big columns."

"He built those?"

"He helped build those two columns. See, they built that right after they came up here."

I didn't know that. The columns he's talking about—and there are actually three instead of two—are the great symbols of the Cherokee Nation in the West. For years, I've had an old photograph of the columns stuck on my refrigerator door. They are all that's left of the remains of the Cherokee Female Seminary, the very first public school for girls west of the Mississippi, which my great-grandmother on my father's side attended.

Everything about the journey until now has been a little world-historical. Hearing that our ancestor helped build the columns is the first time I felt an actual familial connection to the story.

I ask John A. about our family and the Cherokee presence in Oklahoma. I ask him a lot of off-topic questions about his service in World War II, mainly because I was dying to; I was never allowed to ask him about it when I was a kid, because thirty years after V-J Day, he was still having nightmares and flashbacks. And then I ask him a mundane, reporterly question about whether he thinks the state of Oklahoma has done a good job educating its students about American Indian history. He says yes, then jumps into a non sequitur about his own education that I haven't been able to stop thinking about since.

"I just wish that I could have maybe went to school a lot more. I didn't get no education. That was one of my big faults. But when I was growing up, it took everybody to make a living. I had to work." He says he only got a third-grade education. "Did you know that?"

"No. Third grade."

"That's all I've got," he says. "Third grade. We didn't get no education. So what you learn, you can't afford to forget."

On this trip I've been so wrapped up in all the stories of all the deaths on the Trail of Tears. Sitting there, listening to my uncle ask "what if," I realize that there are lots of ways that lives are pummeled by history.

If the Trail of Tears is a glacier that inched its way west, my uncle is one of the boulders it deposited when it stopped. He

had to work the farm, and the farm he worked was what was left of his grandfather's Indian allotment. And then came the Dust Bowl, and then came the war. All these historical forces bore down on him, but he did not break. Still, compared to him, compared to the people we descend from, I am free of history. I'm so free of history I have to get in a car and drive seven states to find it.

Uncle John A. remarks, "It's good to know where you're from. To know where your beginning is. It really, probably, don't amount to all that much. Only just to one's self. It has nothing to do with what you're going to do tomorrow or a week or two from now. But at least, if you want to look back on this trip, and say, 'Well, I was down in the area there where some of my ancestors originated from.'"

The next morning, the columns are the first thing we see when we get to Tsa-La-Gi. The last time we were here, we were nine years old. Not surprisingly, the columns are more diminutive than we remember. We rush over to the amphitheater entrance. We walk past the place where you'd get your programs, and Amy waves hello to the statue of Sequoyah. She points to the stage where the Phoenix would rise again. I point to the spot where Stand Watie was always throwing a fit.

Unfortunately, due to loss of funding the drama here at Tsa-La-Gi won't be performed this summer. Amy and I sit in the chairs where we first learned about the Trail of Tears and talk about our trip. Our experiences were different. She minored in Native American Studies in college. She not only owns a copy of *Black Elk Speaks,* she could quote from it.

For Amy, the trip was about empathy: "I've been pretty close to tears sometimes just thinking about the pain, what the kids must have been thinking. When we were driving, I just kept imagining the kids saying, 'Where are we going? Where are we going? What is happening?' I've just been thinking about what it really must have been like."

I've been thinking about those kids, too. But the person I identify with most in this history is John Ross, because he was caught between the two nations. He believed in the possibilities of the American Constitution enough to make sure the Cherokee had one, too. He believed in the liberties the Declaration of Independence promises, and the civil rights the Constitution ensures. And when the U.S. betrayed not only the Cherokee but its own creed I would guess that John Ross was not only angry, not only outraged, not only confused, I would guess that John Ross was a little brokenhearted.

Because that's how I feel. I've been experiencing the Trail of Tears not as a Cherokee, but as an American.

John Ridge, one of the signers of the Treaty of New Echota, once prophesied, "Cherokee blood, if not destroyed, will wind its courses in beings of fair complexions, who will read that their ancestors became civilized under the frowns of misfortune, and the causes of their enemies." He was talking about people like my sister and me. The story of the Trail of Tears, like the story of America, is as complicated as our Cherokee-Swedish-Scottish-English-French-Seminole family tree. Just as our blood will never be pure, the Trail of Tears will never make sense.

works illustrated

Ann Agee (born 1959, Philadelphia)

The Birth of Emilio
2001
Porcelain, china paint, gold luster
8½ × 9 × 14½ inches
Courtesy of the artist and PPOW Gallery,
New York
PLATE 1

Janine Antoni (born 1964,
Freeport, Bahamas)

Momme
1995
C-print
36 × 29 inches
Courtesy of the artist and Luhring Augustine
Gallery, New York
PLATE 45

Umbilical
2000
Sterling cast silver of family silverware and
negative impressions of the artist's mouth
and mother's hand
8 × 3 × 3 inches
Courtesy of the artist and Luhring Augustine
Gallery, New York
PLATE 2

Diane Arbus (1923–1971, born New York)

*A young family in Brooklyn going for a Sunday
outing. Their baby is named Dawn. Their son is
retarded.*
1966
Gelatin silver print
14¹⁵⁄₁₆ × 14¹⁵⁄₁₆ inches
Courtesy of the Fogg Art Museum, Harvard
University Art Museums, National Endowment
for the Arts Grant
PLATE 4

*This is Eddie Carmel, a Jewish giant, with his
parents in the living room of their home in the
Bronx, New York*
1970
Gelatin silver print
14¹⁵⁄₁₆ × 14¹⁵⁄₁₆ inches
Courtesy of the Fogg Art Museum, Harvard
University Art Museums, National Endowment
for the Arts Grant
PLATE 12

Tina Barney (born 1945, New York)

The Boys
1990
Chromogenic color print (Ektacolor)
48 × 60 inches
Museum of Fine Arts, Boston, Contemporary
Curator's Fund, including funds provided by
Barbara and Thomas Lee
PLATE 9

Romare Bearden (1912–1988,
born Charlotte, North Carolina)

Family
1967–68
Collage on canvas
56 × 44 inches
Museum of Fine Arts, Boston, Abraham
Shuman Fund
PLATE 3

Sanford Biggers (born 1970, Los Angeles)
and Jennifer Zackin (born 1970,
Waterbury, Connecticut)

a small world . . .
2000
video installation
dimensions variable
Collection of the artists
PLATE 40

Frédéric Brenner (born 1970, Paris)

*Grigoriy Aaronovich and Yevgeniya Yosifovna
with their children, David, Liza, and Arkady,
and their dogs, Pobeda and Tobias, Leningrad
(now St. Petersburg)*
1991
Gelatin silver print
14 × 11 inches
Courtesy of Howard Greenberg Gallery,
New York
PLATE 13

Paul Cadmus (1904–1999, born New York)

Family Group
1964
Egg tempera on Whitman board
14¾ × 19¾ inches
Modern Art Museum of Fort Worth, gift of
the American Academy of Arts and Letters,
Childe Hassam Fund
PLATE 67

Albert Chong (born 1958,
Kingston, Jamaica)

Throne for the Justice
1990
Solarized gelatin silver print
41¾ × 32¼ inches
Museum of Art, Rhode Island School of Design,
Providence, Walter H. Kimball Fund
PLATE 44

Richard Cleaver (born 1952,
Camden, New Jersey)

House on Fire
1998
Ceramic, wood, freshwater pearls,
glass beads, 22K gold leaf, oil paint
30 × 24 ×13 inches
Collection of Martha L. Kearsley
PLATE 68

Chuck Close (born 1940, Monroe, Washington)

Maggie
1984
Litho ink on silk paper
19⅛ × 15½ inches
Private collection
PLATE 26

Maggie
1998–99
Oil on canvas
72 × 60 inches
Private collection
PLATE 27

Gregory Crewdson (born 1962, Brooklyn)

Untitled (penitent girl), from the *Twilight* series
2002
Digital Chromogenic Fujicolor Crystal Archive print mounted on aluminum
48 × 60 inches
Collection of Ann and Steven Ames
PLATE 70

Roy DeCarava (born 1919, Harlem, New York)

Sherry, Susan, Wendy, and Laura
1983
Gelatin silver print
13¹⁵⁄₁₆ × 10¹⁵⁄₁₆ inches
Addison Gallery, Phillips Academy, Andover, Massachusetts
PLATE 25

Keith Edmier (born 1967, Chicago)

Beverley Edmier, 1967
1998
Cast urethane resin, cast acrylic resin, silicone, acrylic paint, silk, wool, and Lycra fabrics, cast silver buttons, nylon tights
50¾ × 31½ × 22½ inches
Collection of Rachel and Jean-Pierre Lehmann
PLATE 46

Walker Evans (1903–1975, born St. Louis)

Wooldridge Family Monument, Maplewood Cemetery, Mayfield, Kentucky
1947
Gelatin silver print
7⅞ × 7⁹⁄₁₆ inches
The J. Paul Getty Museum, Los Angeles
PLATE 48

Larry Fink (born 1941, Brooklyn)

Pat Sabatine's Eleventh Birthday Party, April 1980 (Martin's Creek)
1980
Gelatin silver print
17⅝ × 11¾ inches
Museum of Fine Arts, Boston, gift of Janet Singer
PLATE 34

Robert Frank (born 1924, Zurich)

Mary and Children
Late 1950s
Gelatin silver print
8 × 12⅜ inches
Courtesy of Howard Greenberg Gallery, New York
PLATE 24

William Gedney (1932–1989, born Albany)

South Dakota
1966 (printed 1971)
Gelatin silver print
11 × 14 inches
Courtesy of Howard Greenberg Gallery, New York
PLATE 14

Simryn Gill (born 1959, Singapore)

No. 10, from *A Small Town at the Turn of the Century*
1999–2000
Chromogenic development print
36 × 36 inches (image)
Edition of 5
Courtesy of the artist and Barbara Flynn, Sydney and New York
PLATE 80

No. 16, from *A Small Town at the Turn of the Century*
1999–2000
Chromogenic development print
36 × 36 inches (image)
Edition of 5
Courtesy of the artist and Barbara Flynn, Sydney and New York
PLATE 79

No. 19, from *A Small Town at the Turn of the Century*
1999–2000
Chromogenic development print
36 × 36 inches (image)
Edition of 5
Courtesy of the artist and Barbara Flynn, Sydney and New York
PLATE 77

No. 29, from *A Small Town at the Turn of the Century*
1999–2000
Chromogenic development print
36 × 36 inches (image)
Edition of 5
Courtesy of the artist and Barbara Flynn, Sydney and New York
PLATE 78

Jim Goldberg (born 1953, New Haven, Connecticut)

I love David. But he is to[o] fragile for a rough father like me.
1982
Published in *Rich and Poor*, 1985
Gelatin silver print
13⅞ × 10¹³⁄₁₆ inches
Museum of Fine Arts, Boston, A. Shuman Collection
PLATE 52

We haven't done anything to promote it, but she seems to think that she is Shirley Temple.
1982
Published in *Rich and Poor*, 1985
Gelatin silver print
14 × 10¹⁵⁄₁₆ inches
Museum of Fine Arts, Boston, A. Shuman Collection
PLATE 53

Nan Goldin (born 1953, Washington, D.C.)

Lil Laughing, Swampscott, MA
1996
Cibachrome print
30 × 40 inches
Edition 1/15
Courtesy of the artist and Matthew Marks Gallery, New York
PLATE 22

My Father Shaving, Swampscott, MA
1997
Cibachrome print
30 × 40 inches
Edition 1/15
Courtesy of the artist and Matthew Marks Gallery, New York
PLATE 23

Sidney Goodman (born 1936, Philadelphia)

Figures in a Landscape
1972–73
Oil on canvas
55 × 96 inches
Philadelphia Museum of Art, purchased with the Philadelphia Foundation Fund (by exchange) and the Adele Haas Turner and Beatrice Pastorius Turner Memorial Fund, 1974
PLATE 30

David Hockney (born 1937, Bradford, England)

My Mother, Bolton Abbey, Yorkshire, Nov. '82
1982
Photographic collage
47½ × 27½ inches
Edition 4/20
Courtesy of the artist
PLATE 31

Seydou Keita (1921–2001, born Bamako, Mali)

Untitled (Man Holding Baby)
1949–51 (printed 1996)
Gelatin silver print
24 × 20 inches
Museum of Fine Arts, Boston, Horace W.
Goldsmith Foundation Fund for Photography
PLATE 16

Byron Kim (born 1961, La Jolla, California)

Emmett at 12 Months
1994
Egg tempera on wood
Twenty-five wood panels; each 3 × 2½ inches
Courtesy of the artist and Max Protetch Gallery,
New York
PLATE 28

Whorl (Ella & Emmett)
1997
Egg tempera on panel
Left panel: 4½ × 4 inches
Right panel: 4¾ × 4½ inches
Private collection
PLATE 29

William Klein (born 1928, New York)

Holy Family on Wheels
1956 (printed later)
Gelatin silver print
19¹¹⁄₁₆ × 15¾ inches
Courtesy of Howard Greenberg Gallery,
New York
PLATE 10

Edward Koren (born 1935, New York)

Mailboxes
1992
Pen and India ink on paper
22½ × 29⅛ inches
Courtesy of the artist
PLATE 50

"Your father and I want to explain . . ."
1995
Pen and India ink on paper
22¼ × 25½ inches
Courtesy of the artist
PLATE 49

Charles LeDray (born 1960, Seattle)

Family
1985–88
Fabric, thread, leather, ribbon, buttons,
embroidery floss, horsehair, shirt label
11½ × 8¼ × 7 inches
Private collection, Courtesy of Sperone
Westwater Gallery, New York
PLATE 73

Glenn Ligon (born 1960, Bronx)

Dad (version 1), #1
2000
Oil crayon and silkscreen on primed canvas
48 × 36 inches
Courtesy of the artist and D'Amelio Terras
Gallery, New York
PLATE 62

The Letter B (version 1), #1
2000
Flashe paint and silkscreen on primed canvas
48 × 36 inches
Courtesy of the artist and D'Amelio Terras
Gallery, New York
PLATE 61

Hung Liu (born 1948, Changchun, China)

Father's Day
1994
Oil on canvas with antique architectural panel
54 × 72 inches
Courtesy of Bernice Steinbaum Gallery, Miami
PLATE 32

Kerry James Marshall (born 1955, Birmingham, Alabama)

Souvenir II, from *Mementos*
1997
Acrylic and collage on canvas
108 × 120 inches
Addison Gallery, Phillips Academy, Andover,
Massachusetts, gift of the Addison Advisory
Council in honor of John ("Jock") M. Reynolds's
directorship of the Addison Gallery of American
Art, 1989–1998
PLATE 74

Elaine Mayes (born 1938, Berkeley, California)

Group Portrait, from *Photographs of
Haight Ashbury*
1970
Gelatin silver print
8⅞ × 9 inches
Museum of Fine Arts, Boston, Polaroid
Foundation Purchase Fund
PLATE 15

Duane Michals (born 1932, McKeesport, Pennsylvania)

A Letter from My Father
1975
Gelatin silver print with text
4¹³⁄₁₆ × 7¹⁄₁₆ inches
Edition 3/25
Museum of Fine Arts, Boston,
Sophie M. Friedman Fund
PLATE 51

Tracey Moffatt (born 1960, Brisbane, Australia)

Birth Certificate, 1962, from the
Scarred for Life portfolio
1994
Photolithograph
31½ × 23½ inches
Museum of Fine Arts, Boston, gift of Diego
Cortez in memory of Harry Brams
PLATE 59

Useless, 1974, from the *Scarred for Life* portfolio
1994
Photolithograph
31½ × 23½ inches
Museum of Fine Arts, Boston, gift of Diego
Cortez in memory of Harry Brams
PLATE 60

Charles Moore (born 1931, Hackleburg, Alabama)

Birmingham
1963 (printed later)
Gelatin silver print
11 × 14 inches
Courtesy of Howard Greenberg Gallery,
New York
PLATE 6

Alice Neel (1900–1984, born Merion Square, Pennsylvania)

Linda Nochlin and Daisy
1973
Oil on canvas
55⅛ × 44 inches
Museum of Fine Arts, Boston,
Seth K. Sweetser Fund
PLATE 17

Shirin Neshat (born 1957, Qazvin, Iran)

My Beloved, from the *Women of Allah* series
1995
Black-and-white RC print with ink additions
32 × 21½ inches
Worcester Art Museum, Worcester,
Massachusetts, Sarah C. Garver Fund
PLATE 33

Nicholas Nixon (born 1947, Detroit)

The Brown Sisters
1975–99
Twenty-five gelatin silver prints
49 × 59 inches (including frame)
Anonymous gift, Courtesy of the Fogg Art
Museum, Harvard University Art Museums.
Davis Pratt Fund, Courtesy of the Fogg Art
Museum, Harvard University Art Museums
PLATE 35

Catherine Opie (born 1961,
Sandusky, Ohio)

*Catherine, Melanie & Sadie Rain, New York,
New York,* from the *Domestic* series
1998
Chromogenic print
40 × 50 inches
Edition of 5
Collection of Gregory Miller, New York
PLATE 11

John O'Reilly (born 1930,
Orange, New Jersey)

With Whitman
1981
Tinted photograph and halftone montage
4⅞ × 5½ inches
Courtesy of the artist and Howard Yezerski
Gallery, Boston
PLATE 72

Eakins' Student as Balthazar Carlos
1996
Polaroid montage
6⅞ × 5⁵⁄₁₆ inches
Collection of the artist
PLATE 71

Bill Owens (born 1938, San Jose, California)

*This is Valerie's world in miniature. She makes
it what she wants it to be . . . without war, racial
hate or misunderstanding. Ken and Barbie (dolls)
are man and woman rather than Mom and Dad.
They enjoy living, and having a camper truck
is the good life. Today Valerie has the chicken
pox and can't go out and play,* from *Suburbia*
c. 1970
Gelatin silver print
8½ × 5⅝ inches
Courtesy of Howard Greenberg Gallery,
New York
PLATE 8

Charles Ray (born 1953, Chicago)

Family Romance
1993
Mixed media
54 × 85 × 11 inches
Collection of Eileen and Peter Norton,
Santa Monica
PLATE 69

Faith Ringgold (born 1930,
Harlem, New York)

Tar Beach, Part I from the *Woman on a Bridge*
series
1988
Acrylic on canvas, bordered with printed,
painted, quilted, and pieced cloth
74⅝ × 68½ inches
Solomon R. Guggenheim Museum, New York,
gift of Mr. and Mrs. Gus and Judith Lieber
PLATE 64

Milton Rogovin (born 1909, New York)

Triptych, from the *Buffalo's Lower West
Side Revisited* series
1973, 1985, and 1991
Three gelatin silver prints
7¹³⁄₁₆ × 6⁵⁄₁₆; 6⅞ × 6¾; and 7³⁄₁₆ × 6⅜ inches
Hallmark Photographic Collection, Hallmark
Cards, Inc., Kansas City, Missouri
PLATE 36

Tim Rollins + K.O.S. (Rollins born 1955,
Pittsfield, Maine)

The Interior of the Heart
1987–88
Acrylic, watercolor, and bistre on book
pages mounted on canvas
90 × 102 inches
Rose Art Museum, Brandeis University,
Waltham, Massachusetts, gift of Sandra
and Gerald Fineberg, Boston
PLATE 65

Diego Romero (born 1964,
Berkeley, California)

Iwo Jima Pot, from the *Never Forget* series
2001
Polychromed earthenware
21½ × 11 inches
Peabody Essex Museum, purchased with
funds provided by Margie and James Krebs
PLATE 75

Roger Shimomura (born 1939, Seattle)

American Diary: December 25, 1941
1997
Acrylic on canvas
11 × 17 inches
Courtesy of the artist and Greg Kucera Gallery,
Seattle
PLATE 37

American Diary: May 16, 1942
1997
Acrylic on canvas
11 × 17 inches
Collection of Lawrence and Karen Matsuda,
Courtesy of Greg Kucera Gallery, Seattle
PLATE 38

American Diary: July 15, 1943
1997
Acrylic on canvas
11 × 17 inches
Courtesy of the artist and Greg Kucera
Gallery, Seattle
PLATE 39

Yinka Shonibare (born 1962, London)

Nuclear Family
1999
Mixed-media installation: wax-printed cotton
textile, mannequins
Pedestal: 96 × 180 × 5 inches
Collection Seattle Art Museum. Gift of Agnes
Gund and Daniel Shapiro in honor of Mr. and
Mrs. Bagley Wright
PLATE 76

Joe Steinmetz (1905–1985, born
Germantown, Pennsylvania)

Untitled (Tupperware party, Sarasota, Florida)
1958
Gelatin silver print
9¾ × 12½ inches
Courtesy of the Fogg Art Museum, Harvard
University Art Museums, on deposit from
the Carpenter Center for the Visual Arts
PLATE 5

Paul Strand (1890–1976, born New York)

The Family, Luzzara, Italy
1953
Gelatin silver print
7½ × 9½ inches
Courtesy of Howard Greenberg Gallery,
New York
PLATE 18

Thomas Struth (born 1954, Geldern, West Germany)

The Shimada Family, Yamaguchi
1986
C-print
26½ × 33½ inches
Courtesy of the artist and Marian Goodman Gallery, New York
PLATE 19

Hiroshi Sugimoto (born 1948, Tokyo)

The Royal Family
1994
Gelatin silver print
20 × 24 inches
Courtesy of Sonnabend Gallery, New York
PLATE 47

Larry Sultan (born 1946, New York)

Thanksgiving Turkey/Newspaper, from *Pictures from Home*
1992
Two color coupler photographs and two screen-printed Plexiglas panels
Each photograph 30 × 36 inches
Corcoran Gallery of Art, gift of the FRIENDS of the Corcoran Gallery of Art
PLATE 58

Shellburne Thurber (born 1949, Boston)

Edinburg, Indiana: My Grandfather's Bed
1976
Gelatin silver print
30 × 30 inches
Courtesy of the artist
PLATE 42

Edinburg, Indiana: My Grandfather's Study
1976
Gelatin silver print
30 × 30 inches
Courtesy of the artist
PLATE 43

Edinburg, Indiana: My Mother's Portrait
1976
Gelatin silver print
30 × 30 inches
Courtesy of the artist
PLATE 41

Andy Warhol (1928–1987, born Pittsburgh)

Julia Warhola
1974
Silkscreen ink and synthetic polymer paint on canvas
40 × 40 inches
The Andy Warhol Museum
Founding Collection, Contribution The Andy Warhol Foundation for the Visual Arts, Inc.
PLATE 20

Julia Warhola
1974
Silkscreen ink and synthetic polymer paint on canvas
40 × 40 inches
The Andy Warhol Museum
Founding Collection, Contribution The Andy Warhol Foundation for the Visual Arts, Inc.
PLATE 21

Carrie Mae Weems (born 1953, Portland, Oregon)

Alice on Bed, from *Family Pictures and Stories*
1978–84
Gelatin silver print
24 × 36 inches
Courtesy of the artist and PPOW Gallery, New York
PLATE 54

Dad and Me, from *Family Pictures and Stories*
1978–84
Gelatin silver print and text
13 × 8½ inches
Courtesy of the artist and PPOW Gallery, New York
PLATE 57

Daddy at Work, from *Family Pictures and Stories*
1978–84
Two gelatin silver prints and text
Each 8½ × 13 inches
Courtesy of the artist and PPOW Gallery, New York
PLATE 55

Mom at Work, from *Family Pictures and Stories*
1978–84
Gelatin silver print
24 × 36 inches
Courtesy of the artist and PPOW Gallery, New York
PLATE 56

Garry Winogrand (1928–1984, born Bronx)

Hard Hat Rally
1969
Gelatin silver print
13½ × 19 inches
Hallmark Photographic Collection, Hallmark Cards, Inc., Kansas City, Missouri
PLATE 7

Chris Wool (born 1955, Chicago)

Apocalypse Now
1988
Alkyd enamel on paper
28 × 25½ inches
Collection of Lisa Spellman, New York
PLATE 63

Zhang Huan (born 1965, Anyang, China)

Family Tree
2001
Nine color photographs
Each 50 × 40 inches
Collection of Martin Z. Margulies, Miami
PLATE 66

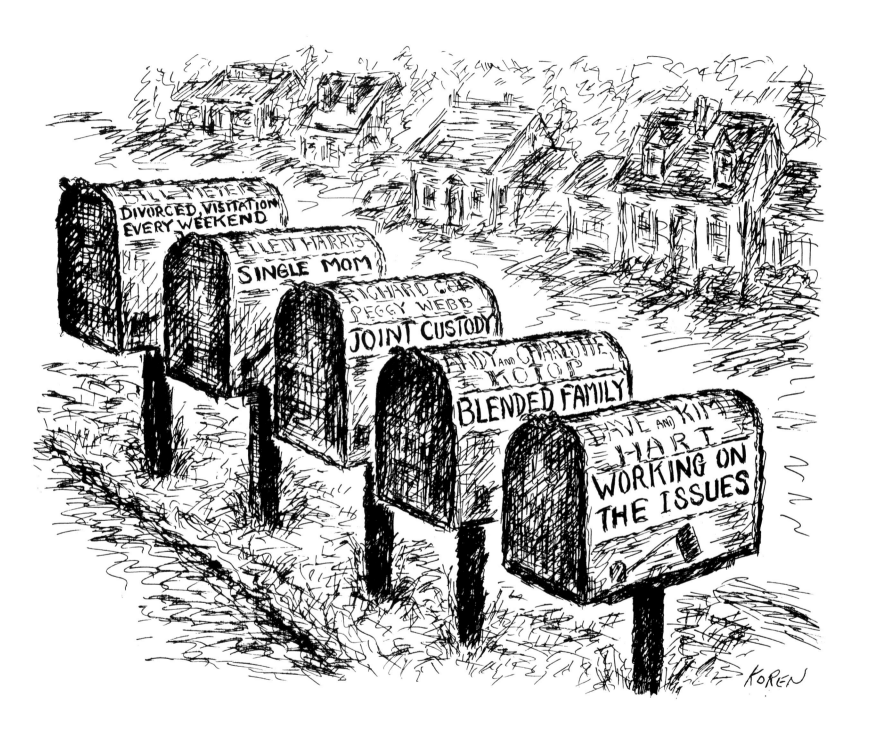

If my family tree goes back to the Romans
Then I will change my name to Jones
If my family tree goes back to Napoleon
Then I will change my name to Smith

—Belle & Sebastian, "Family Tree"
from *Fold Your Hands Child, You Walk Like a Peasant*
(Matador Records, New York, 2000)

acknowledgments

First, I would like to thank the artists whose creative efforts inspired this project and gave it substance. I am indebted to those who communicated with me about their work. In addition, I am deeply grateful to the institutions, private collectors, art galleries, and artists who generously lent works to the exhibition.

It was an honor for me when executive director Dan L. Monroe and his staff invited me to curate a project for the Peabody Essex Museum. My first stint in a museum was in the guise of a graduate school internship at the former Essex Institute in the mid 1970s; it is, therefore, exciting to return as a professional to an organization that has grown and moved in so many new directions. In Salem, I am especially grateful to John Grimes, curator of Native American Art and Culture and deputy director of Special Projects, who has been an excellent steward and guiding light throughout the project; and I give warm thanks to the following colleagues for their help and advice: Nancy Berliner, Naomi Chapman, Merrily Glosband, Lynda Hartigan, Frederick Johnson, Carolle Morini, Vas Prabhu, and Claudine Scoville.

Many people helped me in countless ways as I conducted my research, and I appreciate the generosity of the following individuals: Clifford S. Ackley, Kathleen Adler, John Anderson, Callie Angell, Roland Augustine, Jenny Baie, Calvert Barron, Nicholas Baume, Douglas Baxter, Jonathan P. Binstock, Philip Brookman, Josie Browne, Shaun Caley Regen, Carl Chiarenza, Lisa Corrin, Cherese Crockett, Keith F. Davis, Kimberly Davis, Elizabeth deFato, Gregory Evans, Lee-Anne Famolare, Susan Faxon, Mia Fineman, Zora Hutlova Foy, Pat Fundom, Tom Gitterman, Deborah Gribbon, Joanna Groarke, Jim Harris, Anne E. Havinga, Antonio Homem, Randi Hopkins, Jan Howard, Chiyo Ishikawa, Heidi Zuckerman Jacobsen, Deborah Martin Kao, Judith Keller, Colleen Kelsey, Margery King, Robert Klein, Barbara Krakow, Greg Kucera, Karen S. Kuhlman, Kris Kuramitsu, Katie Lane, Scott Lawrimore, Jack Mackey, Natalia Mager, Ted Mann, Matthew Marks, Jennifer McIntosh, Jen Mergel, Andrea Miller-Keller, Bridget Moore, Lauren Moscoso, Susan Mulcahy, Patrick Murphy, Weston J. Naef, Jennifer Nedbalsky, Leslie Nolen, Wendy Olsoff, Anna O'Sullivan, Lisa Overduin, Jeffrey Peabody, Friedrich Petzel, Karen Polack, Kathryn Potts, Sarah Powers, John Ravenal, Sabine Rewald, Larry Rinder, Jeff L. Rosenheim, Phyllis Rosenzweig, Amanda Rowell, Brian Sholis, Nancy Spector, Lisa Spellman, Mari Spirito, Stephanie Stepanek, Susan L. Stoops, Laura Sundstrom, Nancy Swallow, Lucien Terras, Gary Tinterow, Pamela Vander Zwan, Emily Wei, Howard Yezerski, Donald Young, Tara Young, Jason Ysenberg, Eric Zafran, and numerous staff members of the Minuteman Library Network.

This publication would not have been possible without the collaboration of Marquand Books in Seattle. It is a privilege to have the ongoing interest and support of Ed Marquand. I would like to thank Jeff Wincapaw for his striking design, and Marie Weiler for her expert management of the production. Michelle Piranio, in Portland, Oregon, deserves particular thanks for her excellent editorial job.

On the personal front, I took inspiration from Monique van Dorp and her enthusiastic thoughts as I embarked on this project. Janice Sorkow has been her usual kind and wise self. And John Kirk has been as unstinting as ever in his efforts to make this venture a success on all family fronts.

I dedicate my part in this project to Belle & Sebastian, in gratitude for the beauty and joy in their work.

Trevor Fairbrother
VISITING CURATOR OF CONTEMPORARY ART,
PEABODY ESSEX MUSEUM